Glass
Animals & Figurines

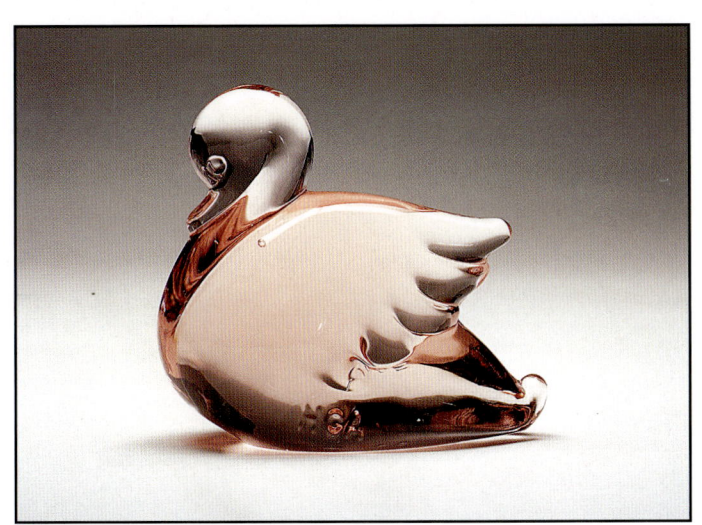
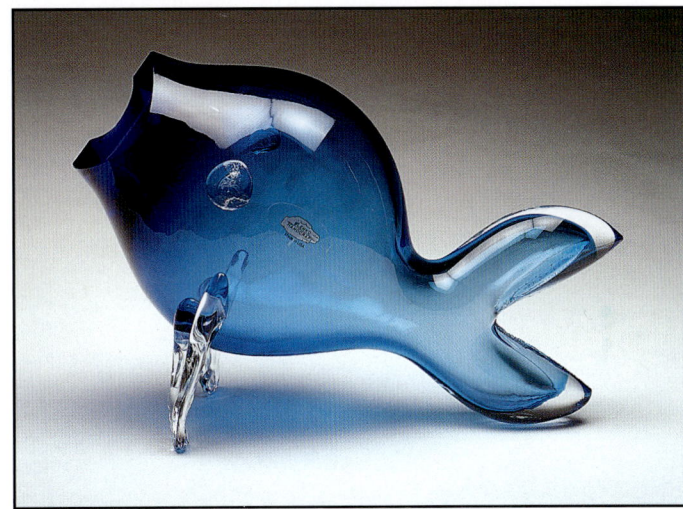

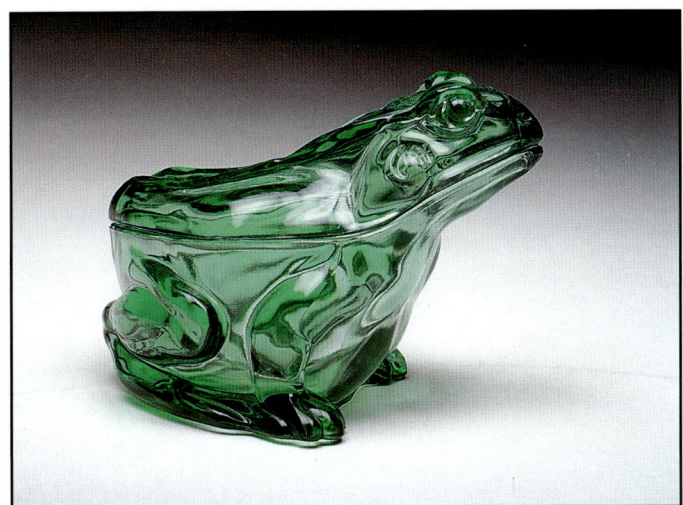

Debbie & Randy Coe

4880 Lower Valley Road, Atglen, PA 19310 USA

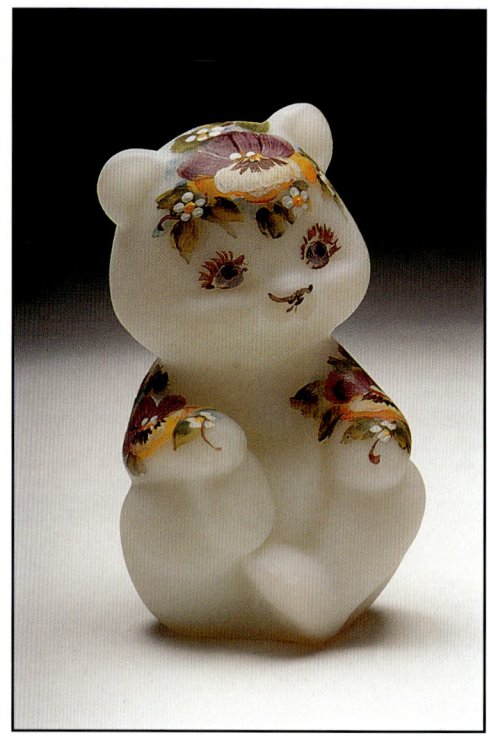

Copyright © 2003 by Debbie and Randy Coe
Library of Congress Catalog Control Number: 2002110627
All rights reserved. No part of this work may be reproduced or used in any form or by any means—graphic, electronic, or mechanical, including photocopying or information storage and retrieval systems—without written permission from the copyright holder.
"Schiffer," "Schiffer Publishing Ltd. & Design," and the "Design of pen and inkwell" are registered trademarks of Schiffer Publishing Ltd.

Designed by Bonnie M. Hensley
Cover design by Bruce M. Waters
Type set in Seagull Hv BT/Zurich BT

ISBN: 0-7643-1707-5
Printed in China
1 2 3 4

Published by Schiffer Publishing Ltd.
4880 Lower Valley Road
Atglen, PA 19310
Phone: (610) 593-1777; Fax: (610) 593-2002
E-mail: Schifferbk@aol.com
Please visit our web site catalog at www.schifferbooks.com

In Europe, Schiffer books are distributed by Bushwood Books
6 Marksbury Avenue Kew Gardens
Surrey TW9 4JF England
Phone: 44 (0) 20-8392-8585; Fax: 44 (0) 20-8392-9876
E-mail: Bushwd@aol.com
Free postage in the UK. Europe: air mail at cost.

This book may be purchased from the publisher.
Include $3.95 for shipping. Please try your bookstore first.
We are always looking for people to write books on new and related subjects.
If you have an idea for a book please contact us at the above address.
You may write for a free catalog.

Dedication

This book is dedicated to our daughters, Tara and Myra. Tara has collected cat figurines since she was about three years old. Myra collected elephant figurines from the age of three and later decided also to collect dog figurines. Both of them love all of God's many creatures. May we all learn to love, respect, honor, value, and appreciate their existence with ours. Without our girls' help, support, and love, this book could not have been completed. Our love for them grows each day.

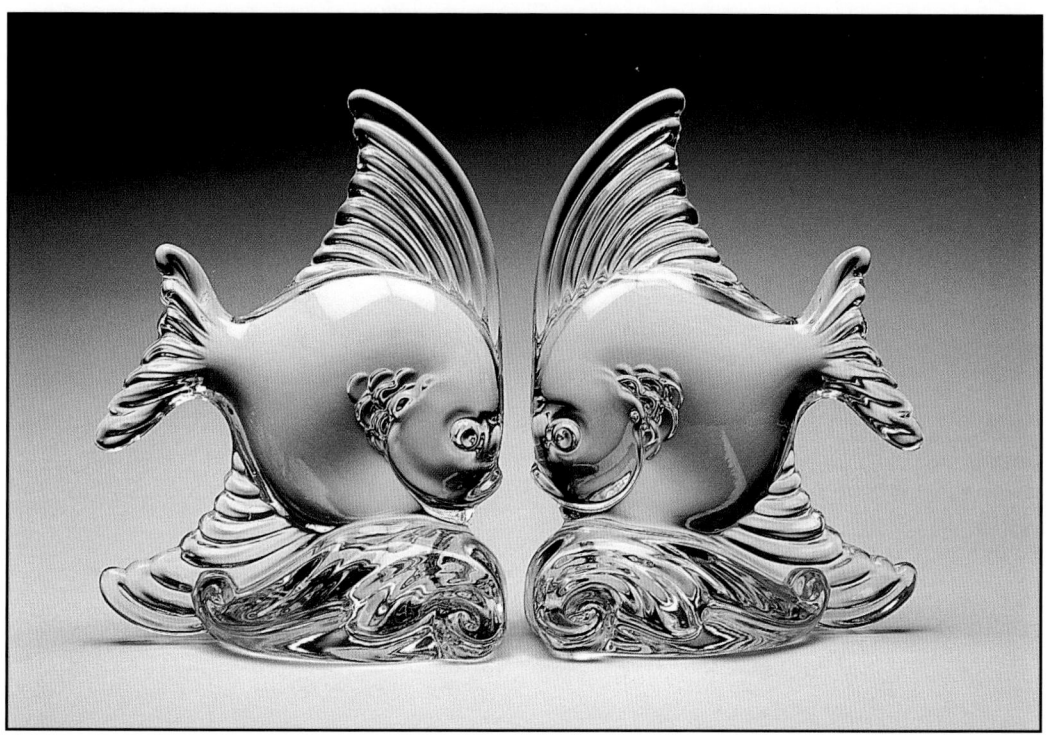

Acknowledgements

A comprehensive project such as this would not have happened without all the fantastic support we received from both collectors and dealers. Numerous collectors supplied us with an endless amount of information. We thank all of you immensely for the glass animals and/or information you provided to us. This book is a product of all the following people who were so willing to share with us: David and Linda Adams, Dale and Joanne Bender, Janine Bender, Sonya Black, Neila and Tom Bredehoft, Al and Carol Carder, Bonnie and Bruce Catton, Darlene and Gordon Cochran, Myra Coe, Larry Cook, Robin and Tim Cook, Penny Drucker, Dianne and Victor Elliott, Patty Foti, Bill Harmon, Robert Henicksman, Helen Jones, Debbie and Ed Lane, Kay and Swede Larsson, Jack McFarlane, Pat and Sue McGrain, Jeff and Tara McRitchie, Donna and Ron Miller, Robby Miller, Barbara and Ed Nunes, Barbara and David Ownbey, Ron Rau, Dean Six, Cecil and Sharyn Taylor, Lynn Thompson, Don Tinney, Richard Varuska, William Walker, Deen Warren, Kent Washburn, Juanita Williams, Jevena Word, Stephanie Word, Tricia Word, Leegh and Michael Wyse.

Lee and Susan Allen of Antiques Downtown were gracious enough to send us photos of the few animals we didn't have access to in our area.

Besides the individuals above, who let us photograph their glass, we were also allowed to photograph at the following shows: Southern Oregon Antiques and Collectibles show in Medford, Oregon; All American Glass show sponsored by the Pacific Northwest Fenton Association in Hillsboro, Oregon; and Rain of Glass show also in Hillsboro sponsored by Portland Rain of Glass club, and Kent Washburn's glass show in San Antonio, Texas. We also photographed at the following antique malls: Lafayette Schoolhouse, Lafayette, Oregon; Centralia Square, Centralia, Washington; and Seaside Antique Mall, Seaside, Oregon. Collectors Showcase in Centralia, Washington also let us photograph pieces from their shop.

Frank M. Fenton, of the Fenton Art Glass Company, was of tremendous help in furnishing background on many of their animals. His many stories were terrific additions to our research material. Jon Saffell, now also with Fenton Art Glass Company, supplied information on the moulds he has designed since starting work there in 1994. Jon was also a long-time Fostoria employee and provided us with new material on several of their animals. He also supplied us with a few Fostoria pictures.

Amy Beaudoin, the publicist for Princess House, gave us some much needed information about this company's history and background. With her help we could accurately list the animals they made.

Suburban Photo, in Beaverton, Oregon, continues to provide us great customer service.

Last, our editor, Nancy Schiffer, has been a great help to us. We appreciate all of her assistance in answering whatever questions we had. Most of all though, she is always accessible when we need something.

We are so grateful for all the resources we were provided. The sharing of information made our job easier. We really appreciate all of your help!

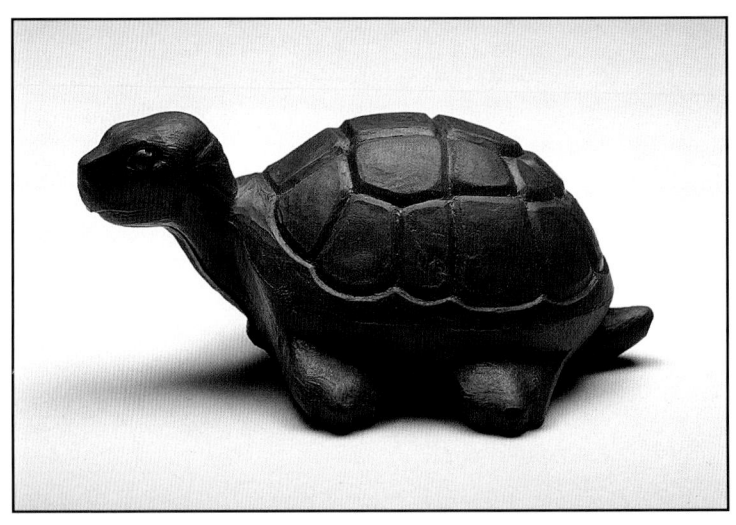

Contents

Preface—5

Introduction—6
What is Included? ... 6
Measurements ... 6
Value Guide .. 6

**American Manufacturers
of Glass Animals & Figurines—7**

Aetna Glass ... 7
Akro Agate ... 7
Aladdin Industries .. 8
Atterbury .. 8
Barth-Art .. 10
Beaumont Glass ... 11
Blenko Glass ... 12
Boyd Crystal Art Glass 14
Bryce, Higbee & Co. 19
Cambridge Glass .. 19
Co-Operative Flint .. 28
Craig's Glass Art Collectibles 30
J.C. Crosetti .. 30
Degenhart Glass .. 31
Dereume Glass .. 32
Duncan & Miller ... 32
Enterprise Manufacturing 37
Federal Glass .. 37
Fenton Art Glass .. 38
Fostoria Glass ... 71
Gibson Glass ... 78
Gillinder Glass ... 78
Guernsey Glass ... 80
K.R. Haley .. 81
A.H. Heisey & Co. .. 83
Hemingray Glass .. 104
Hocking Glass .. 104
Houze Glass .. 105
Hunter Collectible Art Glass 105

Imperial Glass .. 106
Indiana Glass ... 125
Jeannette Glass .. 126
Kanawha Glass ... 127
Kemple Glass ... 129
King Glass ... 130
Libbey Glass .. 130
McKee Glass .. 131
Morgantown Glass Works 133
Mosser Glass ... 134
New Martinsville Glass 138
Northwood .. 144
Paden City ... 144
Pairpoint ... 148
Pilgrim .. 149
Princess House .. 150
Quality Glass ... 152
Rainbow Glass ... 152
L.E. Smith ... 153
Steuben .. 160
Summit Art Glass .. 161
Tiara ... 163
Tiffin ... 164
Viking ... 168
Weishar Enterprises 175
Westmoreland .. 176
Wheaton ... 181
Wilkerson .. 182
L.G. Wright .. 182

Comparison of Similar Moulds—183

Unknowns—185

Collector Organizations—188

Bibliography—189

Index of Animal Shapes—192

Preface

Collecting glass animals and figurines has been a long-time passion of many of our customers. Several of them approached us to do a book on this subject, since there was not a current reference available in this category. This book attempts to address the needs of collectors. We have pictured as many glass animals and figural pieces that we could find.

There is over a century of America's finest glass making displayed in this book. Since this is such an immense topic, we have concentrated only on American glass companies. Some pieces have been made in a multitude of colors, we have pictured a sample of the colors made. When only a few colors were made, we have attempted to give that information. No one book could cover all the glass colors, animals, and figural pieces produced in America over the last century.

We would love to hear about discoveries of animals and figurines not listed here. The book can improve only with continuing input form our readers. If you would like to share your collection with us, we would welcome that gesture. We encourage everyone to give us feedback and, if you have a size that we do not list, let us know.

In striving to get accurate information, we are always looking for old glass catalogs, reprints, and original advertising. If you have any of these you would like to share or sell, we would be very interested in obtaining them.

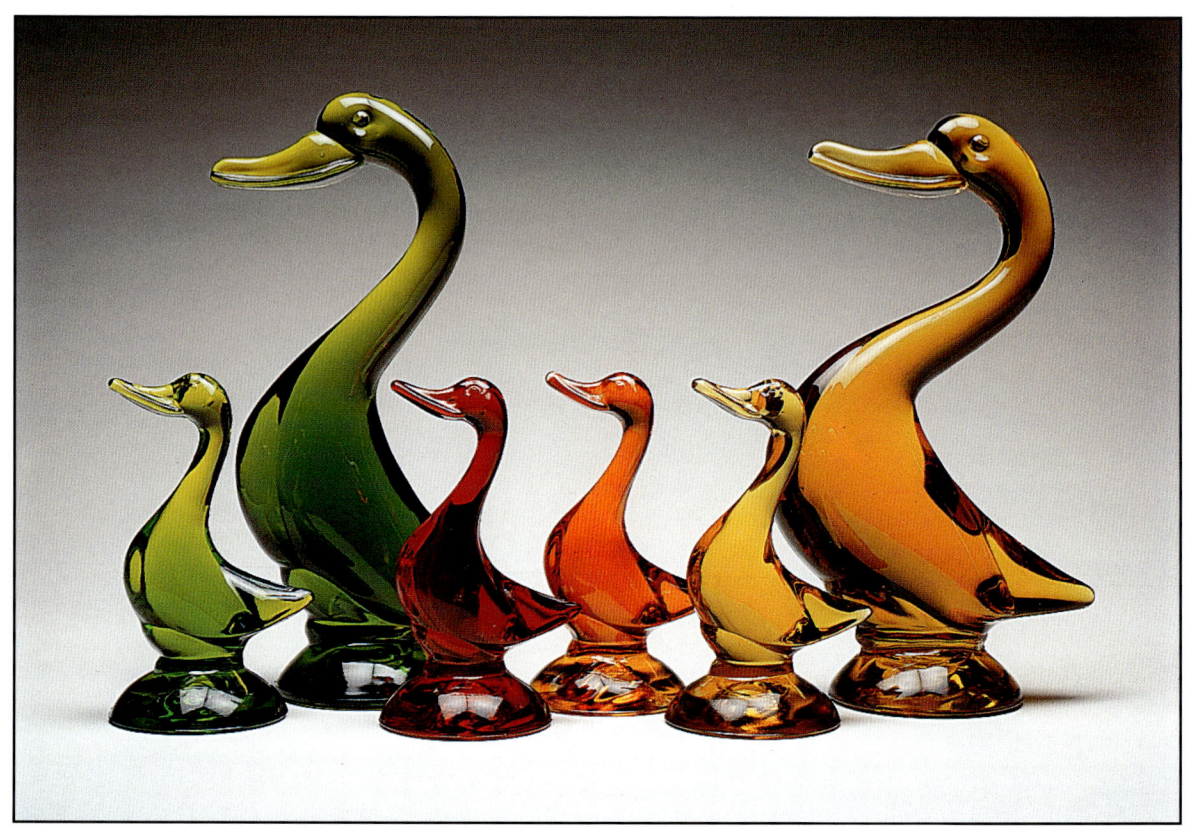

Introduction

What is included?

As we set out to research information about glass animals, it soon became apparent that many other figural pieces of glass needed to be included. What to put in and what to leave out became the question of the day. Full figure glass animals were, of course, the first priority. The other figurines we felt needed to be included are: architectural pieces that are complete in form and ashtrays, bowls, candlesticks, and covered boxes on which the figure is a distinctive part. Bottles and covered dishes that are a complete figure also were included and mugs and pitchers where the handle is an animal. We have also included carts, fictional characters, fruits, powder boxes, seashells, sleighs, and trees.

Measurements

Whenever possible, we include actual measurements. On most pieces, we give the height before the length or width. Width was measured across the diameter. In the case of an owl, it made more sense to measure the way you look at it. Items that hold a liquid also have the ounces capacity listed.

Value Guide

Values are for pieces in **mint condition** only. Items that are scratched, chipped, or cracked will only bring a small portion of the given amount. Pieces that have been repaired should reflect a below-normal value, depending on their appearance. Glass animals that were originally fire-polished normally cannot be repaired to satisfactory condition, depending on the amount of damage.

There are, of course, regional price differences across America. More collectors in one area may be looking for a specific glass animal causing the supply to be depleted. In another area, there may be many of the same glass animals available for sale.

Values were derived from many sources, including dealers actual sales and prices collectors have paid, found on pieces at shows, and reported in national publications. We have consulted with collectors and dealers alike to try to obtain a true reflection of the market.

Where we used the term "no established value" we refer to items that, to the best of our knowledge, have never been sold on the secondary market.

This book is intended only to be a guide when determining what an item is worth. The collector will ultimately decide what to pay for a specific item.

Neither the author or publishers assume any responsibility for any transactions that may occur because of this book.

American Manufacturers of Glass Animals & Figurines

Aetna Glass & Manufacturing Company 1880-1889

Aetna Glass & Manufacturing Company was located in Bellaire, Ohio. This short-lived company operated from 1880 to 1889. The founding president was RT Devries of the Baltimore Ohio Railroad. Manager Henry Leasure was formerly with Central Glass. The company primarily produced pattern glass tableware and stemware. In their last few years, they were also making lantern globes and light bulbs.

The Jumbo covered figural fruit bowl had its design based on the famous Jumbo elephant from the P.T. Barnum Circus. An advertisement in the 1884 *Crockery and Glass Journal* listed it as a perfect imitation of Barnum's elephant. Since the glass elephant was made from only 1883 to 1884, it is assumed there were probably production problems with such a large piece of glass. The elephant weighed just over seven pounds, so presumably cracks and/or breakage developed during the annealing process. With high losses during manufacturing, this is probably why there was a short production time. The large size and the weight of the cover would also explain why that most of the pieces that have survived have some damage to them. For the scarcity of the item, one might be able to live with some chips around the edge where the cover and bottom go together.

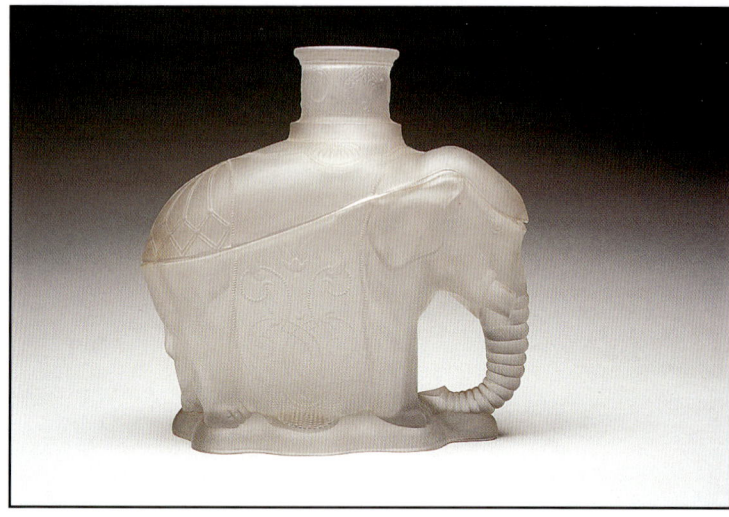

Jumbo, Crystal Satin, 10.3" tall 10" long, Circa 1883-1884, **$450.00**

Akro Agate 1911-1951

Horace Hill, formerly of Navarre Marbles, joined forces with George Rankin and Gilbert March to found Akro Agate in 1911. Originally located in Akron, Ohio, the company was moved in 1914 to Clarksburg, West Virginia, because of a cheaper source of natural gas there.

The company was primarily known as a producer of marbles, and later of children's dishes. They made a distinctive Colonial Lady powder box that is included here. It was made primarily for the J.J. Newberry and Woolworth's stores.

When cheap plastic and metal toy dishes were imported to the United States in the late 1940s, Akro was unable to compete with them and their children's glass dishes line ceased in 1949. Remaining inventory was sold until 1951 when a final closeout auction was held, and the history of Akro Agate came to a close.

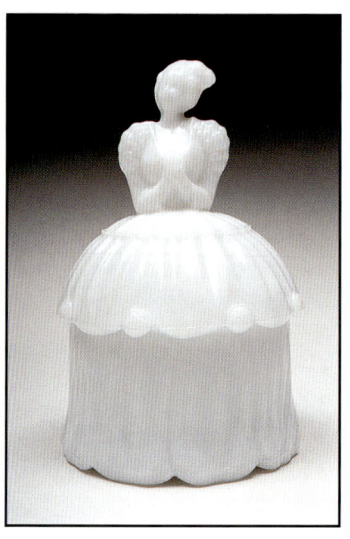

Colonial Lady - puff box #647, Milk Glass, 6.25" tall 4" wide, Circa 1939-1942, **$85.00**

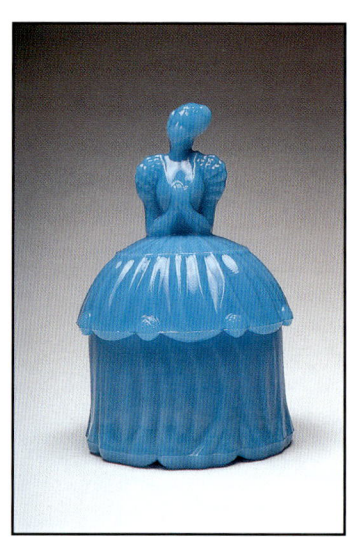

Colonial Lady - puff box #647, Blue Milk Glass, 6.25" tall 4" wide, Circa 1940-1942, **$125.00**

Aladdin Industries Inc. 1907-Present

Aladdin Industries Inc., first known as Aladdin Mantle Company, was located at Alexandria, Indiana.

While on a sales trip for the Iowa Soap Company, in 1905, salesman Victor Johnson ran across a kerosene lamp with a special German mantle burner and was fascinated by the bright light it produced. In 1907 he quit selling soap and formed his own company to sell these burners. A year later he set about improving the burners and making them in the United States. This was the beginning of Aladdin Industries Inc. It remains in business today, still making kerosene lamps.

While the company concentrated on kerosene lamps, and later electric lamps, they did make some giftware that was based on the Lalique style of glass figurines. Some of the figurines were made as a lamp part and were also available as part of the giftware line.

Introduced in the mid-1930s, the lady figurines were designed in the Art Deco style. Their designer, Eugene Schwarz, traveled to Paris in 1925 to view the International Exposition of Art Moderne, where the streamlined style gained popularity. French artist Rene Lalique had a large display there of heavily sculptured glass pieces. Many designers set about copying his style. Schwarz came back with ideas to create some unique lamps. Production of the figurines continued until the 1940s.

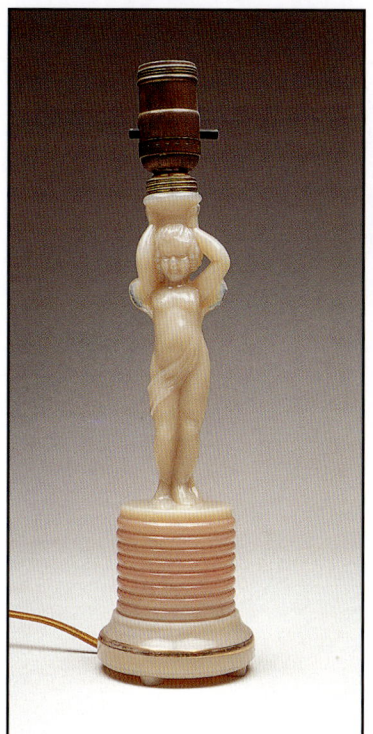

G24 Cherub - boudoir electric lamp, Alacite, 10" tall 3.25" wide, Circa 1939, marked on base "Aladdin", **$225.00**

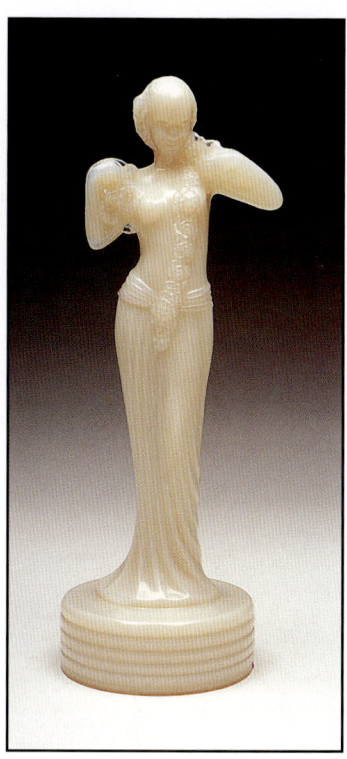

G16 Lady - figure, Alacite, 9.5" tall 3.5" wide, Circa 1939, **$550.00**
Not pictured - G16 Lady figure, other transparent colors, Circa 1939, $950.00
Not pictured - G16 Lady figural boudoir electric lamp (has a hole in the base behind the figure to accommodate the metal shaft for the electric lamp shaft), Alacite, Circa 1939, $250.00

Atterbury 1859-1903

The Atterbury Glass Company, located in Pittsburgh, Pennsylvania, was established in 1859. From the beginning, Atterbury was a huge producer of milk glass. They were known primarily for covered animals, but they also produced numerous novelty items, lamps, bottles, and jars.

The covered animals from Atterbury are highly detailed and sought-after by collectors today. They are an immense group, so we have included only the ones that are full figures. Covered animals could fill a book by themselves.

From 1893 until 1903, Atterbury produced only tableware. When the Atterbury brothers retired in 1903, the factory was closed and the assets were sold.

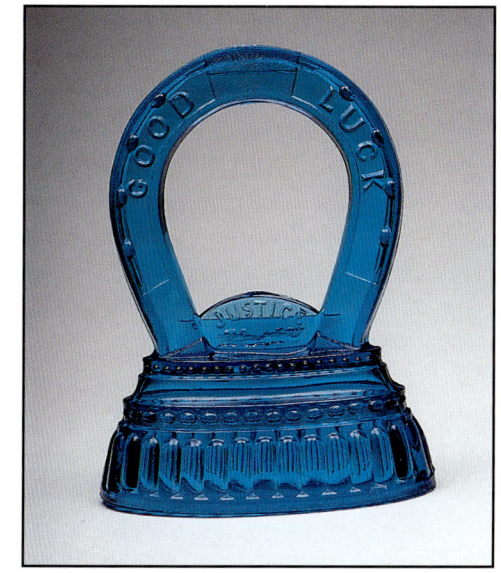

Horseshoe - frame, Dark Blue, 7" tall 4.5" wide. The words "Good Luck" are embossed on top of this horse shoe shaped piece. Note that "Justice for all" is also embossed on a tab that protrudes up from the center of the base between the sides of horse shoe. This scarce piece of glass has wonderful mould detail work, Circa 1881, **$125.00**

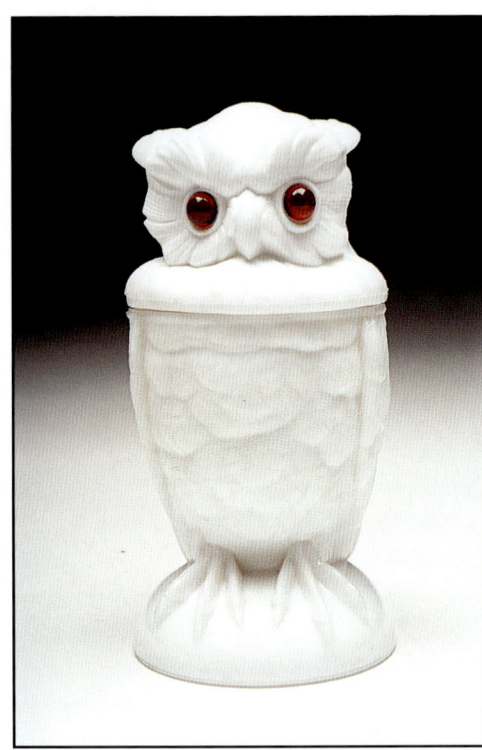

Detail of inside of owl showing the notches that served to hold the head in it's proper place.

Owl, Milk Glass with red glass eyes, 7" tall 3.5" wide, Circa 1870s-1890s, **$175.00**

Barth-Art Glass Company 1943-1952

Harry Barth was the general manager at New Martinsville Glass Company in the 1930s. He resigned in the early 1940s to form his own company, Barth-Art Glass Company, to design moulds. The moulds were sent to Indiana, Paden City, or Viking glass companies to have the glass made. Their glass items were then sent back to Barth-Art for the finishing work of grinding and fire polishing. The glass was sold under the Barth-Art Glass name. Some of the moulds were developed for and sold exclusively to Viking.

The company and its moulds were sold to Viking in 1952.

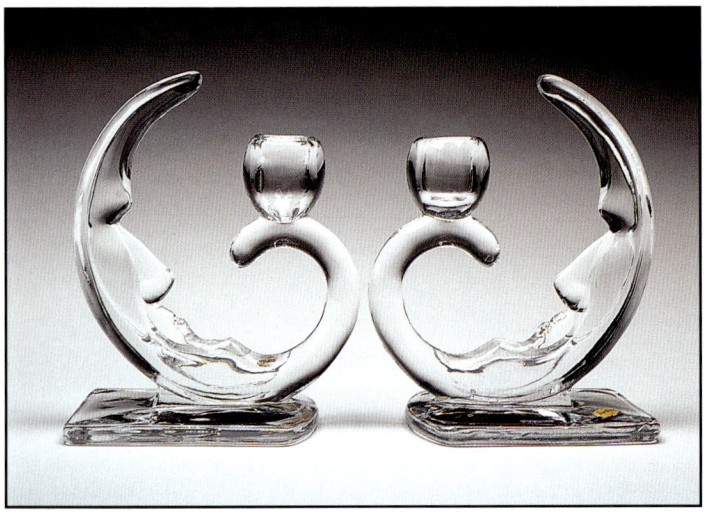

Man in the Moon - candlestick, Crystal, 6.5" tall, Circa 1940s, **$295.00** pair

Detail of label on Man in the Moon candlestick.

Beaumont Glass 11

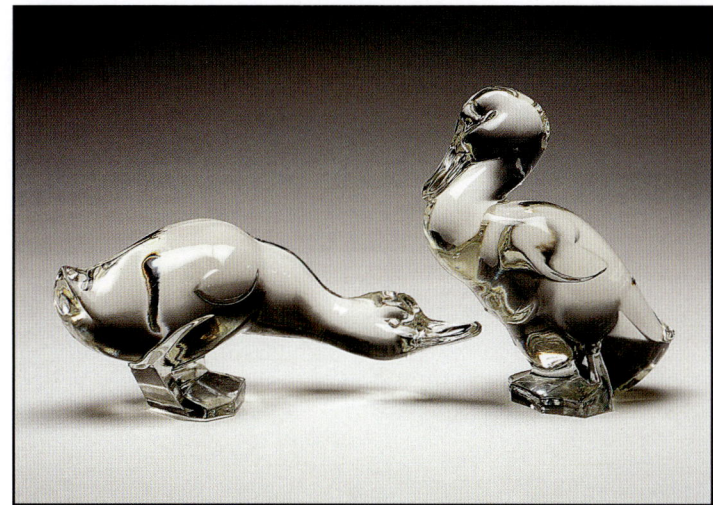

Left: Duck - crouching, Cystal, 2.75" tall 5.75" long, Circa 1940s, **$60.00**
Right: Duck - standing, Cystal, 4.4" tall 3.75" long, Circa 1940s, **$60.00**

Beaumont Glass Company 1916-1991

The Beaumont Glass Company was founded in Morgantown, West Virginia, in 1916. They specialized in making glass stationary items, such as inkwells, pin trays, stamp containers, and glue containers. The glass was made for stationary companies to sell under their own labels. Beaumont also made lighting fixtures and did private mould work.

During the 1930s they developed a gift line and marketed pieces under their own name. This was short-lived and the company returned to contract work.

In 1980s, they made their second try into the giftware field. Beautifully colored cased vases and blown stemware became the focal point of their new line. These items were produced continuously until Beaumont closed in 1991.

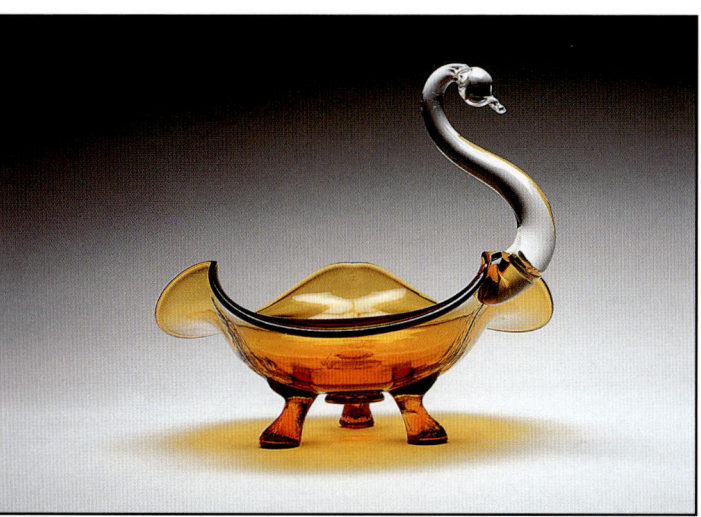

Swan, Amber, 6.5" tall 7.5" long, Circa 1930s. Note, that this is an unusual piece with having the three short feet, **$60.00**

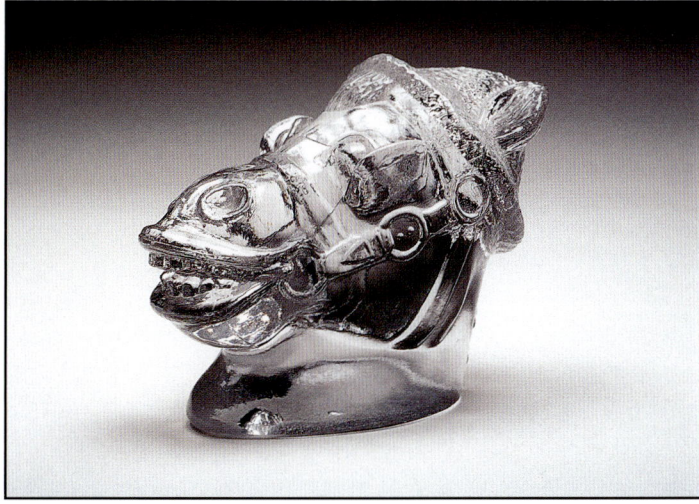

Horse head with hat, Crystal, 3.75" tall, 4.5" long, **$125.00**

Blenko Glass Company 1921-Present

In 1893 William J. Blenko arrived in America from England and started his first glass factory. At age sixty-seven, he relocated to Milton, West Virginia, and established his fourth glass company. His son, William Henry Blenko, joined him two years later, in 1923. A third generation family member, William Henry Jr., joined the company in 1946, and a fourth generation member, Richard Blenko, joined his father in 1976.

Blenko Glass Company has always concentrated on making unique, hand blown glass. For Ronald Reagan's inaugural victory dinner in 1982, Blenko made sixty table settings. Blenko also made the awards for the American Country Music program winners in 1983.

With the fourth generation firmly planted in the company's activities, Blenko's survival seems assured into the future. A Blenko Glass Museum opened in Seattle, Washington, in 2001 that is bound to inspire new collectors of this glass.

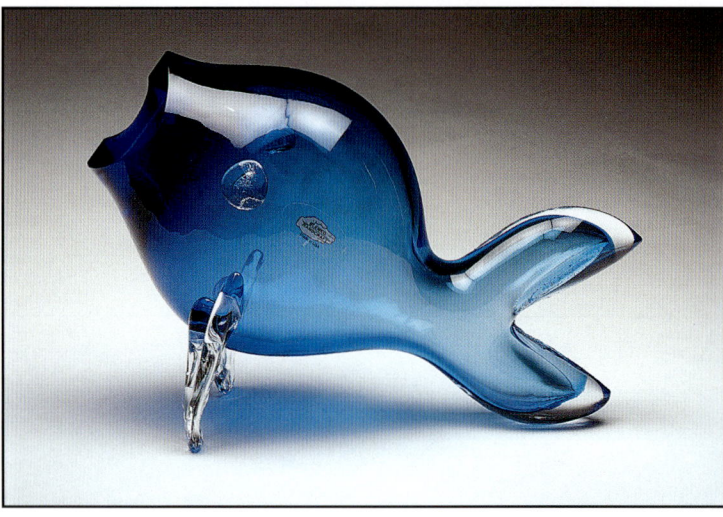

Fish #5433, Azure Blue, 8" tall, 12.75" long Circa 1954-2002, **$75.00**

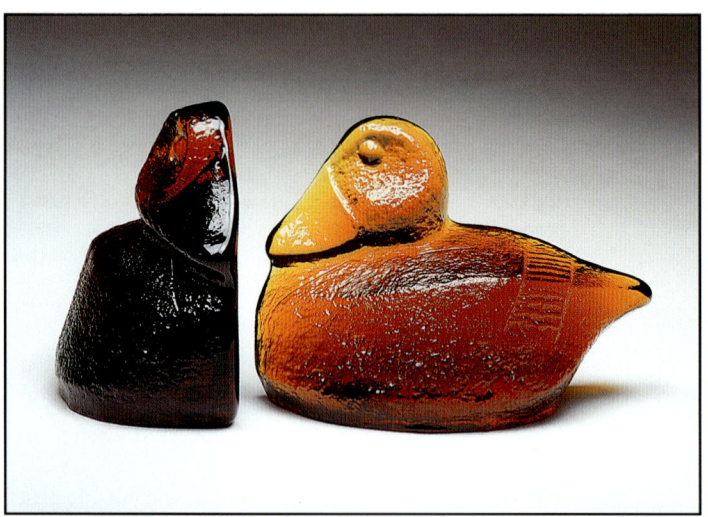

Duck - bookends #2108, Topaz, 4.75" tall, 6.75" long, Circa 1980-2002, **$30.00** Pair

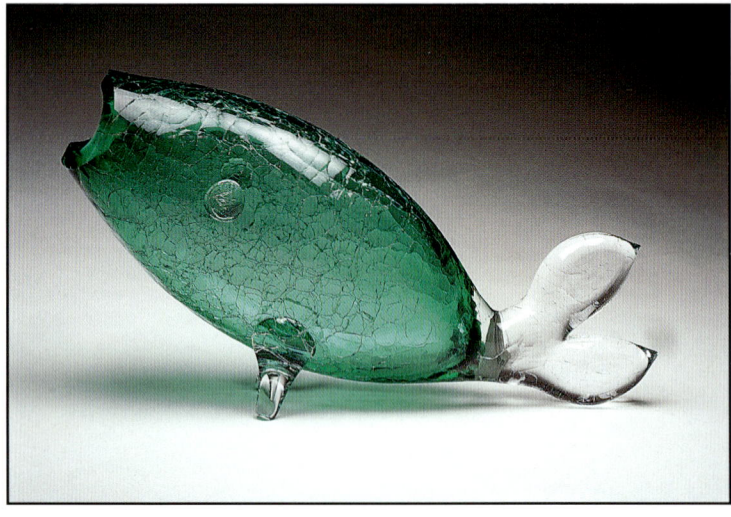

Fish #971M, Sea Foam Green, 8.4" tall, 16.5" long, Circa 1950-2002, **$85.00**

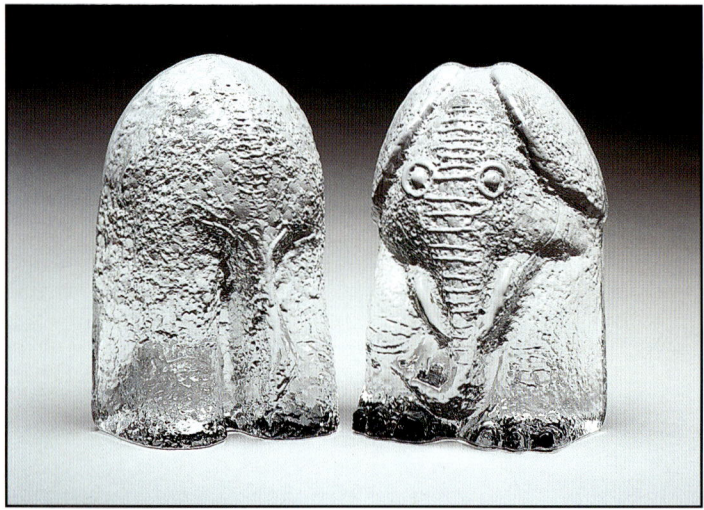

Elephant - bookends #9513, Crystal, 5.75" tall, 4" wide, Circa 1995-2002, **$30.00** Pair

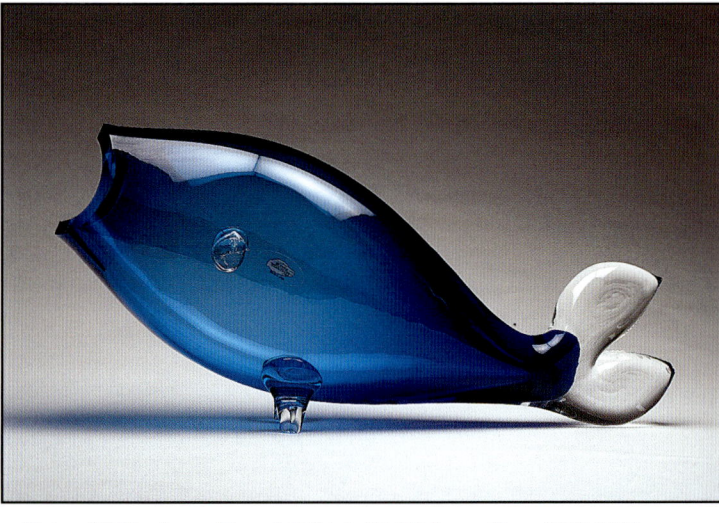

Fish - #971L, Azure Blue, 9.25" tall, 20.25" long, Circa 1950-2002, **$95.00**

Blenko Glass 13

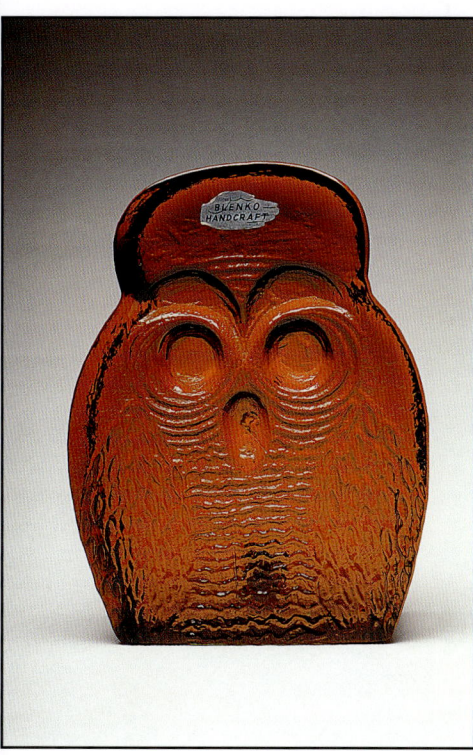

Owl - bookend #6813, Amber, 7" tall, 7" wide, Circa 1968-1971, **$35.00** each

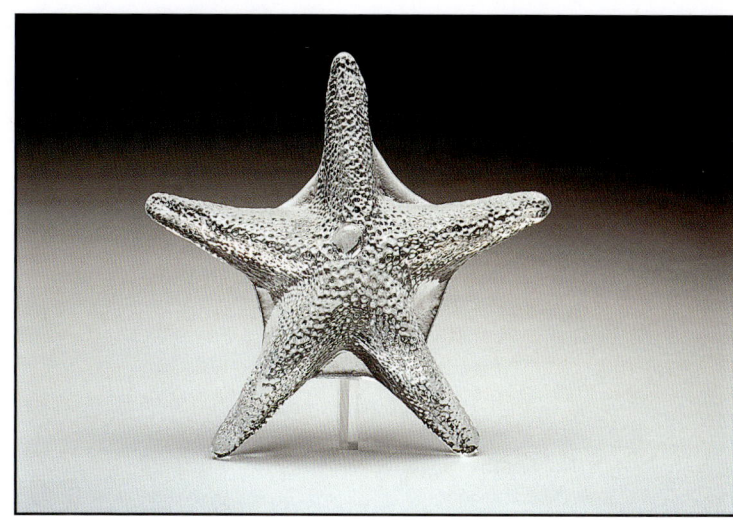

Starfish #941, Crystal, 2.5" tall, 8" wide, Circa 1994-2002, **$16.00**

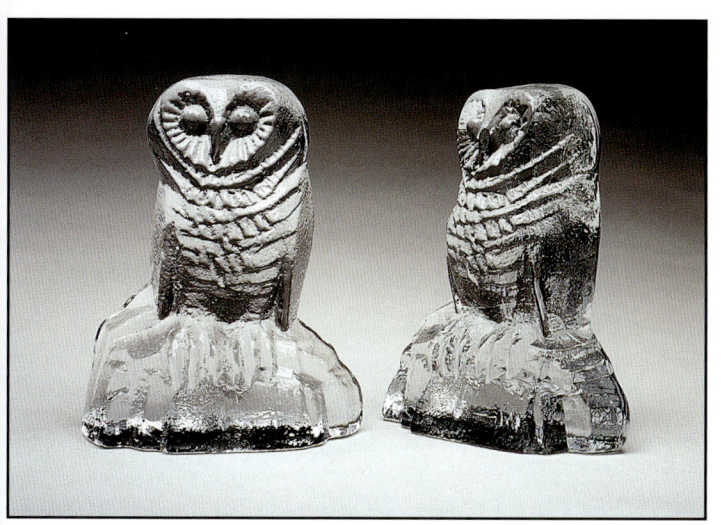

Owl - bookends #2109, Crystal, 6.6" tall, 5.25" wide, Circa 1921-2002, **$30.00** pair

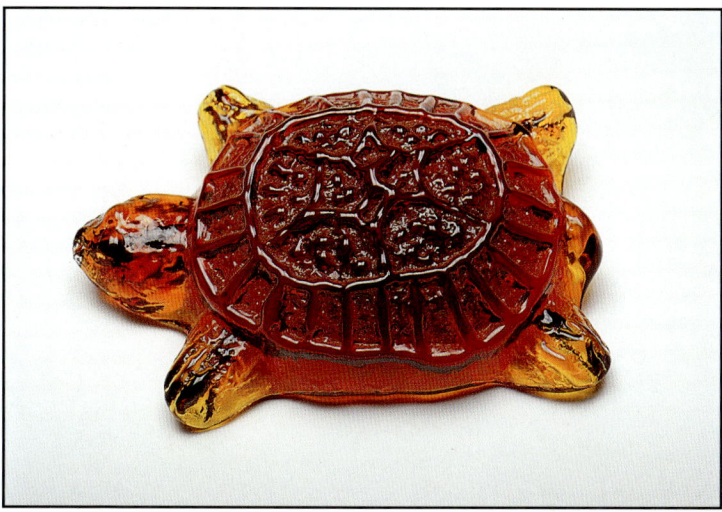

Turtle #2110, Red, 4.75" long 3.5" wide, Circa 1960-1970s, **$25.00**

Sea Shell #944, Crystal, 6.5" tall, 7.25" wide, Circa 1994-2002, **$30.00**

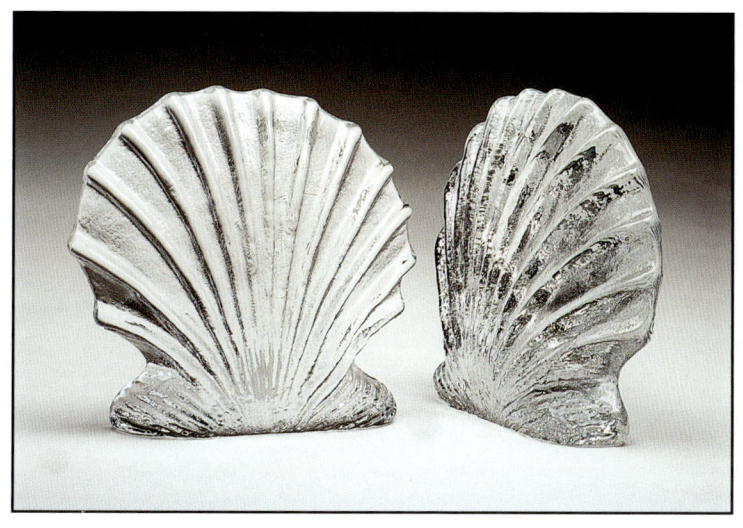

Boyd Crystal Art Glass Company 1978-Present

Mrs. Degenhart (see Degenhart Glass Company) stipulated in her will that employee Bernard C. Boyd was to be offered the first chance to buy the Degenhart glass factory after her death. To help with this new venture in 1978 was Boyd's son, Bernard F. Boyd, his wife, and their son. Six months later the factory was operating again with most of the old Degenhart employees. The Boyd Crystal Art Glass Company produced glass animals from the beginning, and continues today.

All the old Degenhart moulds were remarked with the new Boyd trademark, a B in a diamond, before Boyd made pieces in them. Special new colors are made approximately every six weeks. Only a certain number of moulds are made in each color, to make the pieces true limited editions. Each of the moulds is named for a family member or friend; also, a special name is given to each color.

Today, three generations of Boyd family members are employed at the glass company working in the daily operation and providing tours of their facility. Each month they publish a newsletter for their customers, describing the current colors and moulds that are being used.

The Boyds have left their mark on American glass history by placing their logo on each piece they make. The logo has been altered slightly every five years to help determine the date of the pieces, as follows:

1978-1983 B in a diamond
1983-1988 B in a diamond with a line underneath
1988-1993 B in a diamond with a line above as well as underneath
1993-1998 B in a diamond with a line to the right, above, and underneath
1998-2003 B in a diamond inside a box (made up of the lines for each five year period)

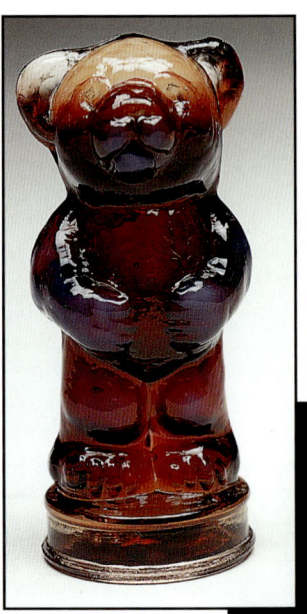

Bear "Andy", Cranberry, 3" tall 1.25" wide, September 2001, **$9.00**

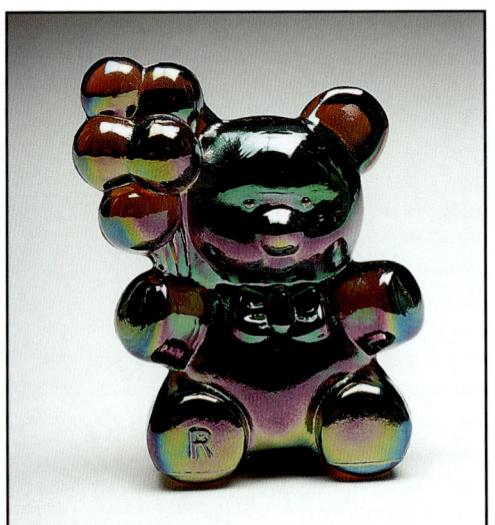

Bear "Patrick", Nutmeg Carnival, 2.1" tall 1.5" wide, January 1999, **$9.00**

Bear "Fuzzy", Sunflower Yellow, 3.1" tall 2.25" wide, January 1988, **$12.00**

Cat "Kitten on a Pillow", 2.85" tall 2" wide.
Top: Candy Swirl, May 1980, **$14.00**
Bottom left: Frosty Blue, February 1979, **$16.00**
Bottom right: Persimmon Slag, April 1980, **$18.00**

Boyd Crystal Art Glass 15

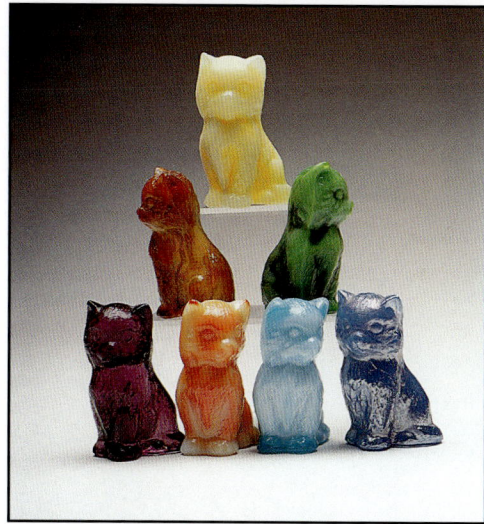

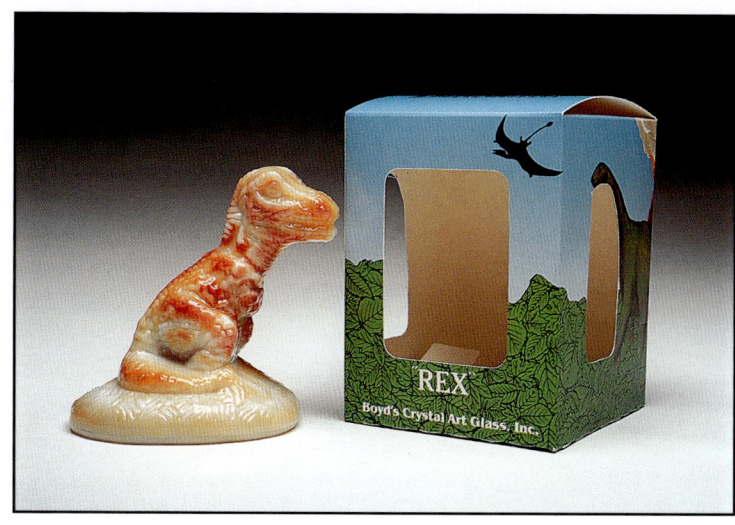

Cat "Miss Cotton", 2.6" tall 1.6" wide, Circa 1982's-current. At the end of 1982, the "Kitten on a Pillow" mould was changed by removing the pillow. The mould was renamed "Miss Cotton" the kitten.
Top: Banana Cream, December 1994, **$12.00**
Center left: Orange Spice, June 1990, **$16.00**
Center right: Nile Green, April 1993, **$14.00**
Bottom left: Plum, October 1988, **$12.00**
Bottom center left: Spring Surprise, May 1997, **$12.00**
Bottom center right: Baby Blue, October 1987, **$14.00**
Bottom right: Mulberry Carnival, November 1998, **$16.00**

Dinosaur "Rex" with original special box, Vanilla Coral, 4.5" tall 3.4" wide, March 1994, **$18.00**

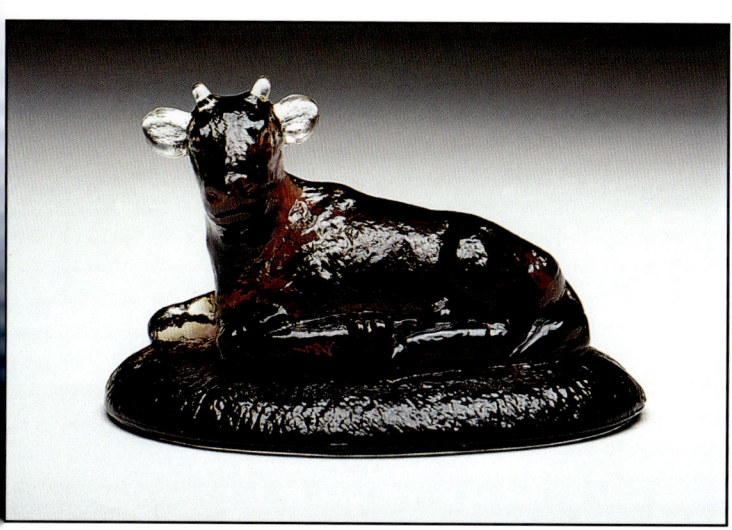

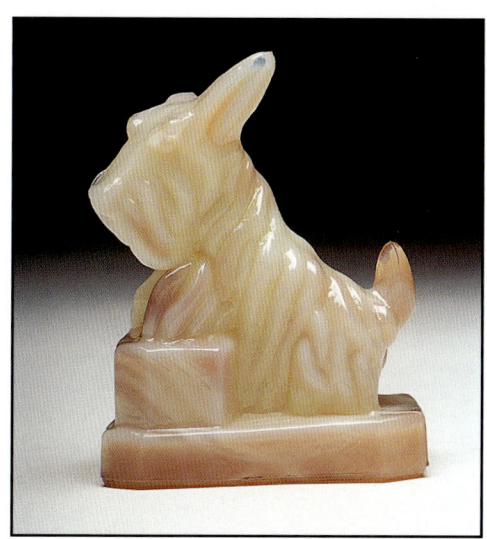

Dog "J.B. Scottie", Ivory Blush, 3.1" tall 2.5" long, June 2001, **$13.00**

Cow "Mabel", Dilemma, 2.5" tall 4" long, July 2001, **$12.00**

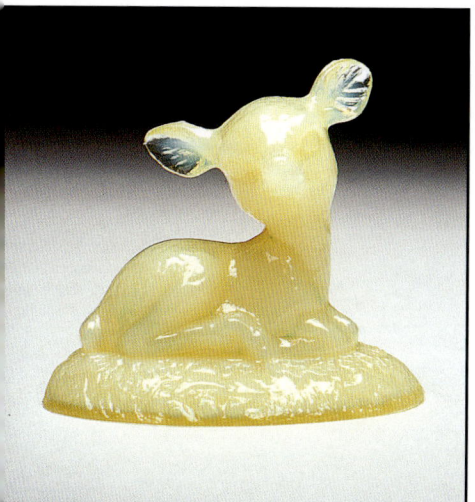

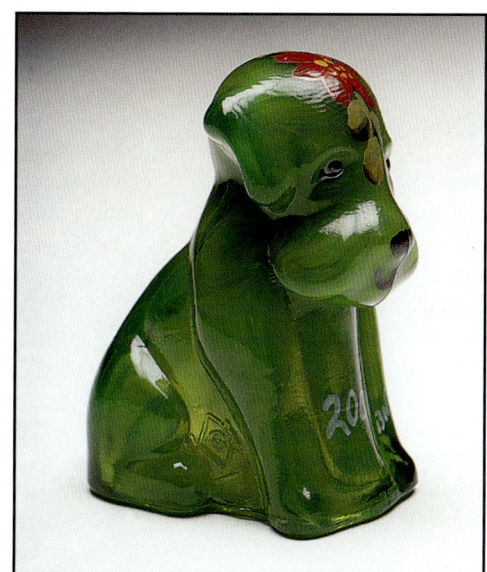

Deer "Bingo", Ivory Blush, 2.5" tall 2.75" long, July 2001, **$9.00**

Dog "Pooche", Green, hand painted, 3" tall 2.5" wide, November 2000, **$18.00**

16 Boyd Crystal Art Glass

Dog "Skippy", Sunburst, 3.25" tall 2.5" long, June 2001, **$9.00**

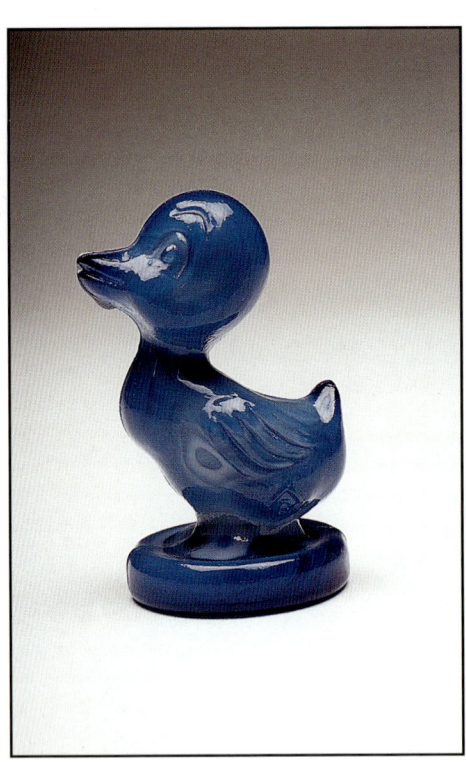

Duck "Debbie", Pocono, 2.75" tall 1.75" long, November 1983, **$12.00**

Eagle "Bernie", Alexandrite, 2.5" tall 1.6" long, July 1993, **$12.00**

Elephant "Zack", 3.5" tall 4.5" long.
Top Left: Alice Blue, hollow base, April 1983, **$16.00**
Top Right: Olde Ivory Surprise, solid base, May 1981, **$14.00**
Bottom Left: Kumquat, hollow base, November 1986, **$24.00**
Bottom Center: Alexandrite Carnival, hollow base, September 1993, **$18.00**
Bottom Right: Furr Green, solid base, August 1981, **$16.00**

Fox "Sly", Purple Fizz, 3" tall 2.5" long, January 2001, **$9.00**

Frog "Jeremy", Jade, 1.25" tall 2.25" long, November 2000, **$8.00**

Boyd Crystal Art Glass

Gorilla "Sonny", Bernard Boyd Black, 2.5" tall 1.6" wide, November 1995, **$9.00**

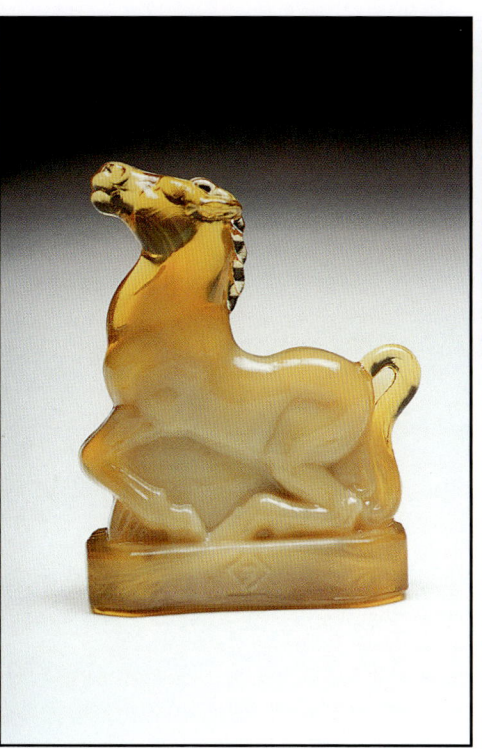

Horse "Little Joe", Autumn Beige, 2" tall 1.6" long, September 1988, **$8.50**

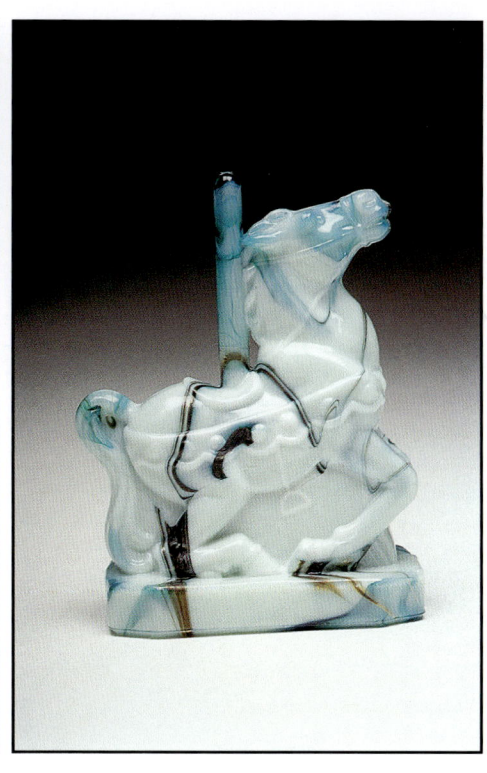

Horse-Carousel "Taffy", Aruba Slag, 4.25" tall 3.25" long, July 2000, **$10.00s**

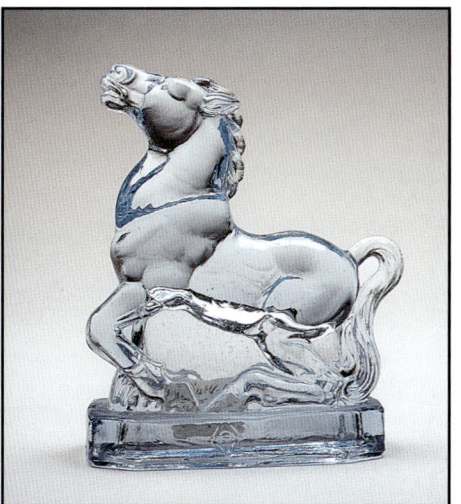

Horse "Joey", Willow Blue, 3.8" tall 3.25" long, July 1980, **$15.00**

Mouse "Willie", Peach, 2" tall 1.6" wide, November 1991, **$8.00**

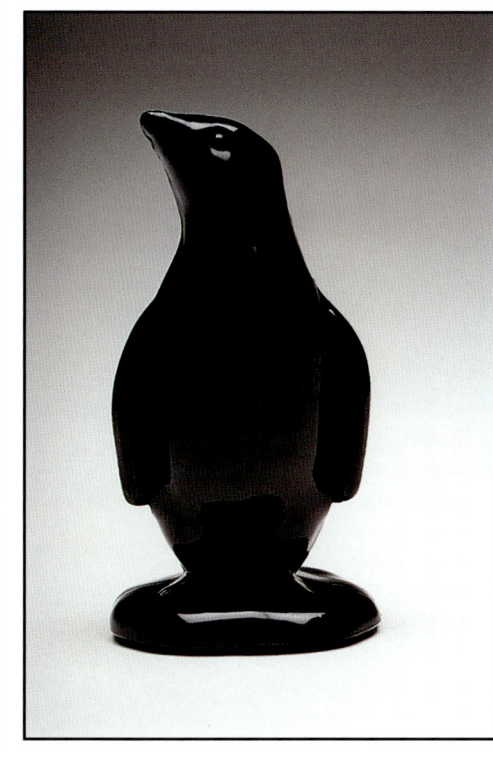

Penguin "Artie", Classic Black, 2.9" tall 1.5" wide, November 1991, **$9.00**

18 Boyd Crystal Art Glass

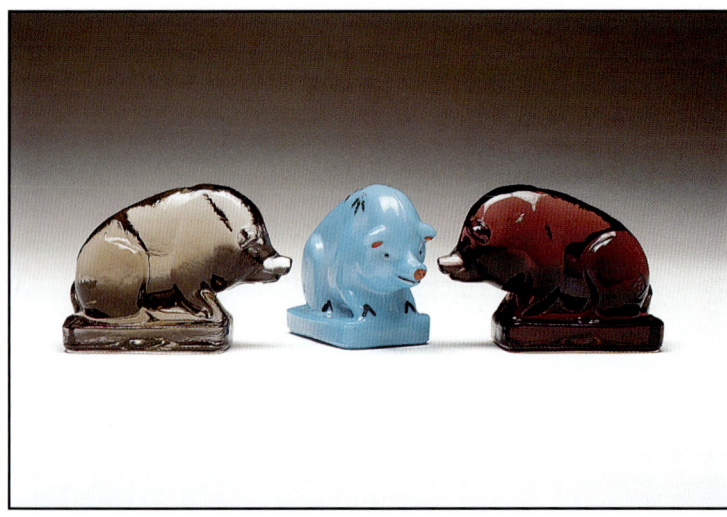

Pig "Suee", 2.1" tall 3" long.
Left: Rosewood, Circa May 1988, **$10.00**
Center: Capri Blue, hand painted, June 1996, **$18.00**
Right: Plum, October 1988, **$12.00**

Tiger "Tommy", 1.5" tall 2.5" long, April 1995.
Top: Milk Glass hand painted, **$18.00**
Bottom left: Banana Cream Carnival, January 1995, **$9.00**
Bottom right: Spring Surprise, May 1997, **$9.00**

Rabbit "Brian Bunny", Purple Valor, 2.1" tall 1.5" long, November 2001, **$8.00**

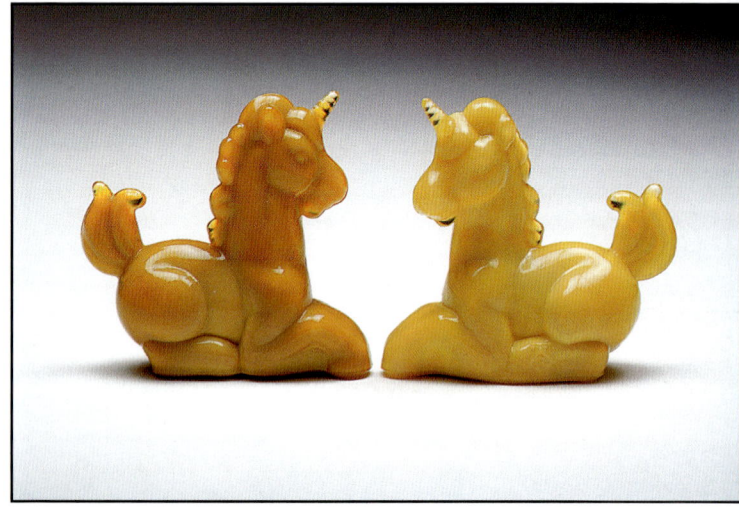

Unicorn "Little Luck", 2.1" tall 2.25" long.
Left: Carmel, August 1985, **$10.00**
Right: Custard, May 1986, **$10.00**

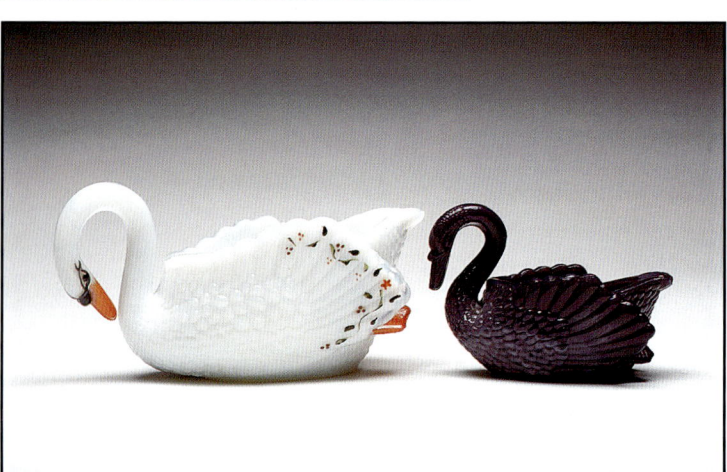

Left: Swan, Milk White hand painted, 2.75" tall 5.25" long, October 1985, **$24.00**
Right: Swan, Heliotrope, 2.5" tall 3.75" long, June 1986, **$18.00**

Bryce, Higbee & Company 1879-1906 and J. B. Higbee 1907-1919

The father and son team of John and Charles Bryce established their own glass factory in 1879, with John Higbee and Joseph Doyle. Each had brought previous glass-making experience from other companies. The company primarily produced pressed tableware. By 1880, they had enough lines developed to be able to display their glass at the Pittsburgh Glass Show.

With the death of John Bryce in 1888, and the forced resignation of Charles in 1904 due to improper handling of company property, control went to John Higbee. Two years later, Higbee died and the factory was closed.

In 1907, Ollie Higbee, the son of John, bought the assets of the company and started a new company, J.B. Higbee, in Bridgeville, Pennsylvania. This company was successful and continued to produce tableware. Upon Ollie's death in 1919, the company was sold to The General Electric Company. Light bulbs and light fixtures are still being made there today.

A unique set of children's dishes, called the menagerie, was made in 1885, consisting of a bear covered sugar, owl creamer, fish spooner, and turtle covered butter. The pieces were made in Amber, Blue, and Crystal. These are all exceedingly hard to find today; we were able to find only the bear to photograph.

Bear, childs covered sugar jar, Crystal, 4.5" tall 2.25" wide, Circa 1885, **$295.00**
Not pictured: Owl creamer, 3.25" tall 2" wide
Fish spooner, 3.25" tall 1.75" wide
Turtle covered butter, 2.25" tall 1.75" long

Cambridge Glass Company 1901-1958

Looking for a way to generate employment for its citizens in 1901, a group of investors from Cambridge, Ohio, filed to build a glass factory there. This same group also owned National Glass, located in Pennsylvania. Arthur Bennett, was selected to be the president. When the investors ran into trouble with National Glass in 1907, dragging Cambridge Glass with it towards bankruptcy, Bennett himself stepped in to help. He purchased the Cambridge company and provided the much needed financing.

Cambridge Glass prospered under his leadership and developed a terrific reputation for the quality of its glass and colors. Tableware and stems were the mainstay of the company, but giftware and novelty items were also produced. The 1930s were strong sales years for Cambridge.

Looking to retire in 1939, Bennett sold the company to his son-in-law and the 1940s saw continued good sales. By the early 1950s, with heavy reliance on their etched tableware, Cambridge was starting to struggle against imports. The factory closed for a short time in 1954, but then reopened. The desired sales didn't return, and the factory was closed for good in 1958.

Imperial Glass Company bought the assets of the Cambridge Company, including many of their moulds.

Bird #1, Crystal, 1.25" tall, 3" long, mid 1930s-1950s, **$25.00**

20 Cambridge Glass

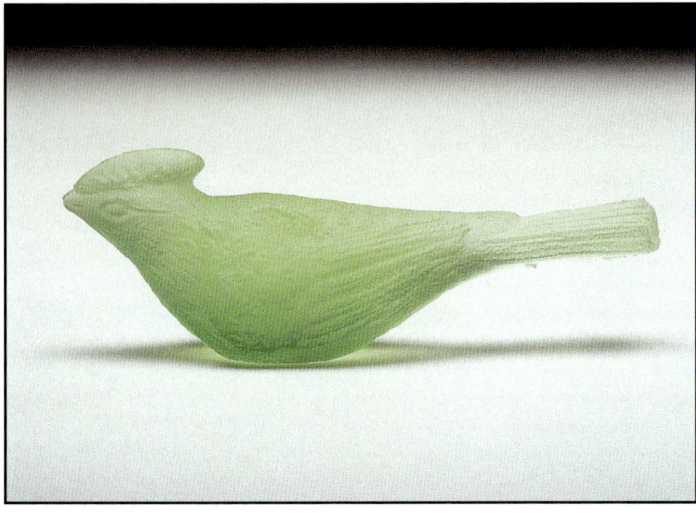

Bird #2, Green Stain, 1" tall, 3.25" long, mid 1930s-1950s, **$35.00**

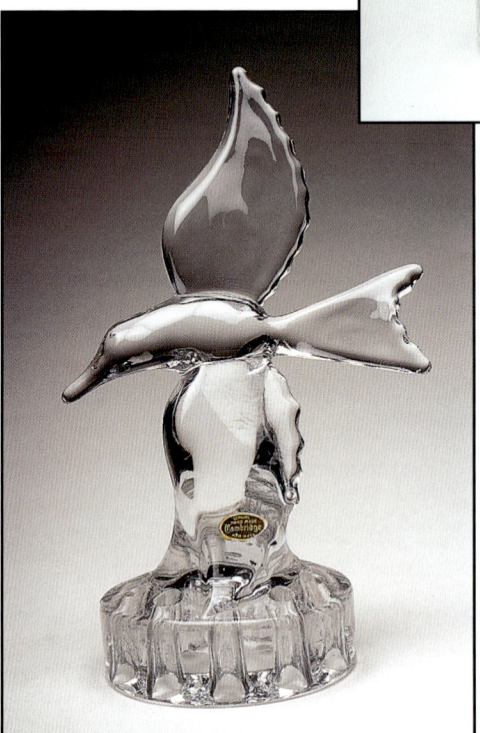

Bird - Heron flower frog #1111 also made later as #119, Crystal, 12" tall 7" wide, Circa 1930s-1940s, **$125.00**

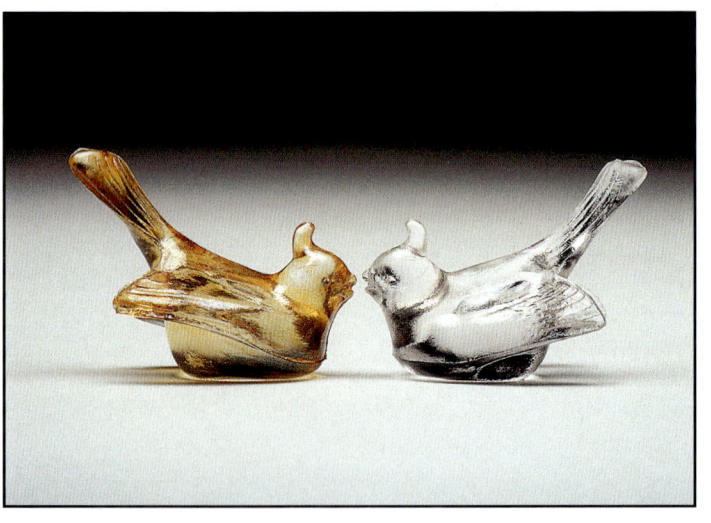

Bird #3, 1.5" tall, 3" long
Left: Amber, **$45.00**
Right: Crystal **$30.00**

Bird - Seagull flower frog #1138, Crystal, 10" tall 4.5" wide, Circa 1930s-1940s, **$78.00**

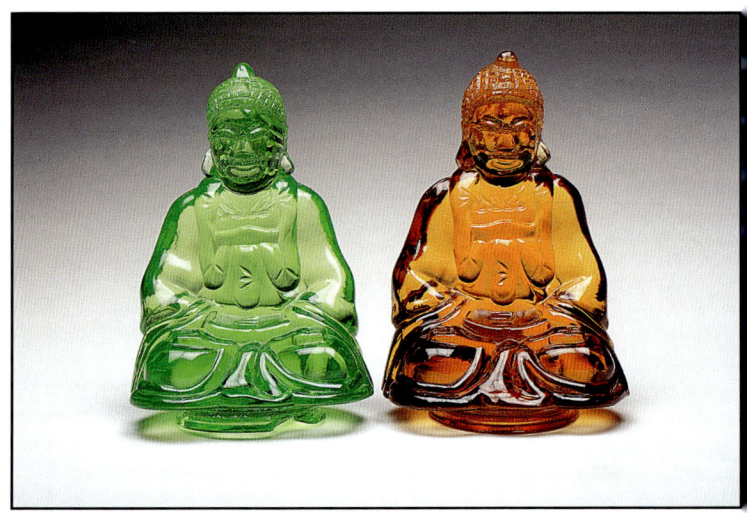

Bird - Blue Jay #1636 (has peg bottom to fit into candle cup), Crystal, 4.25" tall 4.5" long, Circa 1930s-1940s, **$95.00**
Also found as a one piece flower frog, $125.00.

Buddha #521, 6" tall 6" wide, Circa 1930s.
Left: Light Green, **$450.00**
Right: Amber, **$400.00**

Cambridge Glass 21

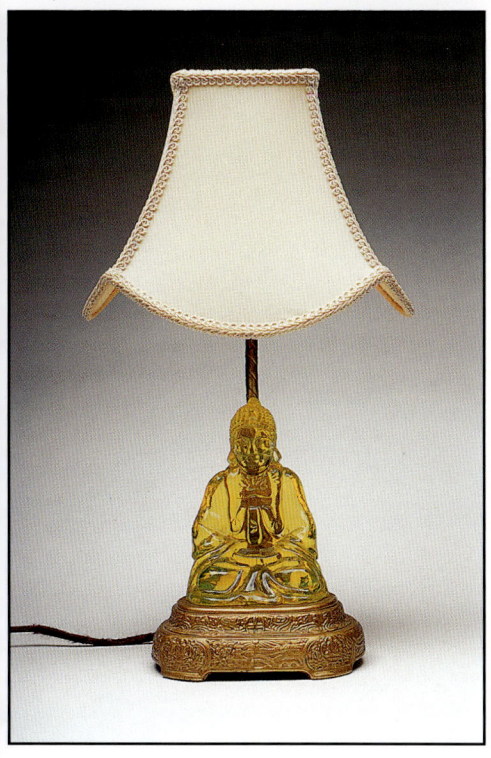

Buddha #521 with metal lighting parts to convert it into electric lamp, Topaz, 7" tall 6" wide, Circa mid 1920s, **$575.00**

Bridge Dog #1371, Tahoe Blue, 1.75" tall 1.75" long, Circa 1930s-1940s, **$40.00**

Butterfly #1, Crystal Satin, 2.25" wide, 1.6" long, mid 1930s-1950s, **$45.00**

Bridge Dog #1371, Tahoe Blue. Side view showing how he was designed to hold a short pencil in his mouth.

Butterfly #3, 3.25" wide, 2.25" long, mid 1930s-1950s
Top: Crystal, **$35.00**
Bottom: Crystal Satin, **$35.00**

Dog "Scottie" bookend #1288, Crystal, 6.5" tall, 5" long, 1920s-1950s, **$150.00** each

22 Cambridge Glass

Dolphin - candlestick #110, 9.5" tall 5.25" wide, Circa 1925-1930.
Left: Amber, **$195.00** pair
Center: Green Satin with gold trim, **$295.00** pair
Right: Pink, **$250.00** pair

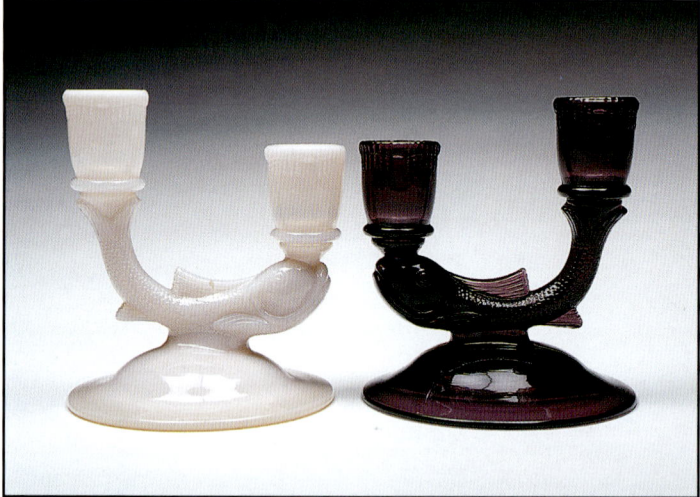

Dolphin - duo candlestick, 5" tall 4.5" wide, Circa 1930s.
Left: Crown Tuscan, **$195.00** pair
Right: Amethyst, **$295.00** pair

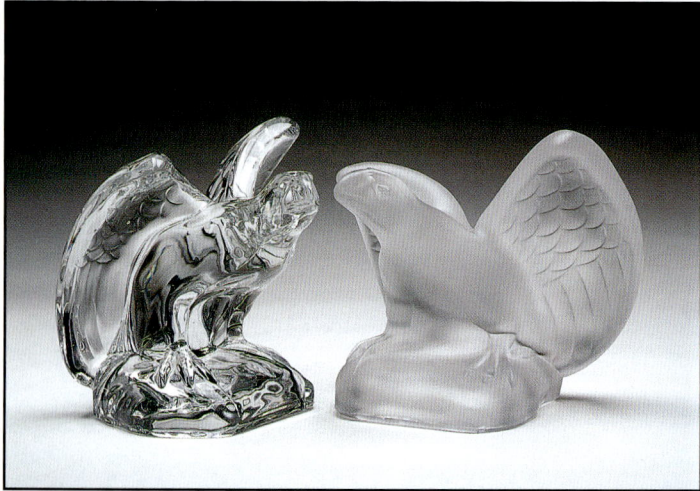

Eagle - bookend #1119, 6" tall 6" wide, Circa 1930s-1940s.
Left: Crystal, **$98.00** each
Right: Crystal Satin, **$85.00** each

Eagle - bookend lamp, Crystal, 6" tall, 6" wide (over all height is 18"), 1930s-1940s, **$195.00** each

Bashful Charlotte - flower frog #1115, Crystal, 11.5" tall 4" wide, Circa 1930s, **$200.00**

Left to right: Draped Lady - flower frogs, Circa 1930s.
1. Draped Lady - flower frog #518, Moonlight Blue, 8.75" tall 4" wide, **$400.00**
2. Draped Lady - flower frog #513, Amber, 13" tall 5" wide, **$300.00**
3. Draped Lady - flower frog #518, Gold Krystol, 8.75" tall 4" wide, **$400.00**
4. Draped Lady - flower frog #513, Crystal, 12.75" tall 5" wide, **$425.00**
5. Draped Lady - flower frog #518, Dianthus Pink, 8.75" tall 4" wide, **$350.00**

Cambridge Glass 23

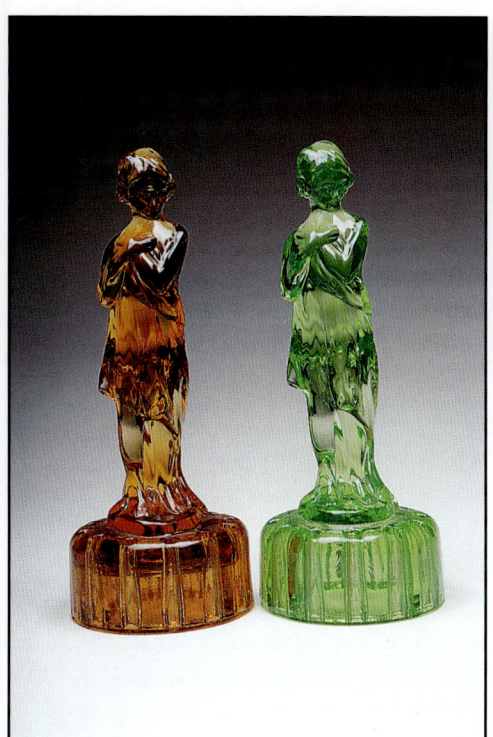

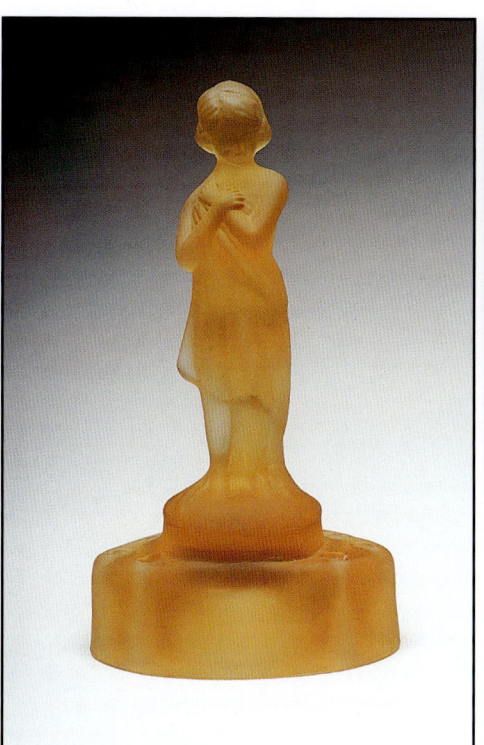

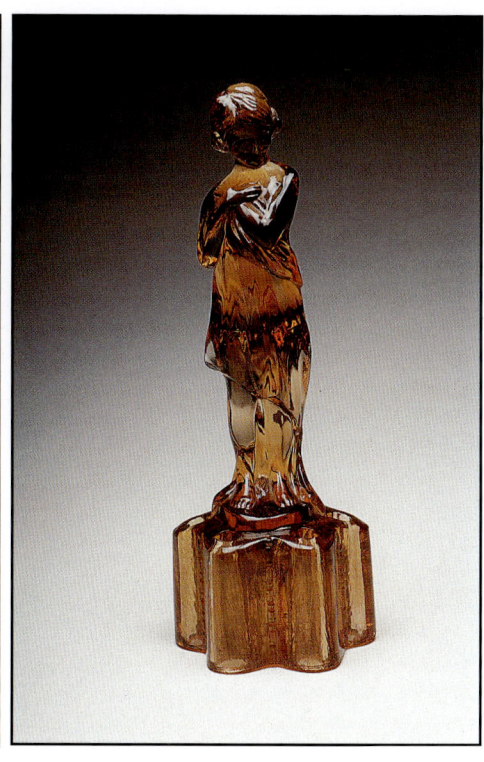

Draped Lady - flower frog #518, 8.75" tall 4" wide, Circa 1930s.
Left: Amber, **$275.00**
Right: Light Emerald Green, **$350.00**

Draped Lady - flower frog with oval base #849, Amber Satin, 8.75" tall 4.75" wide, **$275.00**

Draped Lady - flower frog #513, Amber, 13" tall 5" wide, Circa 1930s, **$300.00**

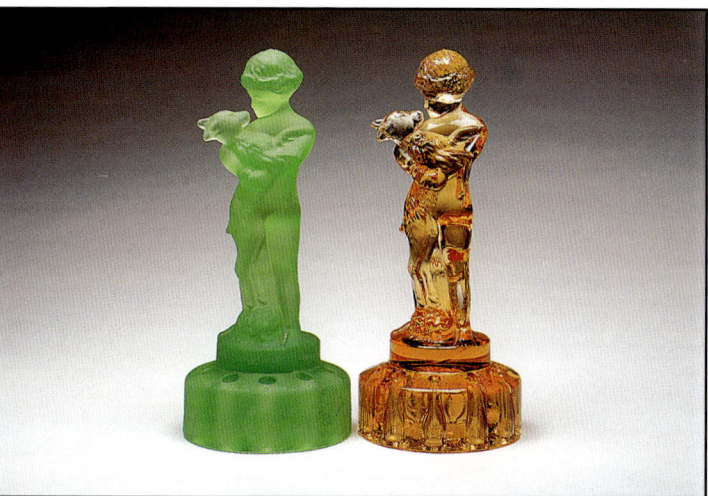

Two Kids - flower frog #509, 9.25" tall 4" wide.
Left: Green Satin, **$495.00**
Right: Amber, **$350.00**

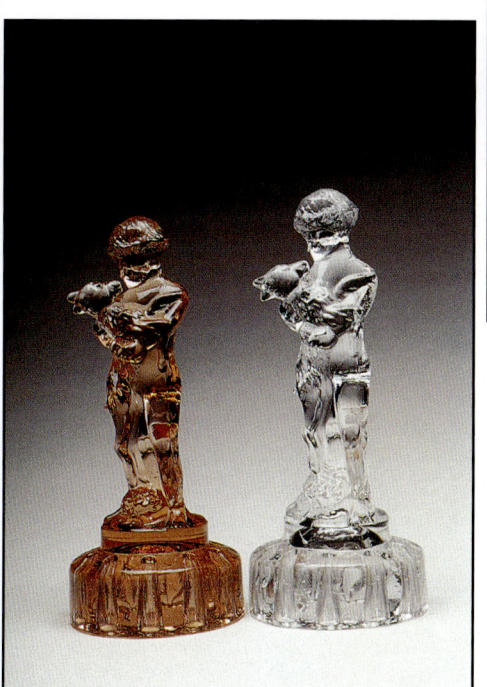

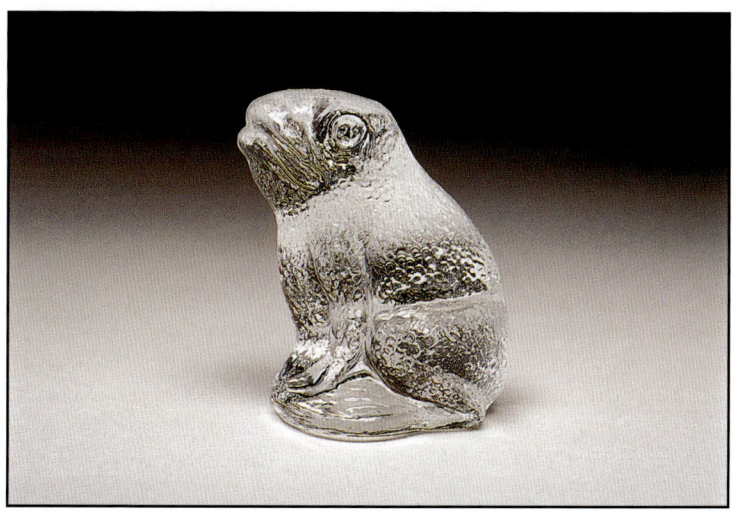

Frog, Crystal, 1.5" tall 1.25" wide, Circa 1934, **$45.00**

Two Kids - flower frog #509, 9.25" tall 4" wide.
Left: Dianthus Pink, **$400.00**
Right: Crystal, **$250.00**

Cambridge Glass

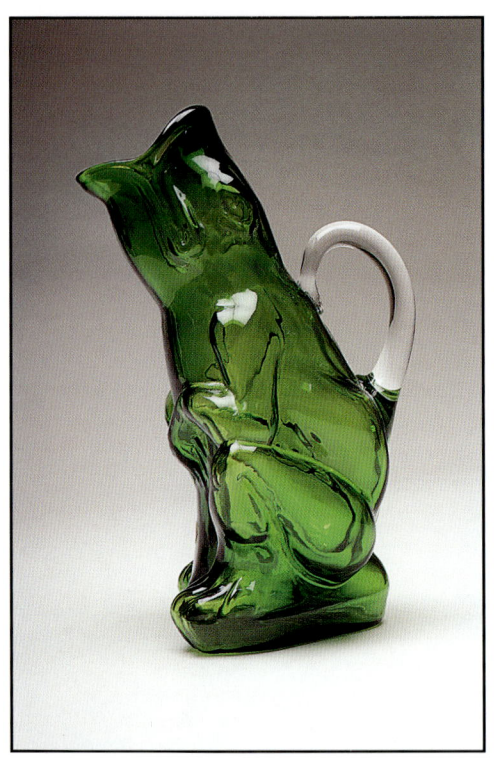

Frog #1352 handled vase, Emerald Green with crystal handle, 9.25" tall 4.75" wide, Circa 1933, **$2,500.00**

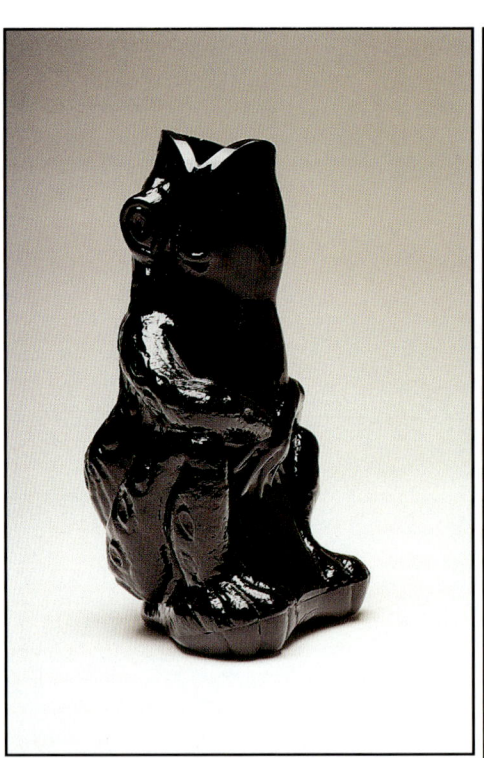

Frog #1352 vase, Ebony, 8.5" tall 4.5" wide, Circa 1933, **$2,000.00**

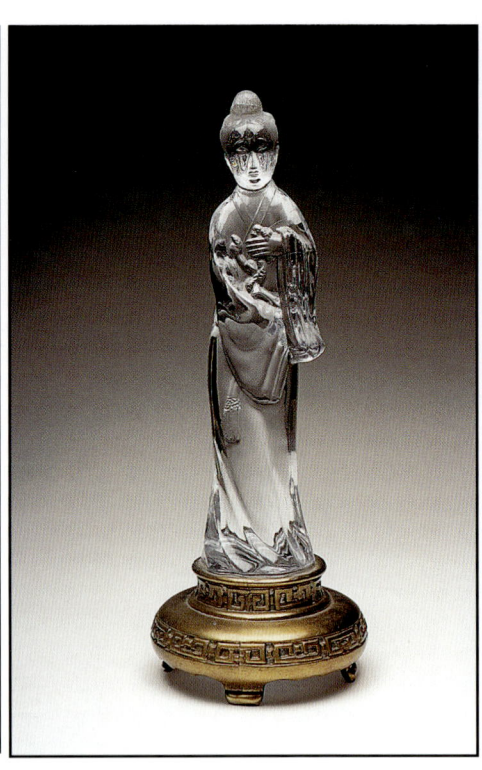

Geisha Lady - lamp base #523, Crystal, 10.4" tall 2.6" wide (measurements for glass), Circa 1920s, **$450.00**

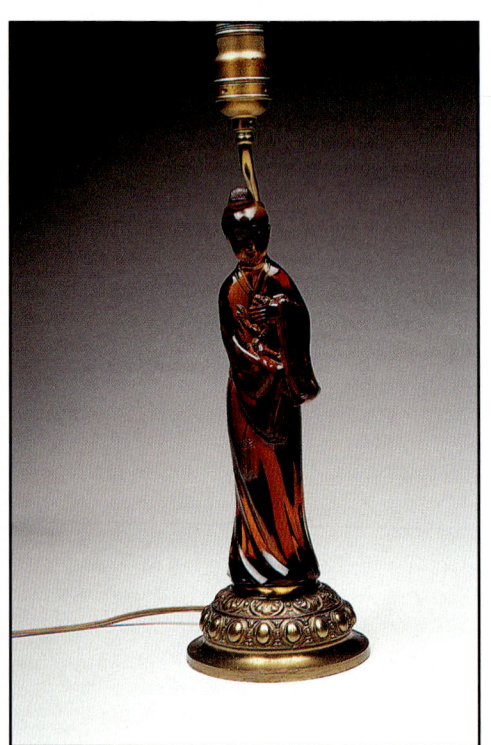

Geisha Lady - lamp #523, Amber, 10.4" tall 2.6" wide (measurements for glass), Circa 1920s, **$700.00**

Rose Lady #512, Amber, 6.25" tall, 1.9" wide, lamp base, 1920s & 1930s, **$300.00**

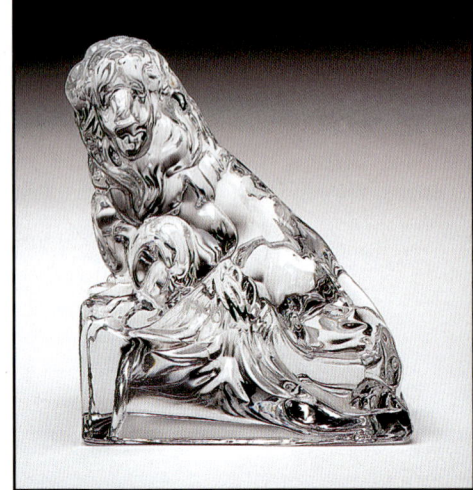

Lion - bookend #1129, Crystal, 6" tall 5" wide, Circa 1920s, **$250.00** each

Cambridge Glass 25

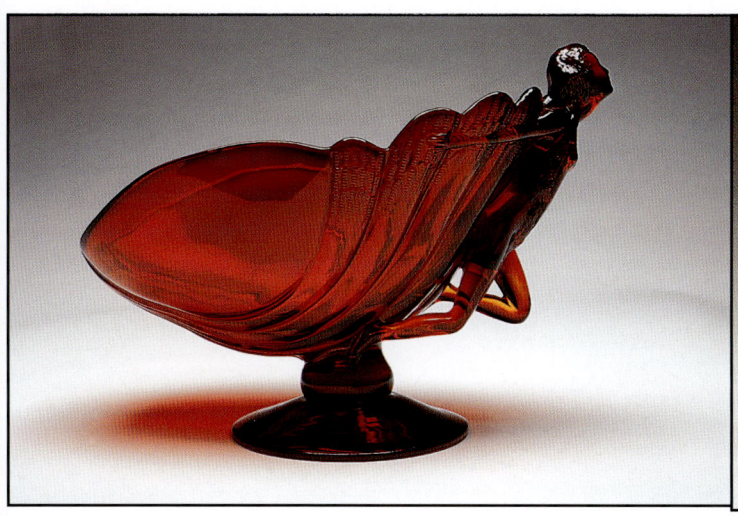

Flying Nude - footed bowl #391/40, Carmen, 8.75" tall 12.25" long, Circa 1930s, **$850.00**

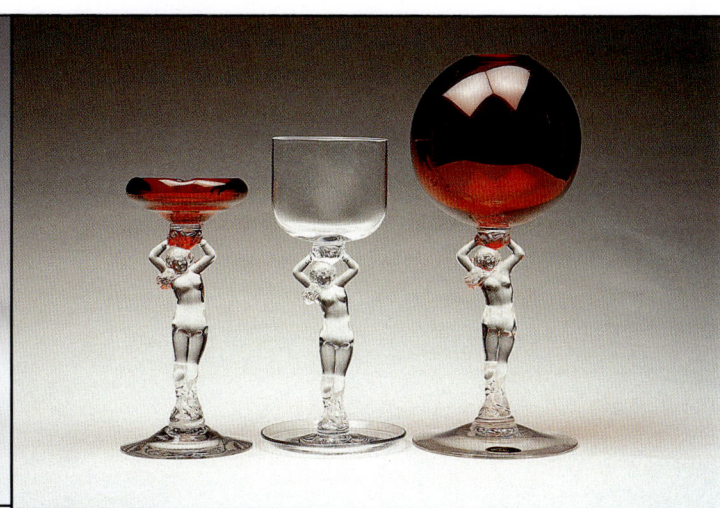

Nude - stems
Left: Ashtray #3011, Carmen, 6.5" tall, 1931, **$450**
Center: Cigarette holder #3011, Crystal, 7.5" tall, 1930s, **$250**
Right: Ivy ball #3011, Carmen, 9.5" tall, 1931, **$350**

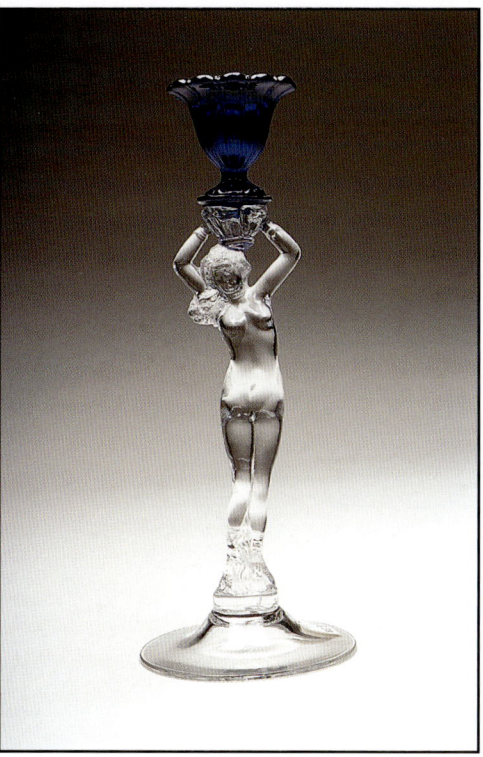

Nude stem - candlestick #3011, Cobalt and Crystal, 8.5" tall, Circa 1933, **$350.00** each

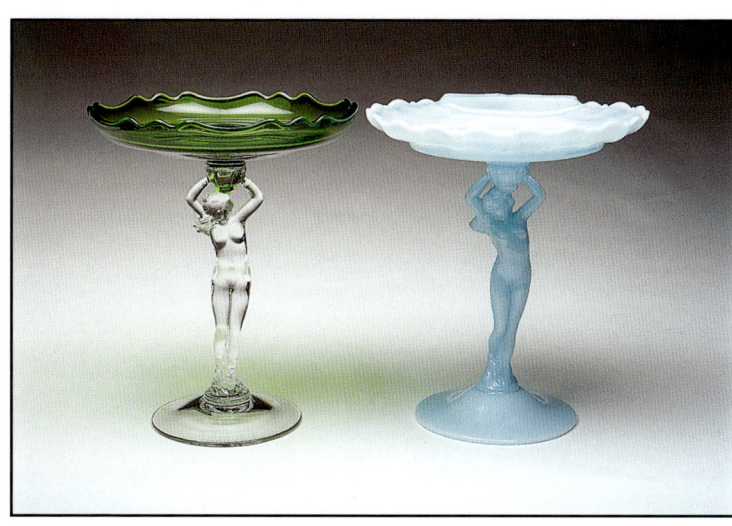

Nude - stems
Left: Compote #3011 Emerald Green, 8" tall, 1931, **$650**
Right: Shell Compote #3011, Windsor Blue, 8" tall, 1937, **$1600**

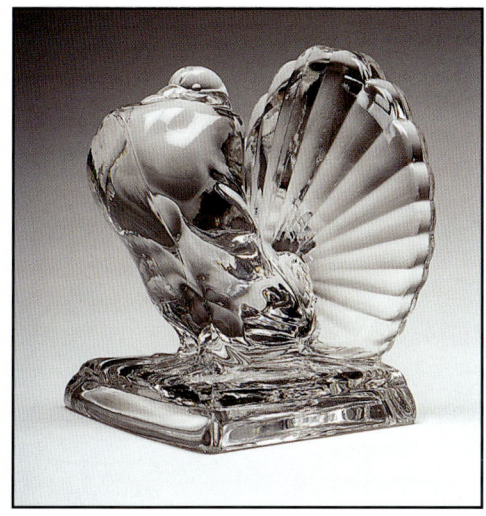

Pouter Pigeon - bookend #122, Crystal, 5.5" tall 3.25" wide, Circa 1949-1953, **$95.00** each

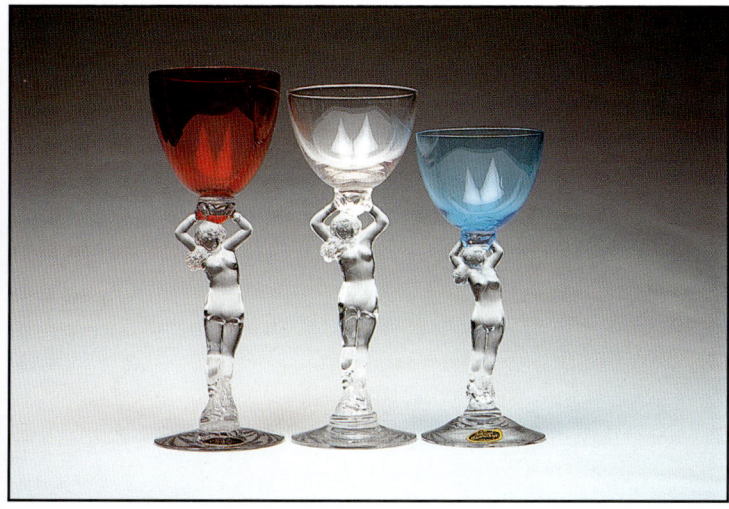

Nude - stems
Left: Carmen, 7.6" tall, 1931, **$250**
Center: Peach Blo, 7.25" tall, 1925, **$195**
Right: Blue, 6.5" tall, 1930s, **$250**

26 Cambridge Glass

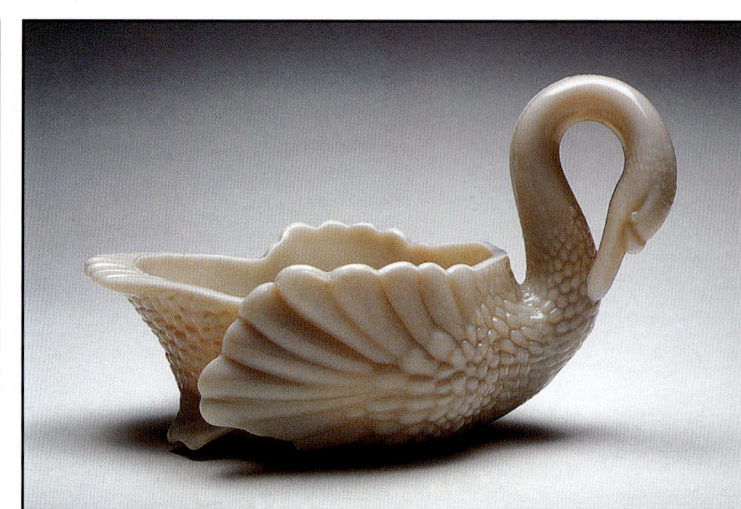

Left: Rabbit - covered (small) #1315, Crystal, 3.25" tall 5" long, Circa 1931, **$250.00**
Right: Rabbit - covered (large) #1316, Crystal, 3.5" tall 7" long, Circa 1931, **$350.00**

Swan #1043, Crown Tuscan, 6" tall 9.5" long, Circa 1928-1958, **$95.00**

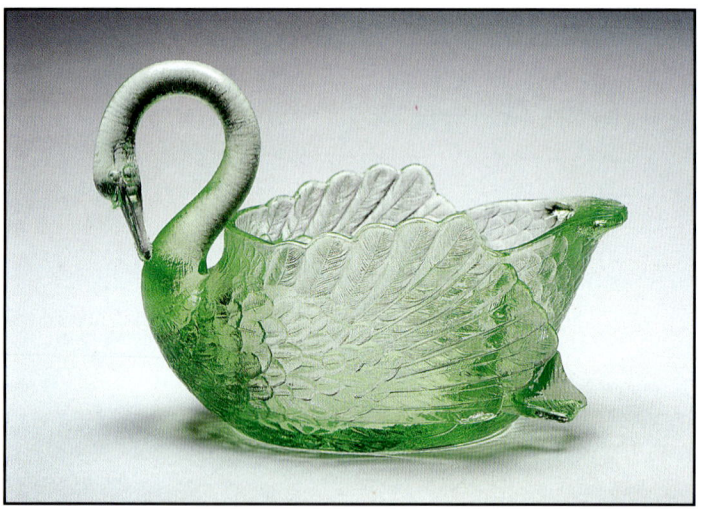

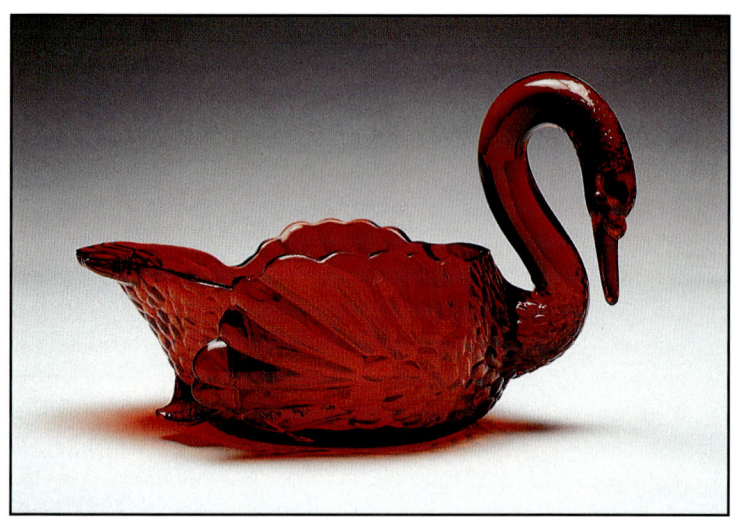

Swan #1042, Emerald Green, 4.75" tall 6.75" long, Circa 1928-1958, **$75.00**

Swan #1043, Carmen, 5.75" tall 9" long, Circa 1928-1958, **$450.00**

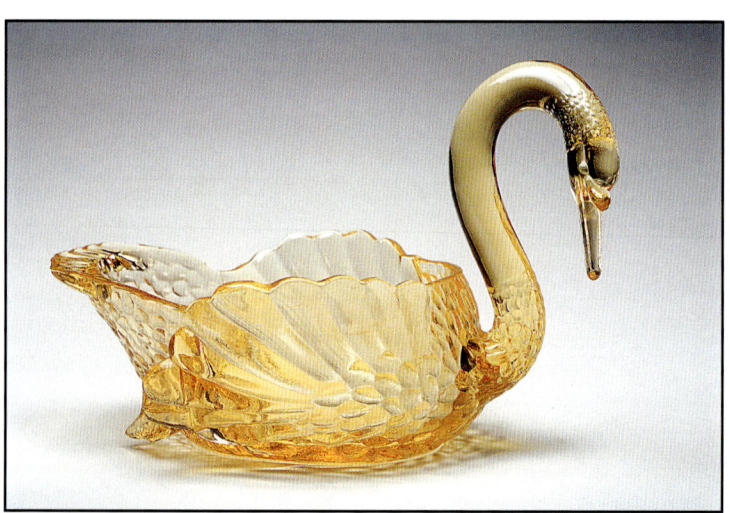

Swan #1043, Gold Krystol (yellow) #1044, 6.1" tall 9.5" long, Circa 1928-1958, **$175.00**

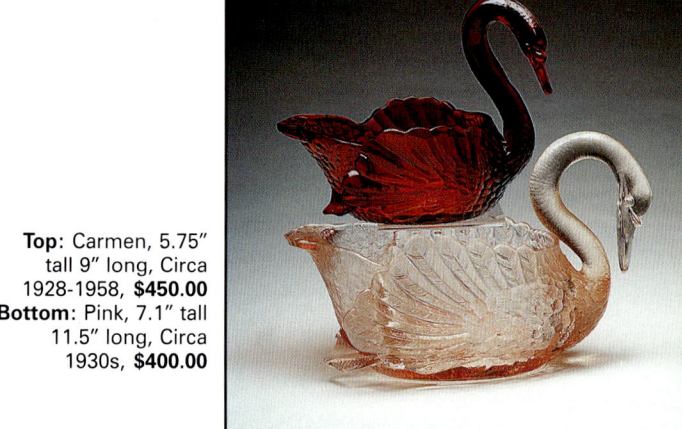

Top: Carmen, 5.75" tall 9" long, Circa 1928-1958, **$450.00**
Bottom: Pink, 7.1" tall 11.5" long, Circa 1930s, **$400.00**

Cambridge Glass

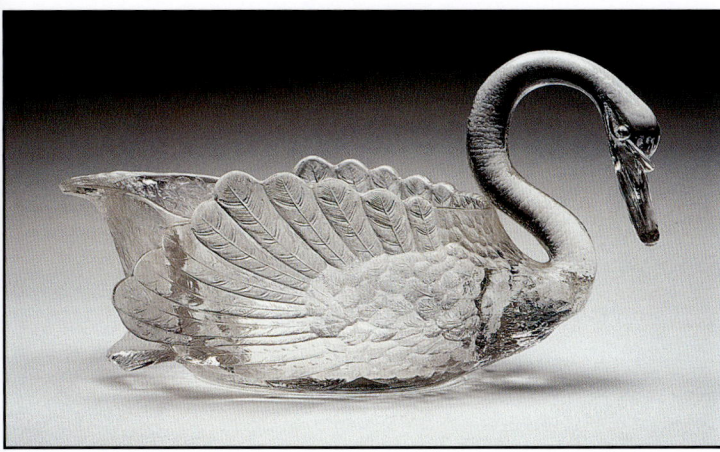

Swan #1044 (older style), Crystal, 7" tall 11.75" long, Circa 1928-1933, **$125.00**

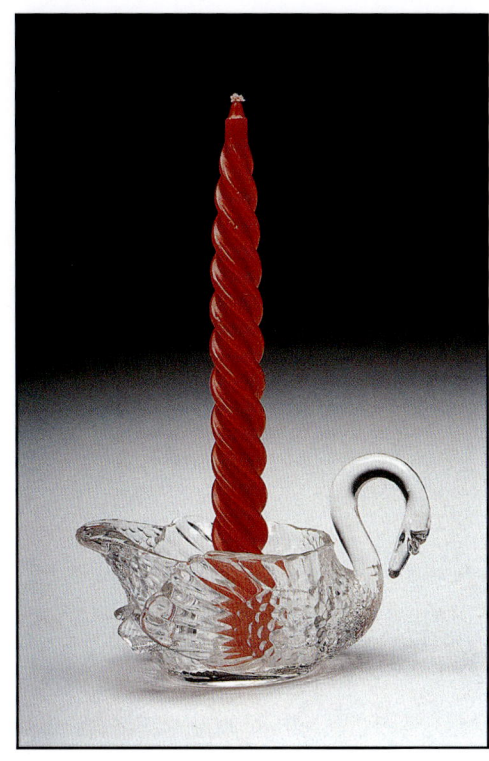

Swan - candleholder #1041/1050, Crystal, 3" tall 5" long, Circa 1928-1958, **$45.00**

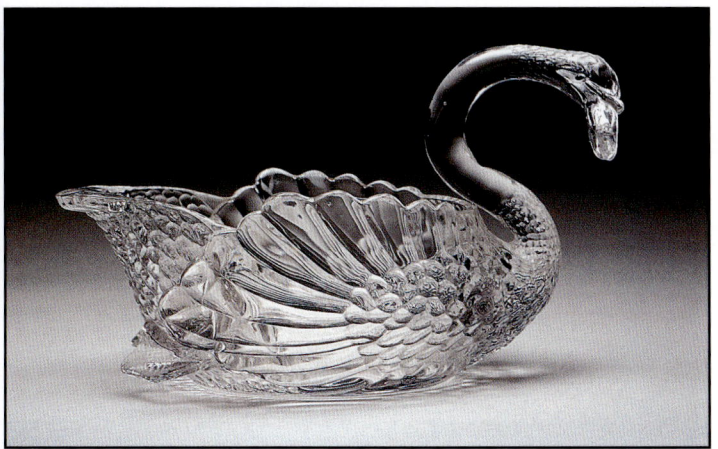

Swan #1044 (newer style), Crystal, 7.5" tall 11.25" long, Circa 1938-1958, **$95.00**

Turkey - covered #1222, Amber, 8.5" tall 8.5" long, Circa 1933, **$850.00**

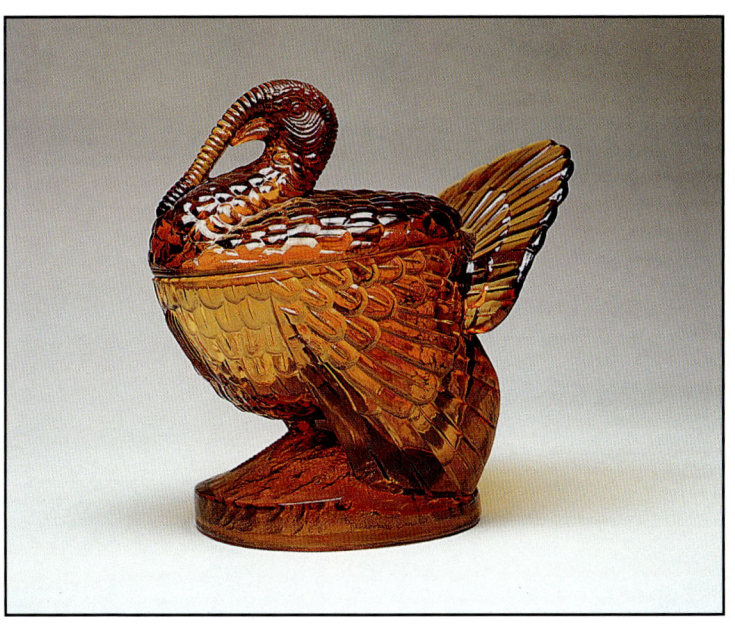

Co-Operative Flint Glass Company 1879-1934

The Co-operative Flint Glass Company began making glass in 1879 in Beaver Falls, Pennsylvania. They produced glassware for restaurants and soda shops. Some novelty and giftware was made in the 1920s and 1930s.

An ad in the December, 1928, *Crockery and Glass Journal* listed them as a top manufacturer of glassware for hotels and restaurants with sales offices in New York, Chicago, and Los Angeles.

The economic downturn in the late 1920s took a heavy toll on Co-operative Flint. Unable to compete, they closed their doors in 1934, and became one of the earliest casualties of the American Depression.

Some of Co-operative Flint's colors were advertised under more than one name, such as their black, which also was called Midnight Glass.

The covered frog that Co-Operative Flint made was also made later by the Erskine Glass Company, in the same colors. Both versions have an inside lip on the lid that goes completely around the edge. Still later, there were other covered frogs made outside the United States and brought to America by import companies; the glass on these is of good quality. On the imported frogs, the inside lip on the lid only goes around the body of the frog, and not around the head. This is the key to identifying the originals from the imported copies. It is not known exactly when the copies were produced.

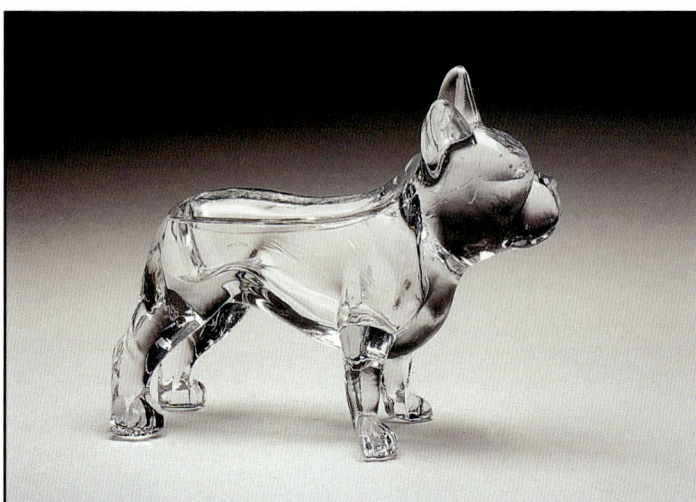

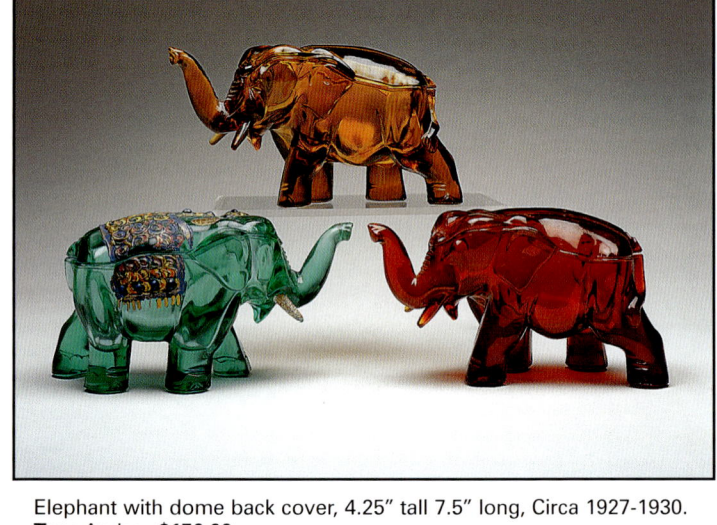

Dog #570 covered dish (back comes off to reveal the dogs open back), Crystal, 6" tall 7.75" long, Circa 1927, **$165.00**

Elephant with dome back cover, 4.25" tall 7.5" long, Circa 1927-1930.
Top: Amber, **$150.00**
Bottom left: Green with original enamel decoration, **$275.00**
Bottom right: Red, **$250.00**

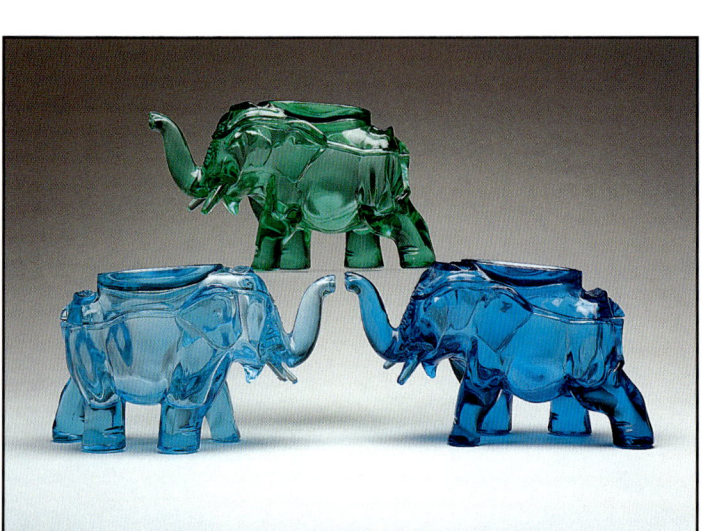

Elephant with ashtray cover, 4.5" tall 7.5" long, Circa 1930.
Top: Green, **$250.00**
Bottom left: Aqua Blue, **$275.00**
Bottom right: Ritz Blue, **$350.00**

Co-Operative Flint 29

Close up of label on top of head of green Elephant with dome back cover.

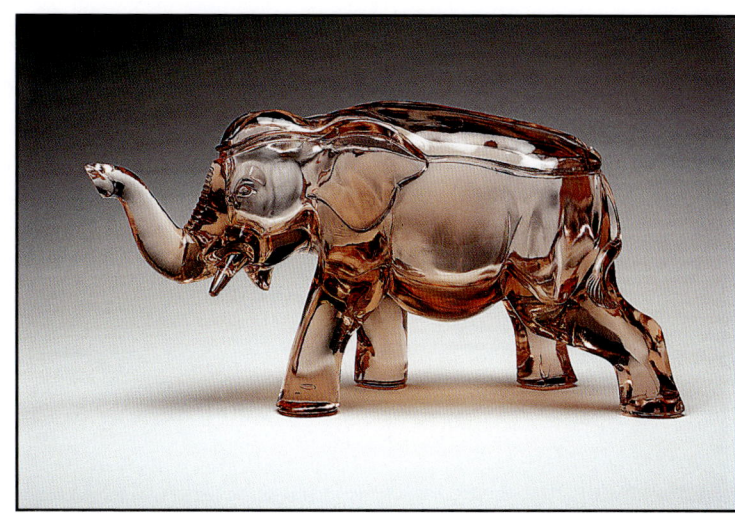

Elephant with domed cover, Pink, 7.25" tall 14.75" long, Circa 1930, **$550.00**

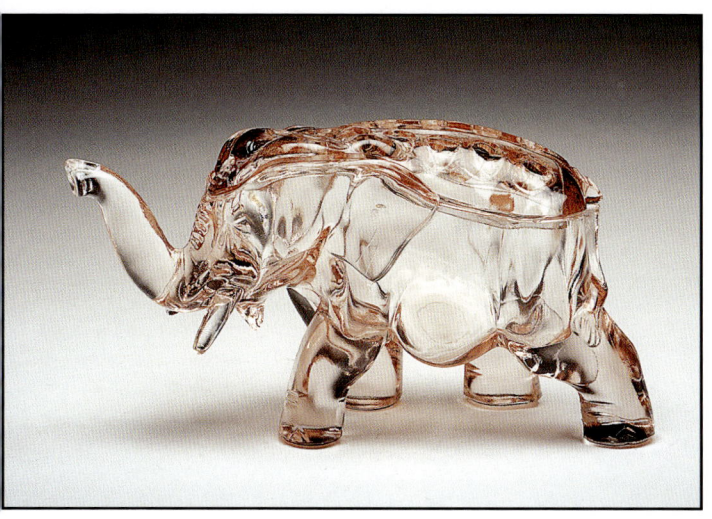

Elephant with flower frog cover, Pink, 4.1" tall 7.5" long, Circa 1930, **$350.00**

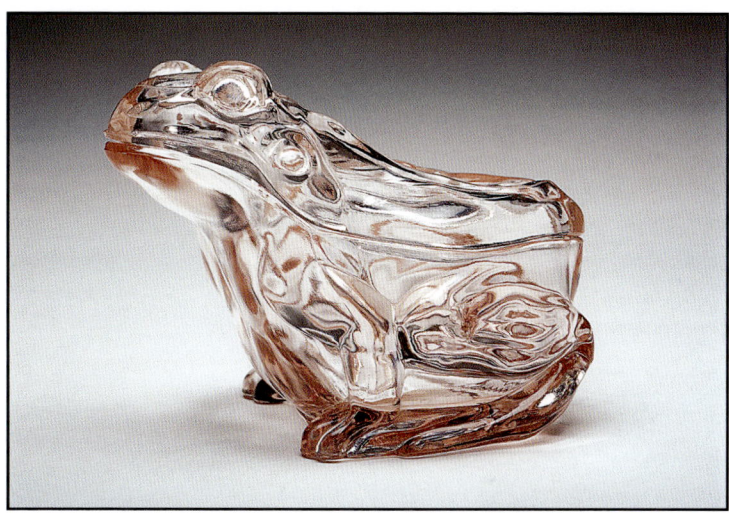

Frog with cover, Pink, 3.8" tall 5.5" long, Circa 1930, **$250.00**
Also the following covered animals were also made: cat, bear, and fish.

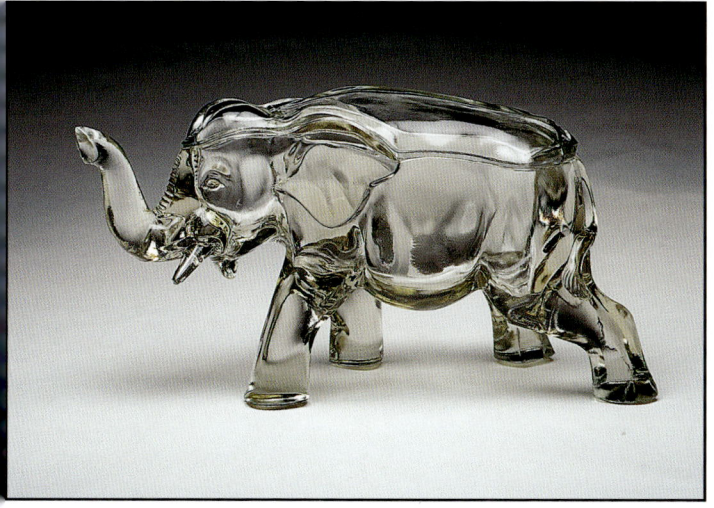

Elephant with domed cover, Crystal, 7" tall 13" long, Circa 1930, **$300.00**

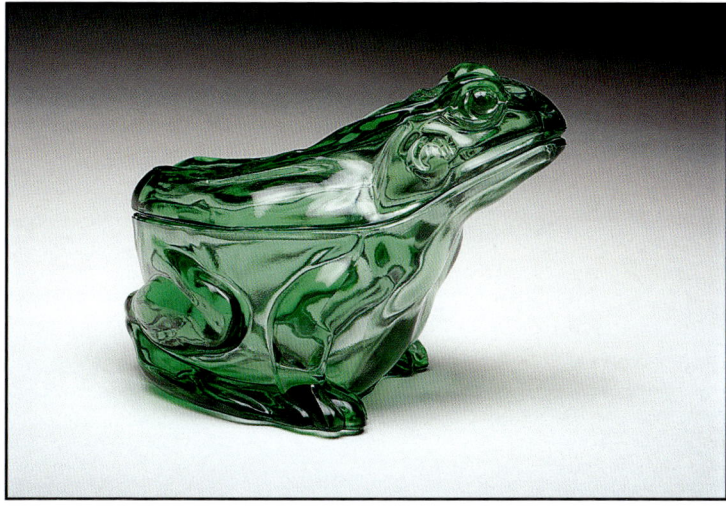

Frog with cover, Green, 3.8" tall 5.5" long, Circa 1930, **$295.00**

Craigs Glass Art Collectibles 1980s

Craigs Glass Art Collectibles was a small glass company operating from Fort Wayne, Indiana. Their Packy elephant paperweight was issued in a new color each month, starting in September, 1980. Advertisements stated that less than 1,000 elephants would be made in each color and only 652 were made in the first color, Carnival Mardi Gras Slag. It is not known how many Packys were made or if Craigs made other animals.

Elephant "Packy", Carmel Slag, 2.5" tall 3.25" long, Circa 1980s, **$18.50**

J.C. Crosetti 1946-1967

The Stough Company, in Jeannette, Pennsylvania, was a major producer of candy containers. When a Stough daughter married J.C. Crosetti in the early 1940s, they opened their own candy container company in Jeannette. From 1946 until the factory closed in 1967, the Crosetti name was put on their containers.

Dog "Scottie" candy container, Crystal, 3.25" tall 4" wide, Circa 1940s. **$30.00**

Dog - Hound candy container, Crystal, 3.5" tall 2.5" wide, holds 2 oz., Circa 1950s. Has a red paper hat that served as a label. Glycerine and Rose water is marked on the hat. Red and white metal screw on lid says "Armstrong, House of Lowell, Inc. Greenville, Ohio. **$25.00** Not pictured, same dog without paper hat label, $15.00

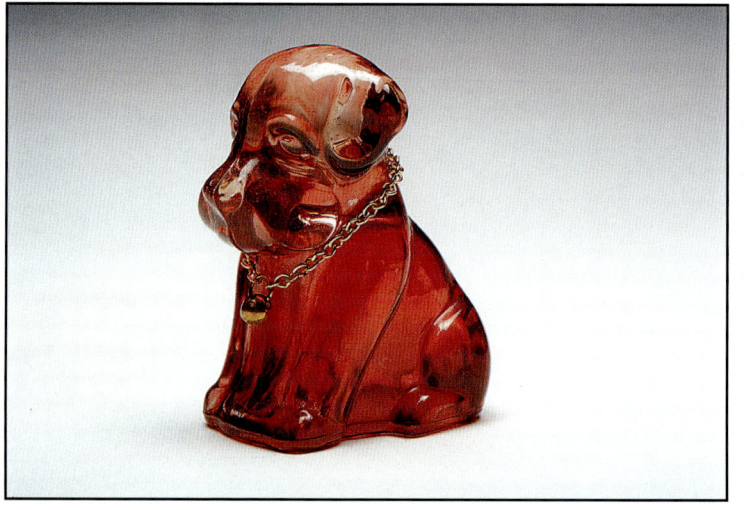

Dog - Pooche candy container, Crystal with ruby flashed on color, 3" tall 2.5" wide, Circa 1950s. Has a metal chain collar. Note, it was marketed with bath crystals. **$18.00**

Degenhart Glass Company 1947-1978

John Degenhart started the Degenhart Glass Company in 1947, after working for several years at Cambridge Glass Company. Located on Morton Avenue in Cambridge, Ohio, Degenhart's factory produced paperweights and novelties. When John died in 1964, his widow turned to Zack Boyd to help her continue the business. Boyd had retired from Cambridge Glass Company and was seventy-six years of age when he went back in the glass business. Boyd's son, Bernard C., also formerly employed at Cambridge, helped his father but kept his job at the Cambridge State Hospital where he was a psychiatric aid. Zack Boyd died in 1968 and Gus Therat was hired to keep Degenhart Glass going. Bernard C. Boyd continued to help the business occasionally until 1976, when he retired from the hospital and returned to glassmaking full time. Two years later, in 1978, Mrs. Degenhart died and the factory closed briefly, but was purchased by Bernard C. Boyd with his son, Bernard F. Boyd, and his wife and their son (see Boyd Crystal Art Glass Company).

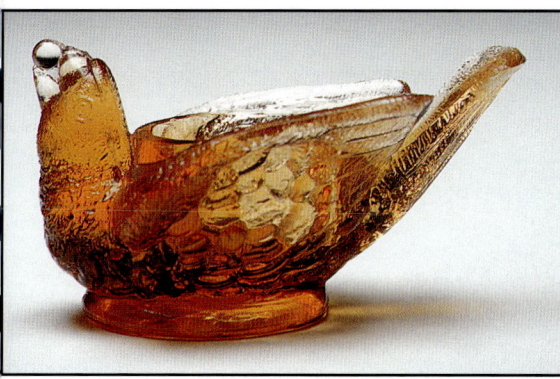

Bird - toothpick with a berry in his beak, Amber, 1.75" tall 3" long, Circa 1947-1978, **$35.00**

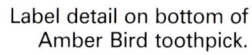

Label detail on bottom of Amber Bird toothpick.

Owl on books, 3.6" tall 1.75" wide, Circa 1947-1978.
Left: Pigeon Blood, **$48.00**
Center: Vaseline, **$40.00**
Right: Blue Opalescent, **$45.00**

Dog "Pooch", Transparent Blue, 3" tall 2.5" long, marked with D in a heart, Circa 1947-1978, **$45.00**

Owl on books, Pigeon Blood, 3.6" tall 1.75" wide, Circa 1947-1978, **$48.00**

Man "Bernard Boyd" (three on bust off base), Red Slag, 4.75" tall 4.25" wide, Circa 1980s, each boy marked with an embossed D inside of a heart, **$175.00**
Not pictured - "Bernard Boyd" figure only, Red Slag, $40.00
These were made by Boyd for the Degenhart museum gift shop.

Dereume (Raymond) Glass Company 1921-Present

The Raymond Dereume Glass Company was established in 1921 in Punxsutawney, Pennsylvania, to be a wholesaler of specialty glassware. They have become primarily a producer of religious glassware for use in churches; their products include sanctuary glasses, vigil glasses, cruets, decanters, and candle holders.

In 1985, the Dereume Glass Company bought Kanawha Glass Company, giving Dereume the opportunity it needed to expand into the giftware business. The entire Kanawha factory was taken apart and moved to Punxsutawney. Currently, Dereume is still operating and utilizing some of the Kanawha moulds.

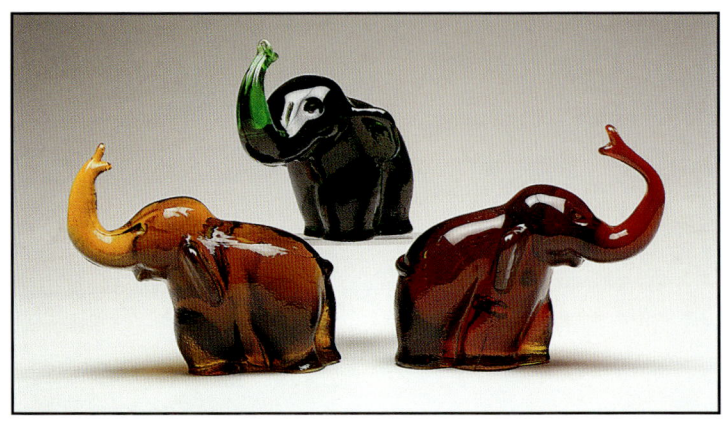

Elephant, 4.1" tall 5" long, Circa 2000.
Top: Green, **$18.00**
Bottom left: Amber, **$15.00**
Bottom right: Ruby, **$20.00**

Duncan & Miller Glass Company 1865-1955

The Ripley & Company Glass Company was founded in 1865 at the end of the Civil War. Two years later George Duncan became a partner and Augustus H. Heisey began work as a salesman. Heisey married George Duncan's daughter in 1870. Ripley's son left the glass business in 1874 to open another glass factory. The Ripley company was renamed George Duncan & Sons when James and Harry Duncan joined the company. John Miller also joined the company at this time.

Tableware was the main product of the Duncan company. The United States Glass conglomerate took over the factory in 1891 and renamed it Factory D. The following year, the factory burned to the ground and U.S. Glass had no plans to rebuild it. James Duncan therefore rebuilt his father's company in Washington, Pennsylvania, in 1893. Heisey left Duncan in 1895 to form his own company (see A. H. Heisey & Co.). When James Duncan died in 1900, the company was incorporated and renamed Duncan & Miller Glass Company.

While tableware continued to be the main product, designer Robert May was brought in to create sculptured and ornamental items. May designed the sailfish, ducks, donkey, cart, peony, fish, and Pall Mall line.

Sales at Duncan & Miller were strong through the 1940s and early 1950s, but poor sales and high labor costs forced the factory to close in 1955. Duncan & Miller was sold to the U.S. Glass factory of Tiffin, Ohio.

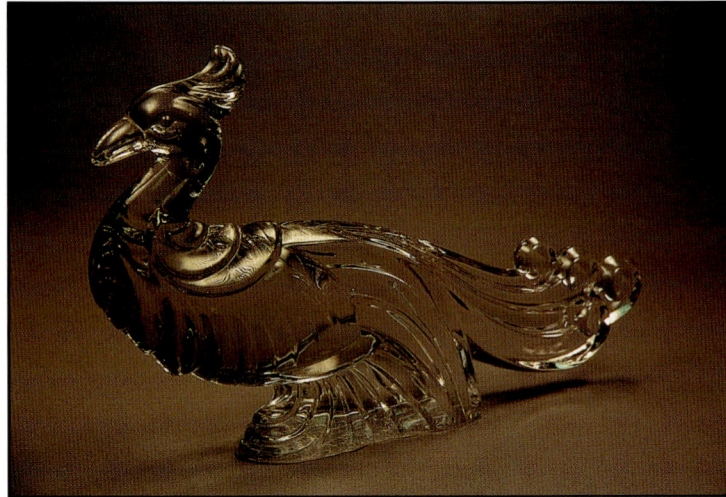

Bird of Paradise, Crystal, 8.5" tall, 13" long, 1930's, **$750.00**

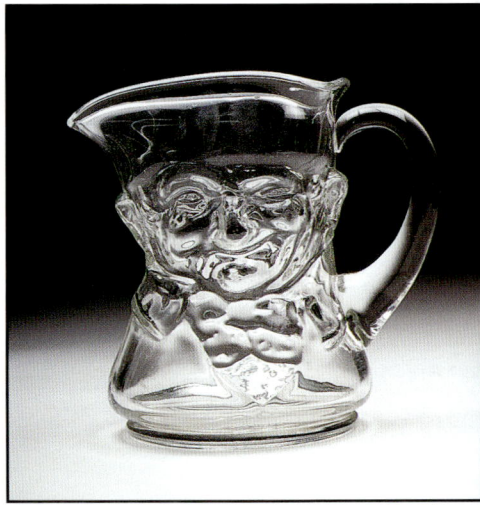

Charley - pitcher, Crystal, 7.5" tall, Circa 1930s, **$200.00**

Duncan & Miller 33

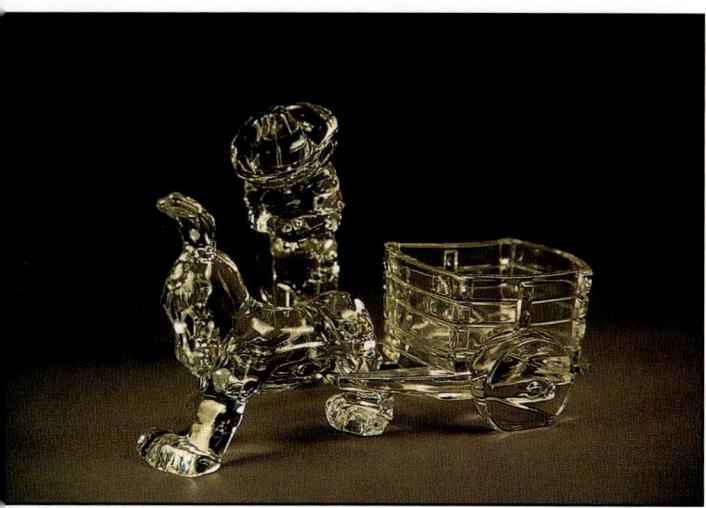

Top: Peon, Crystal, 5.5" tall, 1930's **$250.00**
Bottom left: Donkey, Crystal, 5" tall, 4.5" long, 1930's
Bottom right: Cart, Crystal, 2.75" tall, 6" long, 1930's, **$450.00** 2 piece set

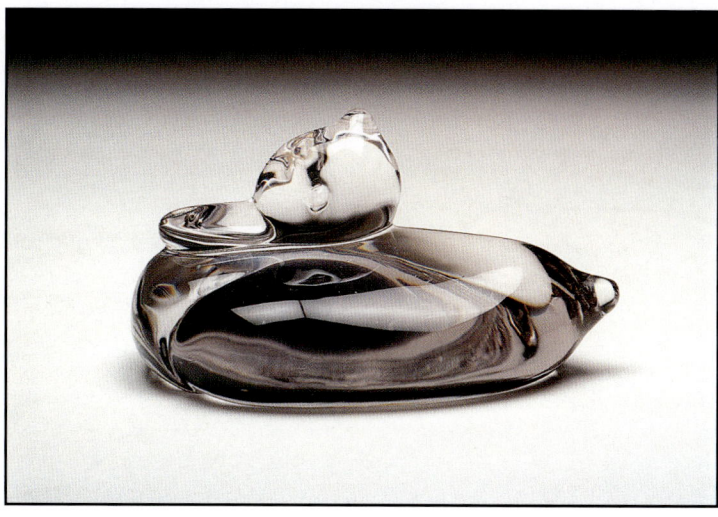

Duck #30 (part of the Pall Mall line) designed by Robert A. May, covered cigarette box, Crystal, 2.75" tall 6" long, Circa 1930s to early 1950s, **$45.00**

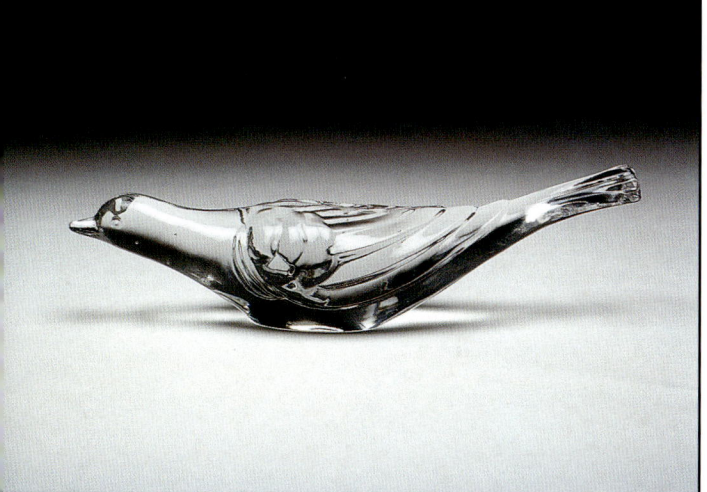

Dove, Crystal, 4" tall, 11.5" long, 1930's, **$250.00**

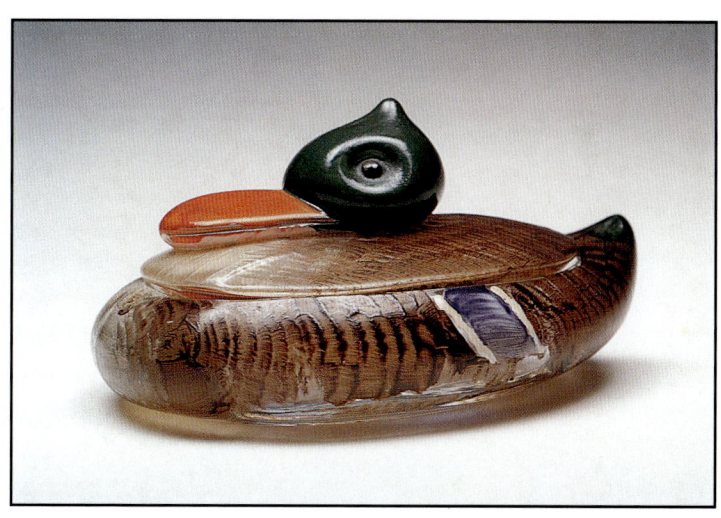

Duck #30 (part of the Pall Mall line) designed by Robert A. May, covered cigarette box, Crystal hand painted, 2.75" tall 6" long, Circa early 1950s, **$95.00**

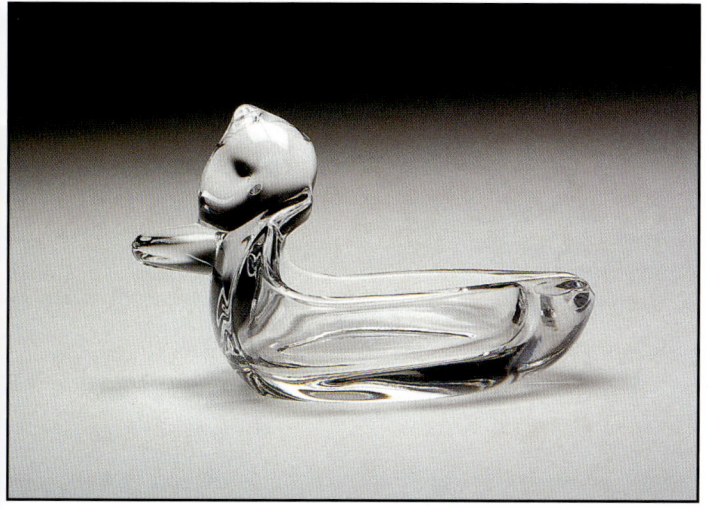

Duck - ashtray #30 (part of the Pall Mall line) designed by Robert A. May, Crystal, 2.75" tall 4.5" long, Circa 1930s to early 1950s, **$18.00** Also came in a larger 7" long size, $24.00

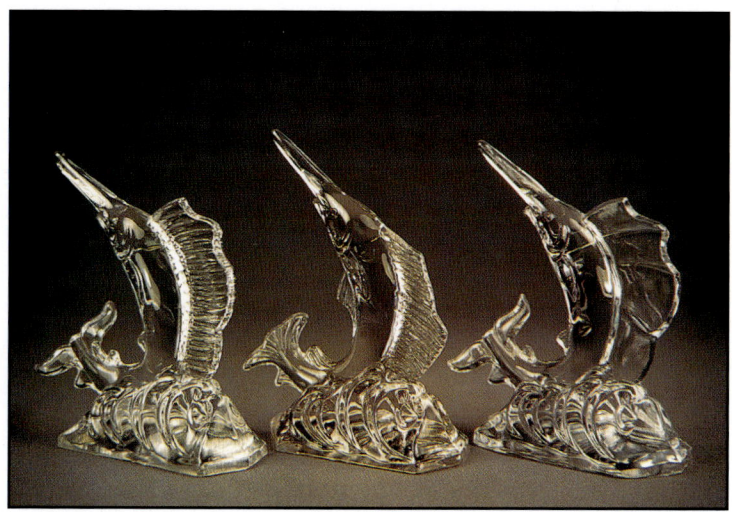

Sail Fish #30 designed by Robert A. May (part of the Pall Mall line. Each of the sail fish has a different style of fin. Crystal, 5" tall 3.85" long, Circa 1940s, **$350.00**

34 Duncan & Miller

Tropical fish - ashtray #130 (part of the Sanibel line) designed by Robert A. May, Blue Opalescent, 3.75" long, Circa 1930s-1940s, **$35.00**

Grouse (Ruffled), Crystal, 6.5" tall, 7.5" long, 1930's, **$1,450.00**

Tropical fish - candle holder, Crystal, 5" tall, 1930's, **$650.00**

Heron #30 (part of the Pall Mall line) designed by Robert A. May, Crystal, 6.75" tall 3" wide, Circa 1930s-1940s, **$95.00**

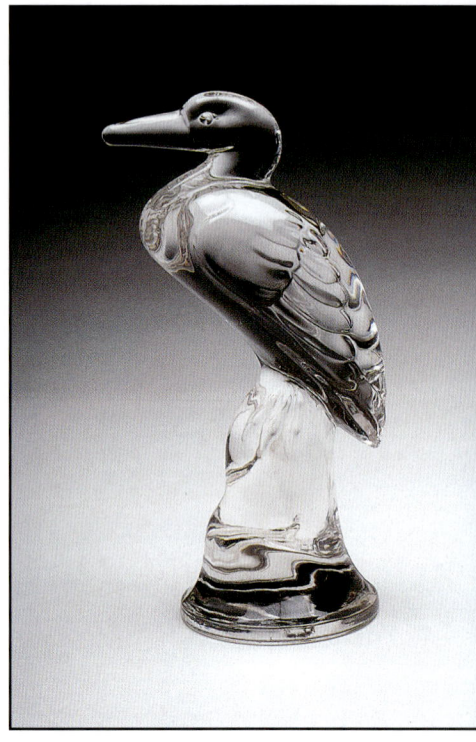

Goose (Fat), Crystal, 6.25" tall, 6" wide, 1930s, **$395.00**

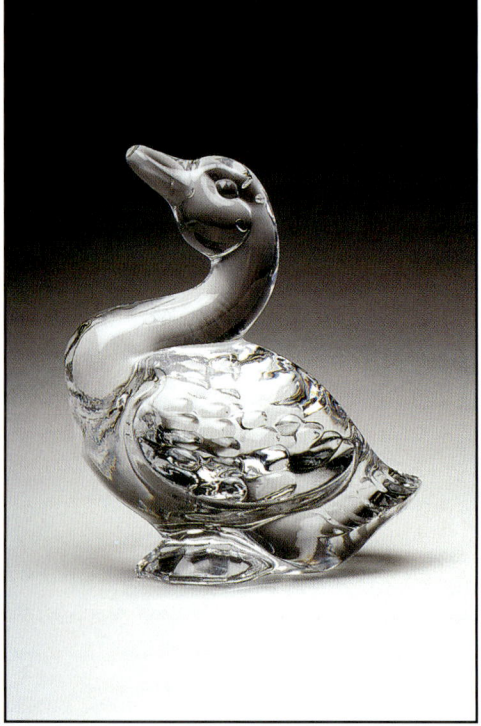

Top: Swan #30-81, Milk Glass with Ruby head/neck, 5.5" tall 8" long, Circa 1940s to early 1950s, **$395.00**
Bottom: Swan #30-82, Milk Glass with Emerald Green head/neck, 7.8" tall 11.5" long, Circa 1940s to early 1950s, **$495.00**

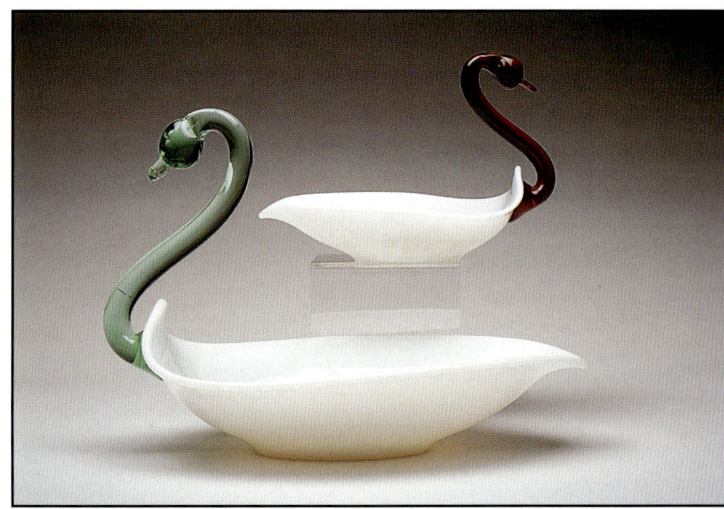

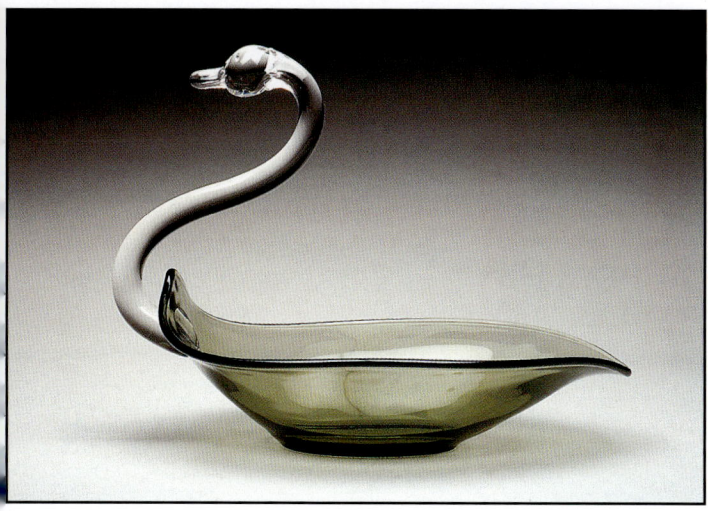

Swan #30-82, Smoke with clear head/neck, 9" tall 12" long, Circa 1940s to early 1950s, **$45.00**

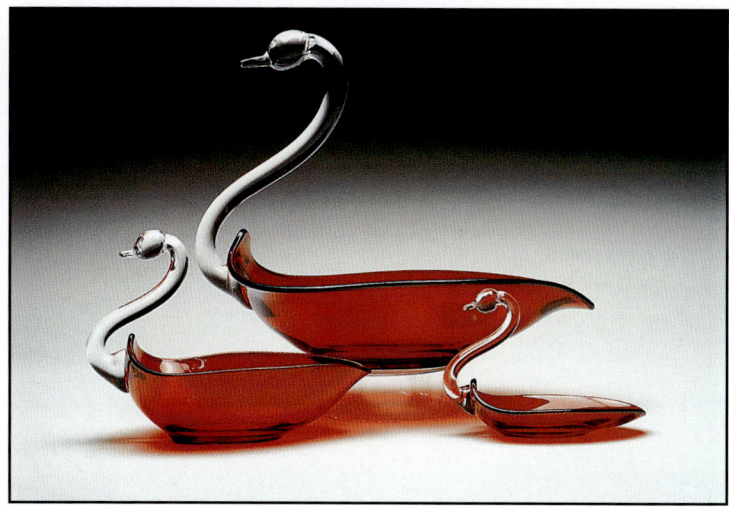

Top: Swan #30-82, Ruby with clear head/neck, 9.5" tall 11.5" long, Circa 1940s to early 1950s, **$125.00**
Bottom Left: Swan #30-81, Ruby with clear head/neck, 5.5" tall 7.5" long, Circa 1940s to early 1950s, **$85.00**
Bottom Right: Swan #30-80, Ruby with clear head/neck, 4" tall 5.5" long, Circa 1940s to early 1950s, **$60.00**

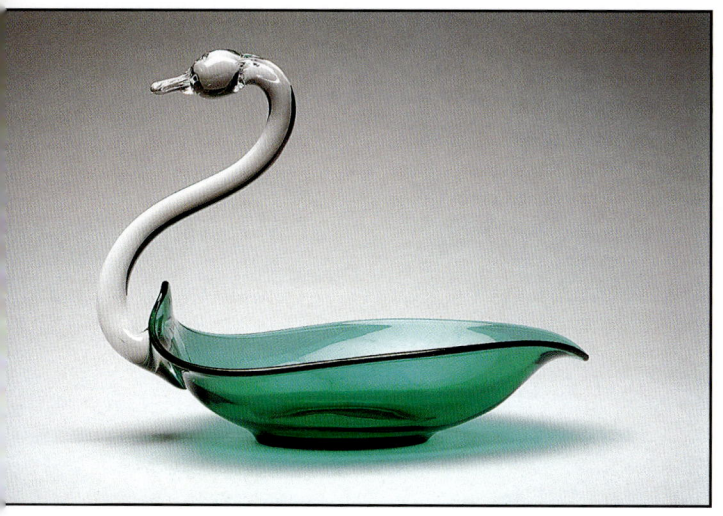

Swan #30-81, Biscayne Green with clear head/neck, 5.5" tall 6.25" long, Circa 1940s to early 1950s, **$65.00**

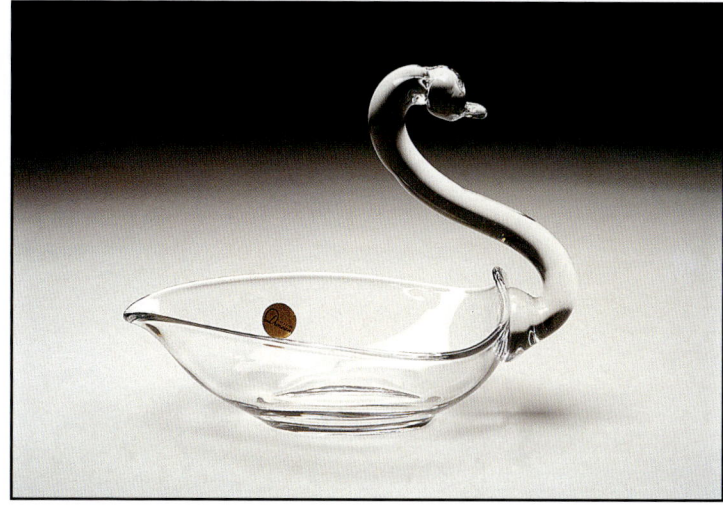

Swan #30-81, Crystal (Note, Duncan paper label), 5.5" tall 8" long, Circa 1930s to early 1950s, **$30.00**

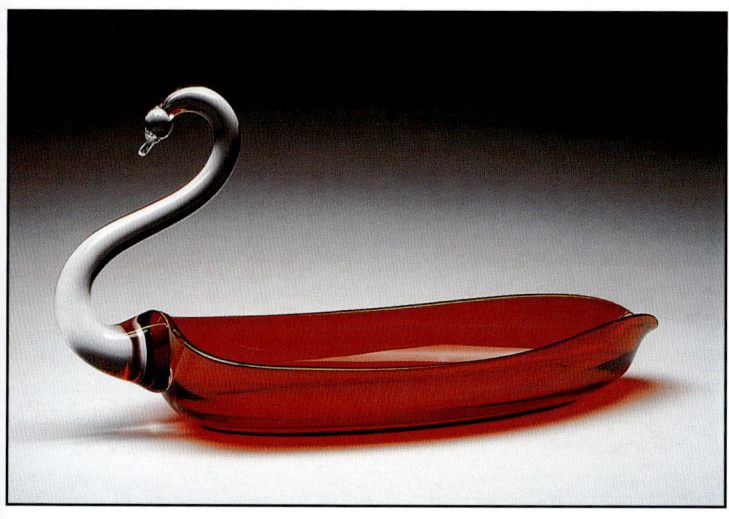

Swan #30-83, Ruby with clear head/neck, 7.25" tall 14.75" long, Circa 1930s to early 1950s, **$125.00**

Swan - Sylvan, Crystal, 9.5" tall 11.75" wide, Circa 1930s to early 1950s, **$95.00**

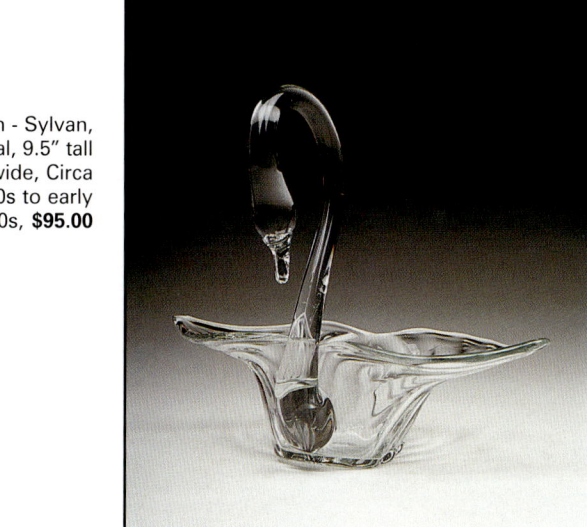

Duncan & Miller

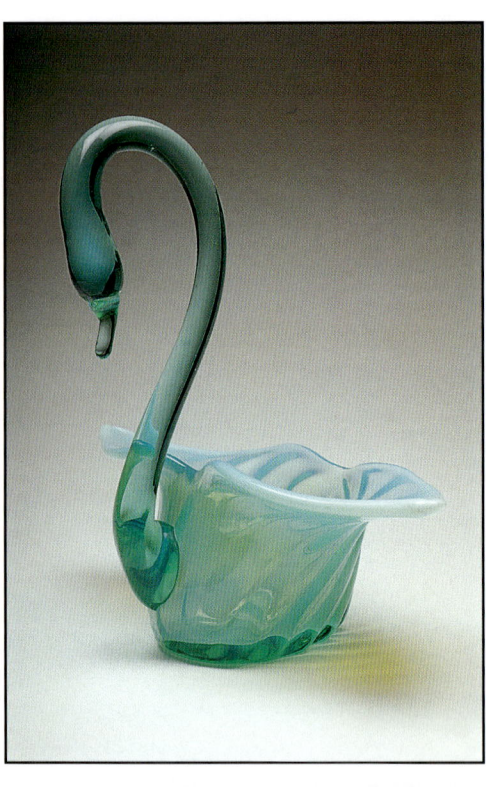

Swan - Sylvan, Green Opalescent, 9.5" tall 11.75" wide, Circa 1940s to early 1950s, **$250.00**

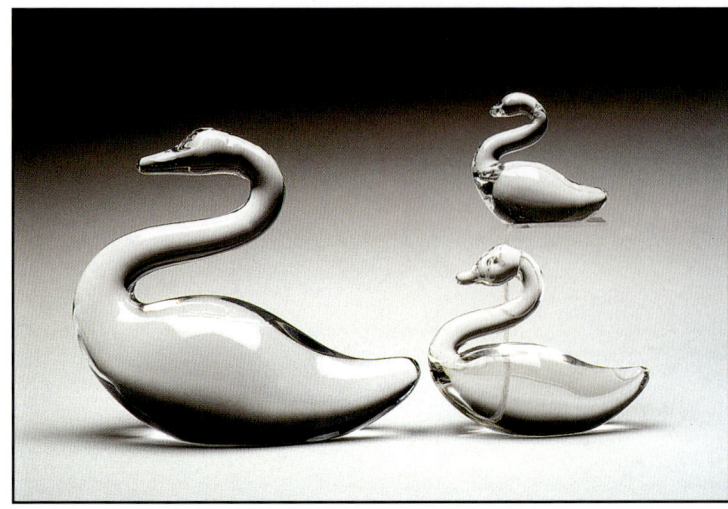

Left: Solid Back Swan #30 (part of the Pall Mall line), Crystal, 6" tall 7" long, Circa 1920s-1930s, **$95.00**
Right top: Solid Back Swan #30 (part of the Pall Mall line), Crystal, 2.75" tall 3" long, Circa 1920s-1930s, **$45.00**
Right bottom: Solid Back Swan #30 (part of the Pall Mall line), Crystal, 3.75" tall 4.75" long, Circa 1920s-1930s, **$68.00**

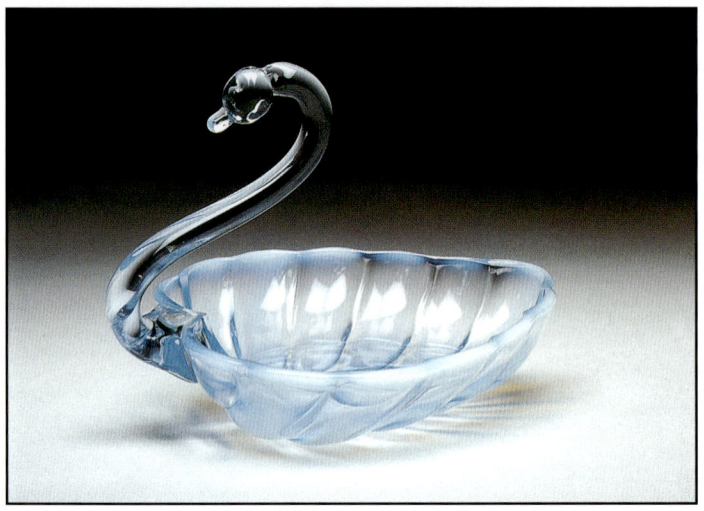

Swan - Sylvan #122, Blue Opalescent, 4.5" tall 5.4" wide 6.5" long, Circa 1940s to early 1950s, **$85.00**
Also came in a 4" $60.00, 8.5" $100.00, and 13" $165.00 sizes. Other items would be a covered candy $150.00 and candle holder $95.00 each. The mould was modified to place a candle cup is in the center of the swan dish.

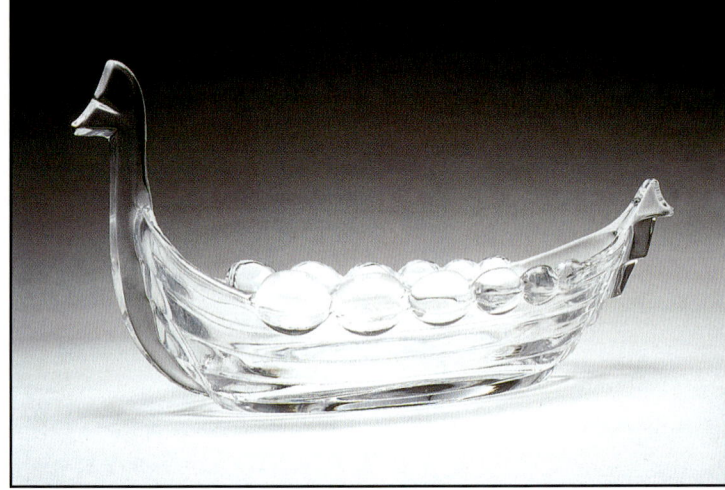

Viking Ship, Crystal, 7" tall 7.5" wide 12.5" long, Circa 1940s, **$245.00**

Enterprise Manufacturing Company 1878-1883

Enterprise Manufacturing Company was established in 1878 in Akron, Ohio. Originally it produced lamp chimneys and a few novelty items.

An ad in the 1883 issue of *Glass and Crockery Journal* refers to this elephant as Baby Jumbo. The ad goes on to say they guarantee their product and if not happy, it may be returned at the company's expense. Suggested uses include a saltcellar, a toothpick holder, or a mustard pot. The company's events following the release of this advertisement are not known.

Elephant with basket on back, Crystal Satin, 3.5" tall 3.75" long, marked on bottom Baby Mine, Circa 1883, **$45.00**

Federal Glass Company 1900-1979

Began in 1900, Federal Glass was located in Columbus, Ohio. Initially, their products were all done by hand including many fine needle etchings and decorations. In the 1920s, Federal was one of the first to begin making machine made glass. All handwork was dropped and this led them to succeed while other companies closed.

In the 1940s they started supplying glass to motels and restaurants. Federal Paper Board Company purchased Federal Glass in 1958 and they became a division of that company. They retained their name and continued to make glass for the home.

Unfortunately after losing market share to both, Anchor Hocking and Libbey, its chief competitors, the decision was made to close in 1979.

Dog #2565, Crystal, 3.1" tall, 2.5" long, **$10.00**

Horse Head - bookends #2563, Crystal Satin, 6" tall, **$65.00** pair

Fenton Art Glass Company 1905-Present

Frank L. Fenton gained his early glassmaking experience at Indiana Glass, Jefferson Glass, Bastow Glass, and Northwood Glass companies. In 1905, Frank L. Fenton and his brother, John Fenton, pooled their resources to set up a glass decorating company in Martins Ferry, Ohio. Later another brother, Charles Fenton, who also worked at Northwood, joined them. They built their glass factory in Williamstown, West Virginia, in 1906. The Fenton Art Glass Company factory opened in 1907. In 1909, John Fenton left Fenton Glass to found Millersburg Glass. Two other Fenton brothers, James and Robert, later joined the family's glassmaking business.

Prosperity propelled sales in the new company for twenty years. When the Depression created lean years in the 1930s, Fenton Glass managed to survive with retail accounts in stores such as Wrisley and Kresge.

Charles Fenton died in 1936 and James died in 1947, so a major blow was struck at the company when Frank L. Fenton died in May 1948, and a few months later Robert Fenton died. Therefore, Frank L. Fenton's two sons, Frank M. Fenton and Bill Fenton, had the company's future thrust on them and they guided the company intact through a rocky time.

Milk glass is said to have kept the company alive in the 1950s, along with the Rubel account. Rubel and Company of New York had contracted the Paden City Glass Company to make glass for him, but after Paden City's closure in 1951 the Rubel account came to Fenton. Also at this time, Paden City's president, Sam Fisher, sold Fenton bird and rooster moulds. The bird mould was made in milk (white) glass and in black glass in 1953 and for two years thereafter. The tall glass rooster was not able to be worked at that time. (However, in the 1960s a new technique was added in the annealing process to enable Fenton workers to make the happiness bird's tail stand up higher. When the new bird was reintroduced in transparent colors, it sold better than the earlier style) The butterfly was introduced in 1970, and it sold well. Tony Rosena, joined the firm about this time to design more animals. Frank M. Fenton remembers, "As we saw them begin to sell, we added more. That's typical Fenton practice. If it sells, we do more."

When the U. S. Glass Company closed its doors in 1962, Frank M. Fenton went to look at their moulds to see which ones to buy. As it turns out, a storm had blown off the roof of the U. S. Glass factory, and the moulds were under three inches of water and mud. Retrieved from that outing were the alley cat, the large owl, and the large rabbit.

Other changes came when the QVC television-shopping program exposed a new audience to Fenton glass. Their designers have continually experimented with Victorian glass formulas to create new giftware in the manner of the old Amberina, Burmese, and Rosalene styles. When American folk art animals became popular in 1991, Fenton re-introduced the tall rooster mould they had bought from Paden City Glass forty years earlier. Since their workers had improved upon 1950s annealing techniques, they were now able to successfully produce the rooster.

A third generation joined the company in the 1960s and 1970s. Frank's sons, George, Mike, and Tom, along with Bill's children, Don, Randy, and Shelly, all obtained key positions at Fenton. George became President in 1986.

Jon Saffell, a former Fostoria employee, joined Fenton in 1994 and set about immediately designing new animals and figurines. The #5292 rooster was his first design in glass. Jon's inspirations come from past experiences and memories. Jon is busy working on new holiday items, including a Halloween collection of a witch, a scaredy cat, and a ghost.

With the recent addition of fourth generation family members, Lynn and Scott Fenton, the Fenton Art Glass Company seems to have control of its future success in the glass market.

Angel #5042BQ "Nature's Spirit" (designed by Jon Saffell), Ivory Satin hand painted, 6.6" tall 4.25" wide, numbered and limited to sales until November 15, 2001, **$60.00**

Angel - boy #5113 "Heavenly", 5.8" tall 2.5" wide.
Left: French Opalescent Iridized WH, Circa 1992, **$28.00**
Right: Iced Poinsettia CV, Pearlized Milk Glass hand painted, Circa 1991-1992, **$38.00**

Fenton Art Glass 39

Angel - girl #5114, 5.8" tall 2.5" wide.
Left: Ice Blue Carnival hand painted LY, Circa 2001, **$35.00**
Right: Pink Chiffon Carnival PA, hand painted, Circa 2001, **$35.00**

Angel #5542, Opal Satin hand painted (Sample item from Fenton Gift Shop marked in pencil w/ color layout), 7.25" tall 4" wide, Circa 1996, **$95.00**

Angel - bell, 5.8" tall 2.5" wide.
Left: Boy #5143JX, Twinning Berries hand painted on Opal Satin, Circa 1998-1999, **$38.00**
Center: Girl #5144VL, Northern Lights hand painted on Opal Satin, Circa 2000, **$45.00**
Right: Christmas girl #5144BM, Opal Satin hand painted, numbered and limited to sales from June to November 15, 1997, **$48.00**

Angel bust #5533, 3.5" tall 3" wide.
Left: Topaz Iridized TS, Circa 2001, **$25.00**
Right: Red Carnival RN, Circa 1994, **$35.00**

Angel Radiant #5542HJ, Opal Satin hand painted with pink blush, 7" tall 4" wide, Circa 1997, **$60.00**

Ballerina #5270WA "Natalie" (designed by Jon Saffell), Rose Buds on Rosalene, 6.5" tall 6.25" wide, limited edition & numbered piece, Circa 1998, **$85.00**

40 Fenton Art Glass

Ballerina #5270 "Natalie" (designed by Jon Saffell), 6.5" tall 6.25" wide.
Left: Rosalene RE (from Fenton Gift Shop NIL [Not In Line]), Circa 1998, **$65.00**
Right: Champagne Satin PQ (iridized), Circa 1998, **$45.00**

Bear - Polar Bear #5109RU, Ruby (from Fenton Gift Shop NIL), 3.25" tall 4.25" long, Circa 1995, **$45.00**

Bear - Day Dreaming #5239, 2.5" tall 4" long.
Left: Aqua Marine Satin AA (from Fenton Gift Shop NIL), Circa 2000, **$30.00**
Right: Plum Carnival PX, Circa 1998, **$40.00**

Bear - Polar Bear #5109, 3.25" tall 4.25" long.
Top left: Woodland Frost FE, hand painted on Opal Satin, Circa 2000-2001, **$28.00**
Top right: Golden Pine Cones VC, hand painted on Ivory satin, Circa 1995, **$35.00**
Bottom left: Vermont Sky MJ, hand painted on Emerald Green, Circa 2001, **$35.00**
Bottom center: Frosty Friends "Snow Flake" DB, hand painted on Opal Satin, Circa 2001, **$38.00**
Bottom right: Golden Flax KG, hand painted on Cobalt, Circa 1995, **$30.00**

Bear - Day Dreaming #5239, 2.5" tall 4" long.
Left: Happy Santa NS, hand painted on Opal Satin, Circa 1990, **$85.00**
Center: Petal Pink PN, Circa 1992-1994, **$40.00**
Right: Burmese hand painted by "Kathleen Sponsler and sold under the Honey Suckle Hollow Art & Antiques" (unauthorized decoration, not done by Fenton), Circa 1998, **$75.00**

Fenton Art Glass 41

Bear - Reclining #5233RU, Ruby, 2.5" tall 3.75" long, Circa 1990-1991, **$45.00**

Bear - Sitting #5151, hand painted Pansies by Louise Piper (most sought after Fenton artist), hand painted on Opal Satin, 3.5" tall 2.25" wide, Circa 1985 (marked on bottom 11-12-85), **$95.00**

Bear - Reclining #5233, 2.5" tall 3.75" long.
Left: Crystal Iridized FM (from Fenton Gift Shop NIL), Circa 1998, **$35.00**
Right: Blue Slag KN/MI (from Fenton Gift Shop NIL), Circa 2000, **$48.00**

Left: Bear - Sitting #5151BE (from Fenton Gift Shop NIL), Burmese Gloss, 3.5" tall 2.25" wide, Circa 1995, **$45.00**
Center: Bear - Sitting #5151BE on bust off base (from Fenton Gift Shop NIL), Burmese Gloss, 7" tall 3.8" wide, Circa 1995, **$75.00**
Right: Bear - Sitting #5151BR (from Fenton Gift Shop NIL), Burmese Satin, 3.5" tall 2.25" wide, Circa 1995, **$50.00**

Bear - Reclining #5233, 2.5" tall 3.75" long.
Top left: Misty Blue Satin LR, Circa 1998, **$45.00**
Top right: Dusty Rose DK, Circa 1993-1994, **$40.00**
Bottom left: Blossoms on Plum Carnival AX, Limited edition, Circa 1998, **$48.00**
Bottom center: Precious Panda PJ, Circa 1988, **$75.00**
Bottom right: Happy Santa NS, Circa 1990, **$85.00**

42 Fenton Art Glass

Bear - Sitting #5151, 3.5" tall 2.25" wide.
Top left: Milk Glass Satin MI, has a cloth scarf (from Fenton Gift Shop NIL), Circa 1992, **$28.00**
Top right: Violets in the Snow DV, satin finish (from Fenton Gift Shop NIL), hand painted, Circa 1980's, **$48.00**
Bottom left: Black (from Fenton Gift Shop NIL), hand painted white flowers & green butterfly, Circa 1996, **$45.00**
Bottom center: Willow Green Opalescent Iridized G1 (from Fenton Gift Shop NIL), Circa 2000, **$35.00**
Bottom right: Violet Satin Iridized XK (from Fenton Gift Shop NIL), hand painted violets, Circa 1999, **$38.00**

Bear - Sitting #5151, Crystal Velvet, 1984, **$95**
This bear was purchased by the Nouveau Art Glass Company in New Jersey to paint with their special decoration. The bears were marketed under Hand Painted Rueven Glass.

Bear - Sitting #5151, 3.5" tall 2.25" wide.
Top left: True Blue IK, Circa 1985-1986, **$65.00**
Top right: Crystal with Cobalt shot up inside (made for the Puget Sound Fenton Finders Club), Circa 1980s, **$75.00**
Bottom left: Natural Brown NJ, Circa 1985-1987, **$65.00**
Bottom center: Red Slag RX, Circa 1984, **$95.00**
Bottom right: Schwarz NC (made to honor Desert Storm), Circa 1991, **$85.00**

Note, that the first Mini Bears were made smaller, in this photo you will notice the difference. The smaller ones were only made for a very short time.
Left: Bear - Mini #5251KN, Cobalt, 2.4" tall 1.5" wide, Circa 2000, **$48.00**
Right: Bear - Mini #5251L9, Ice Blue, 2.75" tall 1.75" wide, Circa 2000, **$24.00**

Bear - Sitting #5151CC (blown item - hollow inside), Country Cranberry, 3.75" tall 2.25" wide, Circa 1994, **$70.00**

Fenton Art Glass 43

Bear - Mini #5251, 2.75" tall 1.75" wide.
Left: Willow Green GY (from Fenton Gift Shop NIL), Circa 2001, **$18.00**
Center: Violet hand painted "Hugs for You" NJ, sitting on special box that this series came with, Circa 2001, **$25.00**
Right: Cobalt Satin KN (from Fenton Gift Shop NIL), Circa 2000, **$14.00**

Bird #5163, 2.75" tall 4" long.
Top left: Gilded Star Flowers HV, Pearlized Milk Glass hand painted with Red Star flowers, Circa 1993, **$30.00**
Top right: Meadow Blossom SF, Opal Satin hand painted with pink flowers, Circa 1991-1993, **$30.00**
Bottom left: Sea Mist Green LE (from Fenton Gift Shop NIL), Circa 1996, **$35.00**
Bottom center: Twilight Blue TB, Circa 1994, **$35.00**
Bottom right: Teal Carnival OI, Circa 1989, **$40.00**

Bear set #5207AX, Plum Carnival hand painted with white flowers, limited to 1250 numbered & matched sets. Circa 1998, **$150.00** for set
Top: Bear - reclining #5233, 2.5" tall 3.75" long, **$48.00**
Bottom left: Bear - Day Dreaming #5239, 2.5" tall 4" long, **$48.00**
Bottom right: Bear - Sitting, 3.5" tall 2.25" wide, **$48.00**

Happiness Bird (former Paden City mould) #5197CY on bust off base (from Fenton Gift Shop NIL), Crystal, 8.5" tall 6.75" long, Circa 1969, **$40.00**

Bird #5163, 2.75" tall 4" long.
Left: Blue Roses on Blue Satin BL, Circa 1978-1982, **$50.00**
Right: Daisies on Cameo CD, Circa 1978-1984, **$45.00**

Happiness Bird (former Paden City mould) #5197CA, Colonial Amber, 4.75" tall 6.75" long, Circa 1967-1968, **$25.00**

44 Fenton Art Glass

Happiness Bird (former Paden City mould) #5197, 4.75" tall 6.75" long.
Top left: Language of Love Z5, Crystal hand painted (40th Anniversary), Circa 2000-2001, **$32.00**
Top right: Blue Burmese Satin UY (from Fenton Gift Shop NIL), Circa 2000, **$60.00**
Bottom left: Daisies on Cameo CD, Circa 1979-1980, **$45.00**
Bottom center: Gold Iridized GJ (from Fenton Gift Shop NIL), Circa 1999, **$40.00**
Bottom right: Teal Royale OC, Circa 1990, **$45.00**

Bird - open back #5240, 3" tall 6.25" long.
Left: Dusty Rose DK, Circa 1991, **$18.00**
Right: Holiday Green GH, Circa 1990-1992, **$16.00**

Bird - Cardinal (former Westmoreland mould) #5245VI, Icicle Kingdom, 2.75" tall 5" long, Circa 1995, **$28.00**

Butterfly on stand #5171RN, Red Carnival, 5" tall 4" long, Circa 2000, **$45.00**

Bird - Blue Jay (former Westmoreland mould) #5245, 2.75" tall 5.25" long.
Top: Cobalt Satin KN (from Fenton Gift Shop NIL), Circa 1999-2001, **$20.00**
Bottom: Cobalt KN, Circa 1999-2001, **$18.00**

Fenton Art Glass 45

Butterfly on stand #5171BA, Blue Satin, 5" tall 4" long, Circa 1979-1982, **$35.00**

Butterfly #5271 (designed by Jon Saffell), 4.1" tall 3.25" wide.
Top: Empress Rose CP, Circa 1999-2000, **$35.00**
Bottom left: Aqua Marine AA, Circa 1999-2000, **$35.00**
Bottom right: Violet OE, Circa 2000, **$35.00**

Butterfly #9580LM, Lime Sherbet Gloss, 1.3" tall 3.5" wide, Circa 1975, **$45.00**

Alley Cat (former U.S. Glass mould) #5177CN, Purple Carnival, 10.75" tall 5.5" long, Circa 1970, **$145.00**

Alley Cat (former U.S. Glass mould) #5177, 10.75" tall 5.5" wide.
Top left: Aquamarine AA (from Fenton Gift Shop NIL), Circa March 2000, **$125.00**
Top right: Country Peach Iridized, made for Levay, Circa 1983, **$175.00**
Bottom left: Red Slag RX, made for Levay, Circa 1984, **$295.00**
Bottom center: Purple Slag PS, Circa 1998, **$150.00**
Bottom right: Azure Blue Satin MM (from Fenton Gift Shop NIL), Circa 1997, **$145.00**

Butterfly on Brass stand #5170, 3.8" wide 3.5" long (Brass is 2" wide 3" long).
Left: Burmese Satin BR (from Fenton Gift Shop NIL), Circa 1992, **$45.00**
Right: Rosalene RE (from Fenton Gift Shop NIL), Circa 1994, **$45.00**

46 Fenton Art Glass

Curious Cat #5243, Medallion Collection Y7, 3.25" tall 2.25" long, Circa 1996, **$48.00**

Happy Cat #5277 (made for FAGCA), Cobalt Iridized, 6.25" tall 3" wide, Circa 1996, **$60.00**

Mini Kitten #5365 (designed by Jon Saffell), Burmese Satin hand painted (made for annual February Fenton Gift Shop sale), 2.75" tall 1.5" wide, Circa 2000, **$35.00**

Curious Cat #5243, 3.25" tall 2.25" long.
Top left: Water Colors PF (from Fenton Gift Shop NIL), Circa 1990, **$35.00**
Top right: Begonias of French Opalescent EI, Circa 2000, **$35.00**
Bottom left: Vining Hearts DW, Circa 1993-1994, **$30.00**
Bottom center: Lilac LX, Circa 1990-1991, **$30.00**
Bottom right: Copper Rose KP (from Fenton Gift Shop NIL), Circa 1990, **$35.00**

Mini Kitten #5365 (designed by Jon Saffell), 2.75" tall 1.5" wide.
Top left: Ice Blue LC, Circa 2000, **$15.00**
Top right: Violet OE, Circa 2000, **$15.00**
Bottom left: Empress Rose CP, Circa 2000, **$15.00**
Bottom center: Sea Green Satin GE, Circa 1999, **$25.00**
Bottom right: Damask Rose on Red Carnival RM, Circa 2001, **$25.00**

Happy Cat #5277 (made for FAGCA), 6.25" tall 3" wide.
Top left: Sea Green Satin GE, Circa 1998, **$45.00**
Top right: Opal hand painted M4, Circa 2000, **$85.00**
Bottom left: Red Crackle, Circa 1999, **$125.00**
Bottom center: Topaz Opalescent Satin TO, Circa 1997, **$75.00**
Bottom right: Blue Burmese Gloss UY, Circa 1995, **$125.00**

Fenton Art Glass 47

Scaredy Cat (designed by Jon Saffell), Black resin (used to test the mould) figure, 4.25" tall 3" long, Circa 2001, This future cat will be offered as part of the 2002 Halloween assortment. **No established value**

Sitting Cat #5165 (on bust off base, from Fenton Gift Shop NIL), Opal Gloss hand painted black & white with floral base, 6" tall 3.8" long, Circa 1996, **$125.00**

Stylized Cat #5065 (designed by Jon Saffell) on bust off base (from Fenton Gift Shop NIL), Violet Iridized OE, 9" tall 3.5" wide, Circa 1999, **$65.00**

Sitting Cat #5165, 3.75" tall 2.6" wide. All cats in this photo have been hand painted, dated, and signed by Louise Piper. They were originally sold at the Fenton Gift Shop (NIL).
Top left: Blackberries on Milk Glass, Circa 1981, **$95.00**
Top right: Pansies on Milk Glass, Circa 1981, **$95.00**
Bottom left: Strawberries on Milk Glass, Circa 1981, **$95.00**
Bottom center: Maple Leaves on Black, Circa 1985, **$115.00**
Bottom right: Holly & Berries on Opal Satin, Circa 1989, **$85.00**

Sitting Cat #5165, 3.75" tall 2.6" wide.
Top left: Daisy on Empress Rose 5L, Circa 2000, **$26.00**
Top right: Pearlized Opal hand painted with Happy Face (sample from Fenton Gift Shop & sold at PNWFA convention auction NIL), Circa 2001, **$85.00**
Bottom left: Grapes on Spruce Green EM, Circa 1998, **$45.00**
Bottom center: Sage Green (made for QVC), Circa 1996, **$55.00**
Bottom right: Celeste Blue hand painted KA (made for QVC), Circa 1995, **$45.00**

Sitting Cat #5165, 3.75" tall 2.6" wide.
Top left: Blue Dogwood on Cameo Satin BD, Circa 1980-1981, **$55.00**
Top right: Violets in the Snow DV, Circa 1979-1982, **$65.00**
Bottom left: Lime Sherbet Gloss LS, Circa 1979, **$60.00**
Bottom center: Roses on Custard RC, Circa 1979-1983, **$45.00**
Bottom right: Peking Blue PK, Circa 1980, **$65.00**

48 Fenton Art Glass

Stylized Cat #5065 (designed by Jon Saffell), 5" tall 2.5" wide.
Top left: Aquamarine AA, Circa 1999-2000, **$25.00**
Top right: Empress Rose CP, Circa 2000-2001, **$30.00**
Bottom left: Amber (from Fenton Gift Shop NIL), Circa 2001, **$35.00**
Bottom center: Symphony on Favrene FW, Circa 2001, **$90.00**
Bottom right: Sweet Harvest RP, Circa 2000, **$50.00**

Kitten #5119 (old style of Kitten), 2.25" tall 4" long.
Top left: Berries & Blossoms RK, Circa 1985-1987, **$50.00**
Top right: Pink Blossom PY, Circa 1985-1987, **$50.00**
Bottom left: True Blue IK, Circa 1986, **$65.00**
Bottom center: Pink Iridized hand painted OS, Circa 1995, **$25.00**
Bottom right: Frosted Asters FA, Circa 1985, **$60.00**

Kitten #5119O9 (comparison detail - to show mould was changed mid year), Blue Iridized, Circa 1992.
Left: Old style of Kitten, 2.25" tall 4" long, **$45.00**
Right: New style of Kitten, 2.1" tall 3.8" long, **$40.00**

Kitten #5119 (new style of Kitten), 2.1" tall 3.8" long.
Top left: Crystal CY, Circa 1993-1995, **$28.00**
Top right: Baby Gift - Boy BP, Circa 1998-2000, **$35.00**
Bottom left: Pink Iridized HZ (from Fenton Gift Shop NIL), Circa 1993, **$25.00**
Bottom center: Twilight Blue hand painted (made for Singleton Bailey), Circa 1994, **$55.00**
Bottom right: Spruce Green hand painted (made for QVC), Circa 1998, **$45.00**

Kitten #5119 (on bust off base, from Fenton Gift Shop NIL).
Left: Opal Satin hand painted to look like a Siamese with flowers on base (old style of Kitten), 5" tall 4" long, Circa 1990, **$125.00**
Right: Favrene FN (new style of Kitten), 5.25" tall 3.8" long, Circa 1999, **$150.00**

Chicken - Chick #5213NY, Yellow hand painted on Opal Satin (part of Natural Animal series), 1.75" tall 2.25" long, Circa January 1985 to December 1986, **$35.00**

Fenton Art Glass 49

Chicken - Mini Rooster #5265 (designed by Jon Saffell), 2.8" tall 2" long.
Top left: Violet OE, Circa 2001, **$9.00**
Top right: Aqua Marine AA, Circa 2000, **$9.00**
Bottom left: Blue Topaz SY, Circa 2001, **$9.00**
Bottom left center: Sea Mist Green LE, Circa 1996, **$12.00**
Bottom right center: Empress Rose CP, Circa 1999, **$10.00**
Bottom right: Chiffon Pink PS (Note, this diachromatic color is really pink and not the blue that it appears to be), Circa 2001, **$9.00**

Chicken - Large Standing Rooster (former Paden City mould) #5257, 7" tall 7" long.
Left: Black OA hand painted Folk Art decoration, Circa 2001, **$159.00**
Right: Opal Satin J1 hand painted accents, Circa 2000, **$149.00**

Clown #5111NK, Cobalt Carnival, 4.75" tall 3.5" long, Circa 1985, **$85.00**

Chicken - Rooster #5292 (designed by Jon Saffell), 5.25" tall 4.8" long.
Left: Violet OE, Circa 2001, **$25.00**
Right: Sea Mist Green LE, Circa 1996, **$27.00**

Chicken - Rooster #5292 (designed by Jon Saffell), 5.25" tall 4.8" long.
Left: Opal Satin J1 hand painted accents, Circa 2000, **$49.00**
Center: Black OA hand painted Folk Art decoration, Circa 2001, **$49.00**
Right: Opal Satin FV hand painted Folk Art decoration, Circa 1998, **$49.00**

Bull Dog #307, Ruby, 2.25" tall 2.75" long, Circa 1933-1936, **$48.00**

Fenton Art Glass

Bull Dog #307, 2.25" tall 2.75" long, Circa 1933-1936.
Left: Ruby, **$48.00**
Right: Crystal Satin, **$40.00**

Dog - Puppy #5225 (new style redesigned by Jon Saffell), 3.1" tall 4.25" long.
Top left: Crystal Iridized hand painted with grapes, Circa 2000, **$32.50**
Top right: Rose Garden EG hand painted on Opal, Circa 2000-2001, **$26.00**
Bottom left: Spruce Green S8 Carnival hand painted, Circa 2000, **$30.00**
Bottom center: Willow Green Opalescent GC hand painted flowers, Circa 2000, **$30.00**
Bottom right: Butterfly Garden on Cobalt KY hand painted flowers, Circa 2001, **$28.00**

Left: Dog - Puppy #5225 (new style redesigned by Jon Saffell), Golden Lab style hand painted on Opal Satin (from Fenton Gift Shop NIL), 3.1" tall 4.25", Circa 1996, **$48.00**
Right: Puppy (old style) #5225, "Flea Hound" decoration hand painted on Opal Satin (from Fenton Tent Sale NIL), 3.25" tall 4", Circa 1996, **$60.00**

Dog - Nipper #5232CY, Crystal, 3" tall 1.75" long, marked on box C.N.D., Circa mid 1980s, **$75.00** Special order made for G.E. Consumer Electronics, who had purchased the RCA family store in New Jersey. The order was for around 4,000 Nippers.

Dog - Puppy (old style) #5225, 3.25" tall 4" long.
Top left: Crystal CY, Circa 1987-1988, **$35.00**
Top right: Victorian Roses VJ hand painted on Opal, Circa 1987-1988, **$40.00**
Bottom left: Natural - light QB, Circa 1987-1988, **$55.00**
Bottom center: Pastel Violets VC hand painted on Custard, Circa 1987, **$40.00**
Bottom right: Natural - dark NJ, Circa 1988, **$55.00**

Dog - Scottie #5214, 3" tall 1.75" wide.
Left: Natural NH, Circa 1986-1988, **$60.00**
Center: Crystal CY, Circa 1986-1988, **$35.00**
Right: Spruce Green Satin SO (from Fenton Gift Shop NIL), Circa 1999, **$30.00**

Fenton Art Glass 51

Dog - Spaniels #5159SP, Natural, 2.6" tall 3.5" long, Circa 1985-1987, $48.00

Donkey #5125, 4.75" tall 4.5" long. Cart #1524, 2.8" tall 5.5" long.
Top: Rosalene RE (from Fenton Gift Shop NIL), Circa 1992, **$150.00 set**
Bottom: Champagne PY (from Fenton Gift Shop NIL), Circa 2000, **$75.00 set**

Dolphin #5137L9 (designed by Jon Saffell), Ice Blue Pearl, 6" tall 7" long, Circa 2000, **$45.00**

Duck #5212NY, Yellow hand painted on Opal Satin (part of Natural Animal series), 1.6" tall 2.25" long, Circa January 1985 - December 1986, **$35.00**

Donkey #5125LQ, Pearlized Milk Glass hand painted with blue & red flowers, 4.75" tall 4.5" long, Circa 1989, **$40.00**
Made for Gracious Touch limited to 200 made. The #5158 elephant was also made in this design as an election special issue.

Duck #5212NY, Orange bill & black eye hand painted on Opal Satin (part of Natural Animal series), 1.6" tall 2.25" long, Circa January 1985 - December 1986, **$35.00**

52 Fenton Art Glass

Duck - Mallard #5147CY, Crystal, 2.25" tall 5.1" long, Circa 1984-1988, **$28.00**

Duckling #5169, 3.5" tall 2.25" long.
Left: French Opalescent FO (from Fenton Gift Shop NIL), hand painted pink roses on French Opalescent, Circa 2000, **$35.00**
Left center: Crystal Velvet VE, Circa 1981-1984, **$40.00**
Right center: Pearlized Milk Glass (from Fenton Gift Shop NIL), Circa 1994, **$35.00**
Right: Daisy Lane UC, French Opalescent hand painted, Circa 2001, **$27.50**

Duck - Mallard #5147, 2.25" tall 5.1" long.
Top left: Burmese Satin BR, hand painted natural markings, Circa 1999, **$48.00**
Top right: Natural Animal NX, Opal Satin hand painted accents & purple bow, Circa 1985, **$60.00**
Bottom left: Spruce Green Carnival SI (from Fenton Gift Shop NIL), Circa 2000, **$25.00**
Bottom center: Burmese Satin BR (from Fenton Gift Shop NIL), Circa 1999, **$35.00**
Bottom right: Spruce Green Carnival SI (from Fenton Gift Shop NIL), hand painted purple & white accents, Circa 2000, **$45.00**

Duckling #5169, "Puddle Parade" series, Pearlized Opal, 3.5" tall 2.25" long.
Top left: Miss Daphne J5, Circa 1994, **$48.00**
Top right: Daffodil J8, Circa 1994, **$48.00**
Bottom left: Delbert J3, Circa 1994, **$48.00**
Bottom center: Ditsy J7, Circa 1994, **$48.00**
Bottom right: Dugan J4, Circa 1994, **$48.00**

Duckling #5169CY, 3.5" tall 2.25" long, Crystal, Circa 1983-1984, **$35.00**

Eagle - paperweight #8470CK, Chocolate, 3.75" tall 4" wide, Circa 1976, embossed on bottom with - "1776 American Bicentennial 1976" (also has Fenton logo in a oval above three stars), **$35.00**

Fenton Art Glass 53

Elephant #5158CY, Crystal (on bust off base, from Fenton Gift Shop NIL), 6" tall 3.75" wide at base, Circa 1984-1989, **$50.00**

Elephant #5136LE (Circus), Sea Mist Green (on bust off base, from Fenton Gift Shop NIL), 6.6" tall 3.75" long at base, Circa 1997, **$60.00**

Elephant #5158, 3.6" tall 3.1" long.
Top left: Berries & Blossoms RK hand painted, Circa 1984-1986, **$45.00**
Top right: Crystal Velvet VE, Circa 1984-1988, **$40.00**
Bottom left: Roses on Custard RC hand painted, Circa 1981-1984, **$40.00**
Bottom center: Cobalt Carnival NK, Circa 1984, **$48.00**
Bottom right: Frosted Asters FA, Circa 1984-1986, **$50.00**

Elephant #5136 (Circus), 3.75" tall 3.25" long.
Top left: French Opalescent FO, Circa 1997, **$30.00**
Top right: Bellflowers LH, Circa 1999, **$35.00**
Bottom left: Green Carnival L6, hand painted, Circa 1995, **$38.00**
Bottom center: Cobalt KN, Circa 1996-1997, **$35.00**
Bottom right: Spruce Green Satin SO, Circa 1998, **$25.00**

Elephant #5158, 3.6" tall 3.1" long.
Top left: Kristin's Floral YB, Circa 1995, **$45.00**
Top right: Pink Roses Blue Satin JS, hand painted, Circa 1985, **$75.00**
Bottom left: Favrene FN (from Fenton special glass room at the FAGCA convention), Circa 1987, **$95.00**
Bottom center: Ruby RU, Circa 1998, **$48.00**
Bottom right: Pearly Sentiments PT, Circa 1988, **$35.00**

Elephant #5136 (Circus), 3.75" tall 3.25" long.
Top left: French Opalescent hand painted flowers DX, Circa 1997, **$35.00**
Top right: Amber Carnival (from Fenton Gift Shop NIL), Circa 2000, **$28.00**
Bottom left: Medallion Collection Y7, Cobalt hand painted, Circa 1996, **$45.00**
Bottom center: Plum Opalescent (from Fenton Gift Shop NIL), Circa 1998, **$50.00**
Bottom right: Spruce Green Carnival SI, Circa 1990, **$28.00**

54 Fenton Art Glass

Elephant - Bottle (made for a whiskey company, as a disposable container), Crystal, 8.1" tall 4.75" wide, Circa 1935. On back of head is marked with "Federal Law Prohibits sale or reuse of this bottle R-344-95-5", **$195.00**

Elephant - Flower Bowl #1618 (Jumbo), 6.75" tall 9" long.
Left: Amethyst, Circa 1928, **$500.00**
Right: Crystal, Circa 1928, **$400.00**

Elephant - Flower Bowl #1618 (Jumbo), Ebony Satin, 6.75" tall 9" long, Circa 1928, **$650.00**

Elephant - Freehand #5012, 2.5" tall 3.25" long.
Left: Orange Vasa Murrhina, Circa 1984, **$75.00**
Center: Smoke (experimental color NIL), Circa 1980, **$65.00**
Right: Rose Vasa Murrhina, Circa 1984, **$85.00**

Elephant - Flower Bowl #1618 (Jumbo), 6.75" tall 9" long.
Left: Rose, Circa 1928, **$500.00**
Right: Ebony, Circa 1928, **$550.00**

Work Elephant #5123, 3.1" tall 3.6" long.
Left: Blue Satin BA (milk glass), Circa 1972, **$250.00**
Right: Crystal satin, Circa 1972, **$150.00**

Fenton Art Glass 55

Work Elephant #5123, 2.9" tall 3.6" long, marked Fenton on left side between legs.
Left: Burmese Satin BA (from Fenton Gift Shop NIL), Circa 2001, **$45.00**
Right: Topaz Iridized TS, Circa 2001, **$30.00**

Fawn #5160, 3.5" tall 3.5" long.
Top left: Woodland Frost FE, hand painted on Crystal, Circa 1999, **$30.00**
Top right: Autumn Leaves LB, hand painted on Opal Satin, Circa 1985-1986, **$24.00**
Bottom left: Opal Satin (from Fenton Gift Shop NIL), hand painted white flowers on brown, Circa 1998, **$45.00**
Bottom center: Sweet Harvest RP, hand painted on Opal Satin, Circa 2000, **$28.00**
Bottom right: Twining Berries JX, hand painted on Opal Satin, Circa 1998-1999, **$28.00**

Fawn #5160CY, Crystal, 3.5" tall 3.5" long, Circa 1983-1988, **$28.00**

Fish - paperweight #5193OQ, Violet Carnival, 5" tall 3" wide, Circa 2001, **$22.50**

Fish - paperweight #5193BL, Blue Satin, 5" tall 3" wide, Circa 1972, **$35.00**

Fawn #5160, 3.5" tall 3.5" long.
Left: Holiday DQ, Crystal, has a cloth scarf, Circa 1992, **$20.00**
Right: Winter NX, Opal Satin, hand painted accents & a cloth bow, Circa 1984, **$28.00**

56 Fenton Art Glass

Goldfish #5276 (designed by Jon Saffell), Burmese Satin BR, 3.75" tall 5" long, Circa 2002, **$35.00**

Sun Fish #5167, 2.75" tall 2.75" long.
Left: Red Carnival RN, Circa 2000, **$30.00**
Left center: Burmese Satin BR on bust off base (from Fenton Gift Shop NIL), 4.3" tall 2.75" long, Circa 1981-1984, **$65.00**
Right center: Misty Blue Iridized LR, Circa 1999, **$30.00**
Right: Pink Chiffon Iridized XT, Circa 2001, **$27.50**

Fish - Freehand (designed by Dave Fetty), Gray Slag, 4.75" tall 10.25" long, Circa 1999, **$375.00**

Frog #5166, 2.25" tall 4" wide.
Left: Daisies on Cameo CD, Circa 1979-1980, **$45.00**
Center: Blue Roses on Blue Satin BL, Circa 1979-1980, **$45.00**
Right: Daisies on Custard DC, Circa 1979-1980, **$45.00**

Sunfish #306, 2.75" tall 2.6" long, Circa 1933-1936.
Left: Green Satin, **$60.00**
Right: Crystal Satin, **$50.00**

Frog #5274 (designed by Jon Saffell), 2.4" tall 3.25" long, Circa 2001.
Left: Crystal Iridized hand painted flowers, **$28.00**
Right: Willow Green GY, **$18.00**

Fenton Art Glass 57

Frog #5274 (designed by Jon Saffell), 2.4" tall 3.25" long, Circa 2002.
Left: Blue Topaz BY, **$18.00**
Right: Violet OE, **$18.00**

Flower Girl #5228 (from Fenton Gift Shop NIL), hand painted Pearlized Opal, 6.75" tall 4" wide, Circa 1996, **$68.00**

Little Girl #5328OE (designed by Jon Saffell), Violet Satin (from Fenton Gift Shop NIL), 6.8" tall 3" wide, Circa 2000, **$35.00**

Fox #5226BR on bust off base (from Fenton Gift Shop NIL), Burmese Satin, 7.75" tall 3.5" wide at base, Circa 1994, **$65.00**

Flower Girl #5228, 6.75" tall 4" wide.
Top left: Celeste Blue/Milk Glass Slag KR/MQ (from Fenton Gift Shop NIL), Circa 1995, **$85.00**
Top right: Petal Pink Iridized HZ (from Fenton Gift Shop NIL), Circa 1991, **$45.00**
Bottom left: Cobalt Carnival K1 (made for QVC), Circa 1997, **$45.00**
Bottom center: Tea Rose WB, Circa 1996, **$60.00**
Bottom right: Teal Royale OC (hand painted for Gracious Touch for a Hostess gift NIL), Circa 1990, **$55.00**

Fox #5226, 4.4" tall 3.5" wide.
Left: Autumn Leaves AW, Black hand painted, Circa 1994, **$45.00**
Right: Crystal CY (from Fenton Gift Shop NIL), Circa 1994, **$25.00**

Southern Belle #5141BQ, hand painted Burmese Satin, 8" tall 5" wide, limited edition #841 of 2,000 made, Circa 1997, **$75.00**

Southern Belle #5141, 8" tall 5" wide.
Left: Rosalene RE (from Fenton Gift Shop NIL), Circa 1994, **$85.00**
Center: Crystal Iridized WH (from Fenton Gift Shop NIL), Circa 1994, **$50.00**
Right: Persian Pearl (from Fenton Gift Shop NIL), Circa 1994, **$60.00**
The hand painted versions were made into bells as a limited edition exclusive for Mary Walrath.

Little Girl #5328 (designed by Jon Saffell), 6.8" tall 3" wide.
Left: Blue Topaz SY (from Fenton Gift Shop NIL), Circa 2001, **$30.00**
Right: Violet Satin XP (Show case dealer exclusive piece), hand painted floral, Circa 1999, **$50.00**

Left: Kissing Boy #5101YL, Candleglow Yellow, 4.5" tall 1.75" wide, Circa 1983-1984, **$45.00**
Right: Kissing Girl #5101YL, Candleglow Yellow, 4.6" tall 1.75" wide, Circa 1983-1984, **$45.00**

Left: Praying Boy (old style) #5100BK, Black, 3.75" tall 1.8" long, Circa 1973, **$45.00**
Right: Praying Girl (old style) #5100JA, Jade, 3.75" tall 1.8" long, Circa 1980, **$45.00**

Left: Kissing Girl #5101QX, Roses on Rosalene (hand painted for QVC), 4.6" tall 1.75" wide, Circa 1992, **$55.00**
Right: Kissing Boy #5101QX, Roses on Rosalene (hand painted for QVC), 4.5" tall 1.75" wide, Circa 1992, **$55.00**

Fenton Art Glass 59

Praying Boy and Praying Girl (old style) #5100, 3.75" tall 1.8" long.
Top left: White Satin WS, Circa 1978-1981, **$60.00 pr**
Top right: Custard Satin CU, Circa 1978-1981, **$70.00 pr**
Bottom left: Lime Sherbet Satin LM, Circa 1978-1980, **$65.00 pr**
Bottom center: Purple Carnival CN, Circa 1978, **$85.00 pr**
Bottom right: Blue Satin BA, Circa 1978-1982, **$75.00 pr**

Luv Bug #5149, 3" tall 1.9" wide.
Left: Opal Satin (from Fenton Gift Shop NIL), Circa 1999, **$20.00**
Center: Crystal CY (Original offering, came with it's own special box), Circa 1985, **$35.00 ($45.00 with box)**
Right: Topaz Opalescent TO (made for Rosso), Circa 1999, **$30.00**

Mouse #5148 on bust off base (from Fenton special glass room at the FAGCA convention NIL), Opal Gloss, 5.5" tall 3.75" wide, Circa 1990, **$50.00**

Left: Praying Boy #5272RE (new style redesigned by Jon Saffell), Rosalene (from Fenton Gift Shop NIL), 3.75" tall, Circa 1999, **$45.00**
Right: Praying Girl #5272RE (new style redesigned by Jon Saffell), Rosalene (from Fenton Gift Shop NIL), 3.75" tall, Circa 1999, **$45.00**

Lion #5241, 2.8" tall 5" long.
Top: Black (from Fenton Gift Shop NIL), Circa 1990, **$35.00**
Bottom left: Red Carnival RN, Circa 1990, **$40.00**
Bottom right: Blue Royale KK, Circa 1990, **$30.00**

Mouse #5148, 2.85" tall 2.75" wide.
Top left: Natural Brown NJ, Circa 1985-1988, **$75.00**
Top center: Opal Satin (unauthorized decoration from Martin House NIL), Circa 1990, **$48.00**
Top right: Happy Santa NS, Circa 1990, **$60.00**
Bottom left: Morning Glories on Sea Mist Green L3, Circa 1997, **$35.00**
Bottom left center: Blue Burmese UY (from Fenton Gift Shop NIL), Circa 2000, **$50.00**
Bottom right center: True Blue IK, Circa 1985-1986, **$45.00**
Bottom right: Red Slag RX, Circa 1984, **$75.00**

Mouse #5148, 2.85" tall 2.75" wide.
Top left: Natural Gray NG, Circa 1984-1989, **$60.00**
Top center: Rosalene RE (from Fenton Gift Shop NIL), Circa 1992, **$38.00**
Top right: Boutonniere WI for January, Circa 1998-1999, **$25.00**
Bottom left: Violet OE, Circa 2000-2001, **$25.00**
Bottom left center: Topaz Iridescent TS (from Fenton Gift Shop NIL), Circa 2001, **$30.00**
Bottom right center: Roses on Burmese BR (from Fenton Gift Shop NIL), hand painted, Circa 1992, **$48.00**
Bottom right: Black Satin BK (from Fenton Gift Shop NIL), Circa 2001,

Nativity set, 1st edition of Angel & Animals #5050NA (designed by Jon Saffell), Circa 1999.
Left: Donkey, Opal Satin hand painted, 3.35" tall 4.4" long
Center: Angel, Opal Satin hand painted, 6.8" tall 4.25" wide
Right: Camel, Opal Satin hand painted, 3.5" tall 5" long, **3 piece set price $145.00**

Nativity set, 1st edition of Holy family #5280NF (designed by Jon Saffell), Circa 1997.
Left: Mary, Opal Satin hand painted, 4.8" tall 1.75" wide
Center: Baby Jesus, Opal Satin hand painted, 1.6" tall 2.5" long
Right: Joseph, Opal Satin hand painted, 6.15" tall 2.25" wide, **3 piece set price $125.00**

Nativity set, 1st edition of Shepherds #5055NS (designed by Jon Saffell), Circa 2000.
Left: Shepherd boy holding lamb, Opal Satin hand painted, 4.25" tall 2.25" wide
Center: Lamb, Opal Satin hand painted, 2.6" tall 2.25" long
Right: Shepherd with staff, Opal Satin hand painted, 6.75" tall 2.25" wide, **$135.00 set** (three piece)

Nativity set, 1st edition of Three Wise Men #5289WM (designed by Jon Saffell), Circa 1998.
Left: Balthazar, Opal Satin hand painted, 6.25" tall 2.25" wide
Center: Melchcor, Opal Satin hand painted, 5.1" tall 2.5" wide
Right: Gaspar, Opal Satin hand painted, 6.75" tall 2.25" wide, **3 piece set price $155.00**

Nativity set #5070NV (designed by Jon Saffell), Christmas Star, Circa 2001, set price **$125.00**
Left: Mary, 6.75" tall 3.5" wide
Center: Baby Jesus, 2.25" tall 3.5" long
Right: Joseph, 7.3" tall 3.4" wide

Fenton Art Glass 61

Owl fairy light #5108, 3.75" tall 3.1" wide.
Top: Crystal Velvet VE, Circa 1979-1989, **$35.00**
Bottom left: Blue Satin BA, Circa 1975-1979, **$45.00**
Bottom right: Lime Sherbet Satin LS, Circa 1979, **$38.00**
Note: Metal insert fits in bottom to hold candle.

Owl #5168, 3" tall 2.5" wide.
Left: Topaz Opalescent TO (made for Rosso), Circa 1998, **$25.00**
Right: Crystal Velvet VE, Circa 1980-1984, **$30.00**

Owl - Decision Maker #5180BK, Black, 3.75" tall 3" wide, Circa 1969-1972, **$48.00**
Note: This piece came with a plastic label around the top rim of the base that read, "Yes, No, Whoo knows, Let George do it." When you spun the owl's head, the beak would stop at your answer.

Owl #5168PK, Peking Blue, 3" tall 2.5" wide, Circa 1980, **$35.00**

Owl #5178PK, Pink Carnival, 6.5" tall 4.5" wide, made from old U.S. Glass mould, made for Levay and numbered edition, Circa 1981, **$95.00**

Owl - Decision Maker #5180BK, Black, 3.75" tall 3" wide, Circa 1969-1972, **$48.00**
Shown apart to illustrate the difference between the fairy light. The top of the owl does not have a hole like the fairy light and it sits on top of the center point of the bottom.

Fenton Art Glass

Owl #5178CC, Country Cranberry, 6.5" tall 4.5" wide, made from old U.S. Glass mould, Circa 1982, **$125.00**

Peacock - bookends #711, Rose Satin, 6" tall, 5.75' wide, 1935, **$700.00** pair

Owl #5258PX, Plum Carnival (from Fenton Gift Shop NIL), 5.5" tall 3" wide, Circa 1998, **$85.00**

Penguin - Frosty Friends "Jasper" #5267DD (designed by Jon Saffell), hand painted on Opal Satin, 4.25" tall 2.5" wide, Circa 2000-2001, **$35.00**

Owl ring tree #9299, 4.5" tall 3" wide.
Left: Dusty Rose DK, Circa 1984, **$15.00**
Center left: Crystal Velvet VE, Circa 1980, **$24.00**
Center right: Purple Carnival CN, Circa 1973, **$30.00**
Right: Custard CU, Circa 1973, **$15.00**

Penguin #5267 (designed by Jon Saffell), 4.25" tall 2.5" wide, **Left to right**:
1. Favrene 8L, QVC item - hand painted, Circa 2001, **$65.00**
2. Crystal Iridized with snow (from Fenton Gift Shop NIL), Circa 2000, **$35.00**
3. Magnolia Holiday - hand painted ST, Circa 2000, **$28.00**
4. Frosty Friends, "Sunny" DB, hand painted on Opal Satin, Circa 2001, **$35.00**

Fenton Art Glass 63

Pig #5220RC, Damask Rose on Red Carnival, 2.5" tall 3" long, Circa 1996, **$40.00**

Rabbit - Mini Bunny #5209LE (designed by Jon Saffell), Sea Mist Green, 1.25" tall 2" long, Circa 1996, **$10.00**

Pig #5220, 2.5" tall 3" long.
Top left: Heav'n N Nature Sing ZD, Circa 1985-1986, **$35.00**
Top right: Pearly Sentiments PT, Circa 1988, **$25.00**
Bottom left: True Blue IK, Circa 1985-1986, **$45.00**
Bottom center: Sea Mist Green LE, Circa 1997, **$20.00**
Bottom right: Red Carnival RN, Circa 1996, **$35.00**

Rabbit - Bunny #5262 (designed by Jon Saffell), 2.75" tall 2.25" wide, Circa 2001
Left: Violet OE (from Fenton Gift Shop NIL), **$12.00**
Right: Ice Blue L9 (from Fenton Gift Shop NIL), **$12.00**

Rabbit - Bunny #5162, 3.25" tall 3" long.
Left: Twilight Blue TB, Circa 1994, **$35.00**
Center: Spring Splendor on Chiffon Pink X9 (Note, this diachromatic color is really pink and not the blue that it appears to be), Circa 2001, **$60.00**
Right: Topaz Opalescent TO (made for Rosso), Circa 1998, **$30.00**

Rabbit - Bunny #5262 (designed by Jon Saffell), wax (used to test the mould, after which the design was changed) figure, 2.75" tall 2.25" long, Circa 2001, No established value because this piece was never made in glass and is shown just to show the progression a mould sometimes takes.

64 Fenton Art Glass

Rabbit #5275SY, Blue Topaz (from Fenton Gift Shop NIL), 2.75" tall 1.75" wide, Circa 2001, **$9.00**

Raccoon #5142, 3.5" tall 2.75" wide.
Left: Raspberry - name given to dark Rosalene (from Fenton Gift Shop NIL), Circa 1994, **$60.00**
Center: Opal Satin (from Fenton Gift Shop NIL), hand painted brown, Circa 1990, **$65.00**
Right: Topaz Opalescent TO (made for Rosso), Circa 1998, **$30.00**

Rabbit (former U.S. Glass mould) #5174GN, Springtime Green Carnival, 5.6" tall 5" long, made for Levay and numbered edition of 276 pieces, Circa 1977, **$90.00**

Left: Reindeer #5261FE (designed by Jon Saffell) Woodland Frost, Crystal Iridized hand painted & brass antlers, 7.5" tall 6.25" long, Circa 2000, **$89.50**
Production problems caused the reindeer not to be offered in 2001.
Right: Sleigh #4695SO, Spruce Green & brass runners, 4.75" tall 7.75" long, Circa 2000, **$59.50**

Rabbit - egg holder #6883Q1, hand painted Folk Art on Opal Satin, 3.25" tall 2.1" wide, Circa 2000, **$25.00**

Rocking Horse #5135VJ, 2.8" tall 2.9" long,
Top: Victorian Roses, Circa 1987-1988, **$35.00**
Bottom Left: Opal Satin with blue, Circa 2001, **$35.00**
Bottom Right: Opal Satin with pink, Circa 2001, **$35.00**

Fenton Art Glass 65

Santa - holding kitten #5249 (designed by Jon Saffell), 8.4" tall 4.25" wide.
Left: Burmese Satin BR (from Fenton Gift Shop NIL), hand painted, Circa 1998, **$120.00**
Center: Tyrolean VD, Opal Satin, hand painted, Circa 2000, **$85.00**
Right: Olde World, Opal Satin (from Fenton Gift Shop NIL). Hand painted very similar to the inline Patriotic Santa VP. This one has a green shirt instead of blue and has gold trees on his red coat. Circa 1998, **$125.00**

Santa #5299 (designed by Jon Saffell) holding list, 7.9" tall 3.8" wide.
Left: Burmese Gloss BE, Circa 1997, **$45.00**
Center: Burmese Satin BR, Circa 1997, **$50.00**
Right: Burmese Satin hand painted with roses on coat (QVC item, signed by Bill Fenton), Circa 1997, **$75.00**

Santa - Fairy Light #5106CG (old style), Colonial Green, 5.4" tall 2.9" wide, Circa 1970-76, **$50.00**

Santa - kneeling by bag #5279 (designed by Jon Saffell), 6.75" tall 4.75" wide.
Left: Americana VH, Opal Satin, hand painted, Circa 2000, **$85.00**
Center: Enchantment JM, Opal Satin, hand painted, Circa 1999, **$85.00**
Right: Northwood's XA, Opal Satin, hand painted, Circa 2001, **$90.00**

Santa #5299 (designed by Jon Saffell) holding list, 7.9" tall 3.8" wide.
Left: Northern Lights VL, Opal Satin hand painted with trees on blue coat, Circa 1998, **$85.00**
Center: Poinsettia Glow P7, Opal Satin hand painted with Poinsettias, Circa 1996, **$85.00**
Right: Olde World Santa I2, Opal Satin hand painted with holly on red coat, Circa 1997, **$75.00**

Santa - Fairy Light #5106, Note, old style is shorter and has a smaller top opening and flat edge on the bottom that the top fits into (top has extra rim to catch on the bottom). The new style has the sculptured base that the top fits into.
Top left: Milk Glass MI (old style), 5.4" tall 2.9" wide, Circa 1977, **$38.00**
Top right: Holly Berry HL (new style) hand painted on Opal Satin, 5.6" tall 3" wide, Circa 1988, **$75.00**
Bottom left: Ruby RU (old style), 5.4" tall 2.9" wide, Circa 1977, **$65.00**
Bottom right: Lime Sherbet Satin LS (new style), 5.6" tall 3" wide, Circa 1979, **$50.00**

66 Fenton Art Glass

September Morn - Nymph #1645, Ruby, Circa 1933-1936, **$350.00**
Left: flower frog, 1.5" tall 2.75" wide
Right: Nymph, 6.25" tall 1" wide
Chabas, a French artist had his September Morn painting, a nude woman wading in a lake, brought to the United States in the late teens. Someone at Fenton was inspired to make a likeness of this girl in the lake. The September Morn is first listed on the 1930 inventory records and later the figures were offered in the Kresge Stores.

September Morn - Nymph #1645, **Left to right:**
1. Celeste Blue KA, 6.5" tall (3.1" wide at base of clear flower block), Circa 1995, **$85.00** (originally came with Celeste Blue cupped in bowl & cobalt 5 leg base 4 piece set price **$145.00**)
2. Topaz TO, 6.5" tall (3.1" wide at base of Topaz flower block), made for the Kansas City Gala, (came in cupped in bowl) Circa 2001, **$125.00**
3. Rosalene RE, 6.5" tall (3.5" wide at base of Milk Glass flower block), made for the Fenton Art Glass Collectors Association, Circa 1990, **$95.00**

September Morn - Nymph #1645, Crystal, 7" tall 7.25" wide, Circa 1933-1936, **$165.00** Shown in #1932 three footed crimped bowl.

Snail #5134, 2.75" tall 4.25" long.
Left: Burmese Satin BR (from Fenton Gift Shop NIL), Circa 1993, **$45.00**
Right: Rosalene RE (from Fenton Gift Shop NIL), Circa 1993, **$40.00**

September Morn - Nymph #1645, 7" tall 2.75" wide (at base of flower block), Circa 1933-1936.
Left to right: Rose **$195.00**, Dark Green **$225.00**, Black **$300.00**, Jade **$275.00**, Ivory **$225.00**, Light Green **$195.00**, Cobalt **$350.00**

Left: Snowlady "Star", Frosty Friends, #5269DB, hand painted on Opal Satin, 3.9" tall 2.25" wide, Circa 2001, **$32.50**
Left center: Snowman "Sky", Frosty Friends, #5268DB, hand painted on Opal Satin, 4" tall 2.15" wide, Circa 2001, **$32.50**
Right center: Snowman "Jolly", Frosty Friends, #5268DA, hand painted on Opal Satin, Circa 2000-01, **$30.00**
Right: Snowlady "Joy", Frosty Friends, #5269DH, hand painted on Opal Satin, Circa 2000-01, **$30.00**
Both Snowman and Snowlady were designed by Jon Saffell.

Fenton Art Glass 67

Snowlady #5269 (designed by Jon Saffell), 3.9" tall 2.25" wide.
Left: Opal Satin (from Fenton Gift Shop NIL), hand painted green hat & cape, Circa 2000, **$65.00**
Right: Opal Satin (from Fenton Gift Shop NIL), hand painted purple hat & yellow cape, Circa 2000, **$65.00**

Swan #5161RC, Roses on Custard, 4" tall 4" long, Circa 1978-1981, **$40.00**

Squirrel #5215, 2.75" tall 2.75" long.
Left: Natural Gray NP, Circa 1986-1987, **$50.00**
Center: Meadow Blooms JU on Opal Satin, Circa 1986-1987, **$45.00**
Right: Natural Brown QN, Circa 1987-1988, **$60.00**

Swan #5161, 4" tall 4" long.
Left: Swan, Lavender Satin LN, 4" tall 4" long, Circa 1978, **$38.00**
Right: Swan, Crystal Velvet VE, 4" tall 4" long, Circa 1978-1988, **$30.00**

Squirrel #5215, 2.75" tall 2.75" long.
Left: Burmese Satin hand painted (from Fenton Gift Shop NIL), Circa 1999, **$50.00**
Center: Burmese Satin BR (from Fenton Gift Shop NIL), Circa 1999, **$40.00**
Right: Burmese Iridized (from Fenton Gift Shop NIL), Circa 1999, **$30.00**

Swan #5161, 4" tall 4" long.
Top: Topaz Opalescent TO (made for Rosso), Circa 1998, **$30.00**
Bottom left: Blue Roses on Blue Satin BL, Circa 1978-1982, **$45.00**
Bottom right: Pearlized Milk Glass, hand painted Enduring Love - 40th Anniversary ZT, Circa 1992, **$18.00**

68 Fenton Art Glass

Swan - pulling a shell (master salt dip), Red Carnival RN, 2.6" tall 4.5" long, Circa 1981, embossed on bottom (capital B and a line with 1 dot above & 2 dots below). This is a copy of an old carnival glass piece. The original was done in Marigold Carnival and has a hollow base, while this one has a solid base. **$30.00**

Left: Tree - Christmas #5557C9, Crystal Iridized with metal bear & white frit decoration, 3" tall 2" wide, Circa 2001, **$15.00**
Center: Christmas Tree #5535ZB, Red with metal squirrel & white frit decoration, 6.25" tall 4" wide, Circa 1998, **$28.50**
Right: Christmas Tree #5556CT, Green with metal bear & white frit decoration, 4" tall 2.5" wide, Circa 2001, **$19.50**

Swan, Blue Carnival, 3.8" tall 4.75" long, **$35.00**

Trees - Christmas, Burmese Satin (from Fenton Gift Shop NIL), Circa 1999.
Left: Small tree #5557BR, 3" tall 2" wide, **$10.00**
Center: Large tree #5535BR, 6.25" tall 4" wide, **$20.00**
Right: Medium tree #5556BR, 4" tall 2.5" wide, **$15.00**

Tree - Christmas, Green Slag (from Fenton Gift Shop NIL), 5.8" tall 4" wide, Circa 1999, **$65.00**

Turtle - flower frog (former Northwood mould) #1564, Topaz, 1.25" tall 4" long, Circa 1926-1929, **$65.00**
Note, after Northwood closed Fenton Art Glass company purchased this mould and made it in several colors. Fenton made one change to the mould, adding two holes to the six existing holes found on the original Northwood turtle.

Fenton Art Glass 69

Turtle #5266 (designed by Jon Saffell), Black resin (used to test the mould) figure, 1.75" tall 4" long, Circa 2001, **No established value**

Turtle - ring tree #9199CA, Colonial Amber, 4" tall 3.5" long, Circa 1967-1968, **$28.00**

Turtle #5266 (designed by Jon Saffell), 1.75" tall 4" long.
Top: Crystal Iridized FM (from Fenton Gift Shop NIL), Circa 2001, **$25.00**
Bottom: Willow Green GY (from Fenton Gift Shop NIL), Circa 2001, **$25.00**

Turtle - ring tree #9199CB, Colonial Blue, 4" tall 3.5" long, Circa 1973-1976, **$35.00**

Turtle #5266 (designed by Jon Saffell), 1.75" tall 4" long.
Left: Blue Topaz XJ, hand painted with small white flowers, Circa 2002, **$20.00**
Right: Willow Green I3, hand painted with small white flowers, Circa 2002, **$20.00**

Turtle #5164VE (mould changed to remove ring tree), Crystal Velvet, 1.5" tall 3.5" long, Circa 1984, **$28.00**

70 Fenton Art Glass

Unicorn #5253BK (from Fenton Gift Shop NIL), Black, 5.1" tall 3.25" long, Circa 1994, **$30.00**

Whale #5152, 2" tall 5" long.
Top: Crystal CY, Circa 1984-1986, **$20.00**
Bottom: Rosalene RE (from Fenton Gift Shop NIL), Circa 1992, **$35.00**

Viking Ship #7677PX, Plum Carnival, 5.75" tall 13.5" long, Circa 1998, **$50.00**

These animals have been produced by Fenton for the PNWFA (Pacific Northwest Fenton Association) for their special annual subscription glass piece. They are made in limited number for each subscriber of the previous year. The first one was for 1994.

Top row left to right:
1. Cat #5165, Black hand painted with white umbrella, 3.75" tall 2.75" long, Circa 1994, **$85.00**
2. Puppy #5225 (old style), Opal Satin hand painted with black spots, 3.3" tall 4" long, Circa 1995, **$85.00**
3. Bear #5151, Ivory Satin hand painted with pink & gold flowers, 3.5" tall 2.25" wide, Circa 1996, **$60.00**
4. Mouse #5148, Opal Satin hand painted with yellow pine cone, 3" tall 2.9" wide, Circa 1997, **$50.00**
Bottom row left to right:
1. Squirrel #5215, Opal Satin hand painted brown & holding an acorn, 2.75" tall 2.5" long, Circa 1998, **$45.00**
2. Lady Bug (Fenton called this mould the Luv Bug), Opal Satin hand painted black with spots on back & holding red heart, Circa 1999, **$28.00**
3. Bunny #5162, Opal Satin hand painted with pink blush, 3.25" tall 3" long, Circa 2000, **$45.00**
4. Duckling #5169, Topaz Opalescent hand painted bee on head & frit trim, 3.5" tall 2.25" long, Circa 2001, **$30.00**

Fostoria Glass Company 1887-1981

Lucien Martin and W.S. Brady founded the Fostoria Glass Company in Fostoria, Ohio, in 1887. Four years later, their cheap gas supply disappeared and the factory was moved to Moundsville, West Virginia, where their investors lived.

W. Dalzell came to Fostoria in 1901 after gaining experience at Dalzell Brothers and Gilmore & Findaly glass companies. A year later, he was selected to be the president of Fostoria Glass where he provided guiding strength for its growth. His right-hand man, Calvin Roe, became the company's president after Dalzell died in 1928. Both Dalzell and Roe steered the company well and developed their lines of colored tableware and etched patterns. Under Roe's guidance, most of the Fostoria glass animals were made. It is not known who designed them.

William Dalzell, the son of W. Dalzell, became Fostoria's president when Calvin Roe died in 1945. William oversaw dramatically increased sales, and production peaked in 1950. Also, he contracted with the Ann Donahue Studios of New York to design animals (Chanticleer and Seahorse) and figurines (Lute, Lotus, Buddha, Madonna, Mermaid, and St. Francis). In 1957, Jon Saffell came to work at Fostoria as a designer and created a number of their stemware patterns.

After William Dalzell retired, Robert Hannum became Fostoria's president in 1958. He was an excellent manager and dealt effectively with labor problems. Upon his death in 1968, David Dalzell, the son of William Dalzell, became president and worked until Fostoria Glass closed in 1983.

During the 1970s, Fernando Alvarez designed a cat, a bird, and a whale. Also, someone at a Philadelphia school of art designed a stork and a rabbit for Fostoria. Jon Saffell also contributed to this small animal line with a frog and a ladybug. In 1979, Jon Saffell created a three-piece Nativity sculpture. His animal-head ashtrays of a lion, a ram, and a dog were created in 1980. During this time, Fostoria created pieces for Avon, but it is not known who designed them.

The high costs involved in the labor-intensive etched tableware production and direct competition from European glassmakers led to the closure of Fostoria Glass in 1991. The company was sold to Lancaster Colony.

Bear - Polar Bear #2531, Crystal, 4.6" tall 4" long, Circa 1935-1944, **$85.00**
Not pictured - Silver Mist, Circa 1936-1943, $75.00
Topaz, Circa 1935-1936 or Gold Tint, Circa 1936-1939, $125.00

Chicken - Chanticleer Rooster #2629, Crystal, 10.75" tall 8.25" long, Circa 1950-1958, **$275.00**
Not pictured - Ebony, Circa 1954-1957, $600.00
Milk Glass (Trial run in 1950s, a worker related that the tail would break off when trying to remove from the mould - Rare item)

Chinese - bookend #2626, Ebony with gold accents, 7.25" tall 6.75" wide, Circa 1957, **$375.00**

Animal head ashtrays (designed by Jon Saffell)
Left: Ram, Crystal, **$45.00**
Center: Lion, Crystal, **$45.00**
Right: Dog, Crystal, **$45.00**

72 Fostoria Glass

Chinese Lute (Lady) #2626, Ebony with gold accents, 12.25" tall 3.5" wide, Circa 1957, **$450.00**
Not pictured - Silver Mist, Circa 1956-1963, $175.00

Deer Standing #2589, Crystal, 4.25" tall 2.1" long, Circa 1940-1943, **$35.00**
Not pictured - Silver Mist, Circa 1940-1943, $35.00
Milk Glass, Circa 1954-1958, $40.00

Deer, reclining #2589 1/2, Milk Glass, 2.4" tall 2" long Circa 1954-1958, **$30.00**
Not pictured - Crystal or Silver Mist, Circa 1940-1943, $30.00

Left: Duck - Mama #2632/404, Transparent Blue, 4.25" tall, Circa 1965-1970, **$45.00**
Not pictured: Amber, Amber Mist, Olive Green, Olive Mist, Circa 1965-1973, $35.00
Center left: Duckling "A" head back #2632/405, Transparent Blue, 2.5" tall, Circa 1965-1970, **$28.00**
Not pictured: Amber, Amber Mist, Olive Green, Olive Mist, Circa 1965-1973, $24.00
Center right: Duckling "B" walking #2632/406, Transparent Blue, 2.4" tall, Circa 1965-1970, **$28.00**
Not pictured: Amber, Amber Mist, Olive Green, Olive Mist, Circa 1965-1973, $24.00
Right: Duckling "C" head down #2632/407, Transparent Blue, 1.5" tall, Circa 1965-1970, **$28.00**
Not pictured: Amber, Amber Mist, Olive Green, Olive Mist, Circa 1965-1973, $24.00

Eagle - bookends #2585, Crystal, 7.5" tall 4.5" wide, Circa 1940-1943, **$195.00** pair

Elephant - bookend #2580, 6.25" tall 7.5" long.
Left: Ebony, Circa 1980, **$175.00** each
Right: Crystal, Circa 1940-1943, **$125.00** each

Fostoria Glass 73

Left: Fish - Gold Fish "B" with tail up (vertical) #2633, Crystal, 3.5" tall 2.5" long, Circa 1950-1957, **$175.00**
Right: Fish - Gold Fish "A" (horizontal) #2633, Crystal, 1.25" tall 4.1" long, Circa 1950-1957, **$100.00**

Horse - Colt, reclining #2589 1/2, Silver Mist, 2.4" tall 2.75" long, Circa 1940-1943, **$30.00**
Not pictured - Crystal, Circa 1936-1943, $30.00
Milk Glass, Circa 1954-1958, $35.00

Left: Fish - flying, vase #2497/787, Teal Green, 6" tall 3.25" long, Circa 1934-1940 (Seafood Cocktail swung out to form a vase), **$45.00**
Right: Fish creamer #2497 1/4, Burgundy, 3.25" tall 5" long, Circa 1934-1940, **$35.00**

Horse - Colt, standing #2589, Crystal, 4" tall 4.25" long, Circa 1940-1943, **$35.00**

Frog #2821/420, Topaz Mist, 1.75" tall 3.5" long, circa 1971-73, **$45.00**

Horse - bookend #2564, Silver Mist, 5.75" tall 7.6" long, Circa 1939-1943, **$75.00** each

74 Fostoria Glass

Lyre - bookend #2601, Crystal, 7.5" tall 5.5" wide, Circa 1941-1958, **$75.00** each

Lyre - candlestick #2601, Crystal, 8" tall 5.5" wide, Circa 1941-1958, **$195.00** pair

Madonna #2635, Silver Mist, 10" tall, Ebony Satin glass base (lighted), 1.8" tall 3.75" wide, overall height 11.6", Circa 1967-1973, **$150.00**
Not pictured - Crystal with Ebony base, Circa 1967-1973, $150.00
Crystal or Silver Mist without Ebony base, $85.00

Madonna, Silver Mist, 4.1" tall 1" wide at base, sold through Fostoria outlet stores Circa 1970s, **$18.00**

Mermaid #2634, Crystal, 10.25" tall 5" long, Circa 1950-1958, **$175.00**
Shown - front view.

Nativity Sculpture - The Magi (designed by Jon Saffell), Crystal, Circa 1980, **$250**
Also made were the Holy Family (1979) and Shepherds (1981).

Fostoria Glass 75

Owl #2821/527, Blue Mist, 2.75" tall 3.25" wide, Circa 1971-1973, **$35.00**

Rabbit - Baby #2821/627, Amber Mist, 1.25" tall 3" long, Circa 1971-1973.
$45.00
Not pictured - Crystal, Silver Mist, Copper Blue Mist, Olive Green Mist, Circa 1971-1973, $45.00 each

Pelican #2531, Crystal, 3.9" tall 4.25" wide, Circa 1935-1943,
$95.00
Not pictured - Crystal, Circa 1935-1943 or Silver Mist, Circa 1936-1943, $65.00
Topaz, Circa 1935-1936 or Gold Tint, Circa 1936-1939, $95.00

Saint Francis, Silver Mist, 13.25" tall 3.6" wide, Circa 1957-1973, **$325.00**

"Rebecca at the Well" comport, Olive Green Mist, 12.75" tall 10.4" wide, made for the Henry Ford Museum (marked HFM), Circa 1965-1970.
$95.00
Not pictured - Silver Mist, Circa 1965-1970, $125.00
Copper Blue Mist, Circa 1965-1970, $195.00

Penguin #2531, Crystal, 4.6" tall 1.8" wide, Circa 1935-1943.
$75.00
Not pictured - Silver Mist, Circa 1936-1943, $65.00
Topaz, Circa 1935-1936 or Gold Tint, Circa 1936-1939, $95.00

76 Fostoria Glass

hand painted red trim, 9" tall 7" wide, Circa 1955 (made for 6 month only), **$350.00+**

Left: Squirrel "A" (sitting) #2631/702A, Amber Mist, 3.25" tall 2.5" long, Circa 1964-1973, **$35.00**
Right: Squirrel "B" (running) #2631/702B, Amber Mist, 2.5" tall 4" long Circa 1964-1973, **$35.00**

Seal #2531, Topaz, 3.75" tall 3.75" wide, Circa 1935-1936, **$125.00**
Not pictured - Gold Tint, Circa 1936-1939, $125.00
Crystal or Silver Mist, Circa 1936-1943, $75.00

Swans - Non production items (not sold to the public). Workers made them during lunch breaks. Fostoria's policy allowed them to experiment with this type of item until 1972.
Top: Swan free hand, Milk Glass, 2.25" tall 2.75" long, Circa 1972, **$45.00**
Center: Swan free hand, Blue, 5.25" tall 10" long, Circa 1920s, **$95.00**
Center: Swan free hand, Topaz & Clear, 5.25" tall 8.25" long, Circa 1940-50s, **$85.00**
Bottom: Swan free hand, Carnival, 10.25" tall 9.75" long, Circa 1960-70s, **$125.00**

Sleigh #2595, Circa 1980-1982.
Left: Red, 2" tall 4.25" long, **$38.00**
Right: Light Blue, 3" tall 6.1" long, **$45.00**

Fostoria Glass 77

Pelican #2531, Amber, 3.9" tall 4.25" wide, made for Fostoria Glass Society of America (Note, not marked), Circa 1987, **$50.00**

Turtle - candle holder, Crystal, 2.25" tall 4.5" long, made for Avon, Circa 1977-1978, **$12.00**

Pelican #2531, Raspberry Ice, 3.9" tall 4.25" wide, made for Fostoria Glass Society of America (Note, marked FGSA 92), Circa 1992, **$55.00**
Not pictured - Opal, Circa 1988, $45.00
Cobalt, Circa 1989, $85.00
Green, Circa 1990, $50.00
Pink, Circa 1991, $50.00

Top: Dove in Flight candle holder, Crystal, 2.75" tall 4" wide, made for Avon, Circa 1977-1978, **$10.00**
Bottom left: Chipmunk candle holder, Crystal, 3.25" tall 4.5" wide, made for Avon, Circa 1978-1979, **$12.00**
Bottom right: Shimmering Peacock candle holder, Crystal, 3.25" tall 4" wide, made for Avon, Circa 1979-1980, **$12.00**

Gibson Glass Company 1985-Present

Prior to starting Gibson Glass in 1985 in Milton, West Virginia, Charlie Gibson had gained experience in glassmaking at Bischoff Glass and Joe St. Clair Glass companies. His company specializes in paperweights and makes baskets, cruets, and some figurines. Much of the Gibson glass is hand-blown. Gibson Glass also buys shards (broken scrap glass) from the Fenton Art Glass Company and re-melts it for use in their moulds.

Left: Fish - free hand, Topaz Iridized, 6" tall 8.5" long, Circa 1990s, **$95.00**
Right: Fish - free hand, Blue Burmese Iridized, 5.75" tall 7.5" long, Circa 1990s, **$125.00**

Squirrel, Cobalt Carnival, 3" tall 3.1 long, Circa 1990s, **$18.00**

Burmese hand made paperweights.
Left: Pear with leaf, Burmese Gloss, 4.75" tall 2.8" wide, Circa 1990s, **$35.00**
Right: Apple with leaf, Burmese Satin, 4" tall 3.1" wide, Circa 1990s, **$30.00**

Gillinder & Sons Glass Company 1861-Present

William Gillinder and his family came to America in 1850 from England. After several failed attempts at starting a glass factory there, Gillinder succeeded in 1861 at Franklin Flint Glass Works in Philadelphia, Pennsylvania. His two sons joined him in 1863 when the company was renamed Gillinder & Sons. When William died in 1871, his sons gained control of the company.

At the 1876 Centennial Exposition in Philadelphia, Gillinder & Sons set up a working glass factory exhibition to show the public how their glass was made. The success of this demonstration was huge, and many of their novelty and giftware items were sold. Twenty-three years later, in 1899, the company repeated the demonstration at the National Export Exhibition.

When the last original Gillinder son died in 1906, the grandsons were operating the company. The original factory was sold in 1913 and the family moved to Port Jervis, New York, to occupy the Flint Glass Works facility and Gillinder & Sons was renamed Gillinder Brothers. Gradually the giftware line was phased out and commercial glassware became the mainstay of the company. They made airport runway lights, medical glass, and military lighting.

Today, Gillinder & Sons is still in the family, now in the hands of Charlie Gillinder and his sister, Susan. Runway and garden lights are still important products for them, and they returned to making giftware in 1970. Old moulds of the puppy, Buddha, peacock vase, and slippers were pulled out of storage to be used again. The new glass is marked Gillinder, in script. As time permits, they hope to expand their giftware line.

Gillinder Glass 79

Buddha, 5.75" tall.
Left: Orange, Circa 1930s, **$200.00**
Right: Dark Green, Circa 1930s, **$250.00**

Dog - Puppy, 5" tall 3.8 wide, Circa 1990s.
Left: Black Satin, **$40.00**
Right: Milk Glass Gloss, **$40.00**

Buddha, Blue Milk Glass, 5.75" tall, marked Gillinder Glass 2000, **$50.00**

Horse Head - bookend, 5.5" tall 4.75 long, Circa 1990s.
Left: Transparent Yellow, **$45.00** each
Right: Opaque Red, **$48.00** each

Mark on base of Buddha.

Lion on oval base, Crystal Satin, 2.75" tall 5.6" long, marked "Gillinder and Sons Centennial Exhibition", Circa 1876 **$95.00**

Left: Lion Head, Alexandrite Satin, 2.5" tall 2.4 wide, marked "Gillinder Glass", Circa 2000, **$18.00**
Right: Lion Head, Crystal Satin, 2.4" tall 2.4 wide, unmarked, Circa 1990s, **$18.00**

Shakespeare bust, Crystal, 5" tall 3.1" wide, embossed on back "Gillinder & Sons Centennial Exhibition, Circa 1876, **$450.00+**

Top left: Starfish, Pink, 2" wide, Circa 2000, **$8.00**
Top right: Seashell (round), Yellow, 1.75" wide, Circa 2000, **$8.00**
Bottom left: Seashell (oblong), Green, 2.1" long, Circa 2000, **$8.00**
Bottom right: Seashell (clam shape), Opaque Tan, 1.75" wide, Circa 2000, **$8.00**

Guernsey Glass Company 1967-Present

Harold Bennett spent most of his adult years in the grocery business. He became a collector of Cambridge Glass, acquiring over 5,000 pieces. He established a museum to house his glass and briefly worked for Cambridge, acquiring a few of their glass formulas.

In 1967, Harold Bennett and his two brothers founded Guernsey Glass Company in Cambridge, Ohio, near the Boyd Glass facility. For the first ten years, Bennett made his own glass and marked it with his trademark, a B inside a triangle. The B stands for the owners' name, Bennett. Bennett now contracts with Mosser Glass, also in Cambridge, Ohio, to make glass items for him with his moulds.

Elephant, 1.5" tall 2.25" long, Circa 1990s
Left: Alexandrite, **$9.50**
Right: Crown Tuscan, **$8.50**

Bridge Dog from Cambridge mold, Red, 1.75" tall 1.75" long, Circa 1980s, **$20.00**
Left: front view (marked with a B inside of a triangle)
Right: side view to show he was made to hold a short pencil in his mouth

Guernsey Glass & K.R. Haley 81

Horse - rocking "Rocky", marked with his name on the left runner, Red with Milk Glass, 3" tall 4.25" long, only a few were made in this two-tone color (marked with a B inside of a triangle), Circa 1981, **$48.00**

Lion, Alexandrite, 1.5" tall 1.75" long, marked with a B, Circa 1990s, **$8.00**

K.R. Haley Glassware 1939-1972

Kenneth Haley worked with his father, Reuben Haley, a designer at Consolidated Glass, from 1925 to 1928. While at Consolidated, Kenneth developed a great friendship with Walt Przybylik, his father's apprentice designer, who was close to his own age. After Reuben Haley's death, Walt and Kenneth continued to work on designs together for twenty years.

Kenneth worked at Phoenix Glass Company until 1934 when he moved to Greensburg, Pennsylvania, to work for the Overmeyer Mould company. In 1939 Haley established General Glassware Company to market his designs and

Bird on Stump, 6" tall 5.5" long.
Left: Crystal Satin with a light red wash (stain), Circa 1945-1960s, **$35.00**
Right: Crystal, Circa 1945-1960s, **$30.00**

three years later he became the vice-president. American Glass Company made the glassware that was sold under the General Glassware name. In the early 1940s, Kenneth Haley formed a new company, K.R. Haley Glassware. This company closed in 1972 when Kenneth retired. The animals shown here were created at General Glassware and/or K.R. Haley.

Chicken, Crystal, 7.75" tall 5.65" long, Circa 1940s, **$40.00**

K.R. Haley

Court Jester bookend (minstrel with banjo), Crystal, 6.75" tall 6" wide, Circa 1940s-1950s, **$68.00**

Dog - Boxer sitting up, Crystal, 4.75" tall 4.25" long, Circa 1939-1940s, **$60.00**

Angelfish, Crystal, 8" tall, 5.5" long, 1940s, **$60.00**

Deer - sitting fawn, Crystal Satin, 6.75" tall 5.5" long, Circa 1945-1960s, **$45.00**

Dog - Boxer laying down, Crystal, 3.5" tall 7.75" long, Circa 1939-1940s, **$60.00**

Horse & Rider - bookend, Crystal, 6" tall 6" wide, Circa 1940s, **$125.00** pair

Horse with Cart, Crystal, 4.5" tall 9.5" long, Circa 1940s, **$35.00**

Horse - vase, 5.25" tall 4.25" long, Circa 1945-1960s.
Left: Milk Glass, **$24.00**
Right: Amber, **$18.00**

Pheasant, Crystal, 5.75" tall 11.25" long, Circa 1945-60s, **$65.00**

A.H. Heisey & Company 1895-1957

Augustus Heisey immigrated to America with his parents from Germany. He first worked for Cascade Glass of Pittsburgh, Pennsylvania. Following military service in the Civil War, he worked for Ripley & Company. Wanting to be his own boss, he built his own glass factory in 1895 in Newark, Ohio.

In 1900, realizing the importance of marking this glass, Heisey developed a trademarked logo: an H in a diamond. From then on, Heisey advertised their pieces to be of high quality, since they were marked.

The Heisey family was fond of horses and had their own stable, which won many prizes. Their mare, Goodness Gracious, was the first to win a championship and was the model for their glass figural show horse. T. Clarence Heisey, Horace King, and Ray Cobel designed most of the horse moulds.

Royal Hickman, formerly employed at Royal Haeger Potteries, came to work for Heisey in 1941. He designed the majority of Heisey's other glass animal pieces. When Tennessee William's play *The Glass Menagerie* was on Broadway in 1946, glass animals from Heisey and Viking were prominently displayed. When the play was made into a movie in 1940, starring Jane Wyman, only Heisey animals were used. Advertisements linked the movie to the store displays to encourage customers to buy their favorite movie-related glass animals.

By the mid-1950s, Heisey was struggling for survival against foreign imports. Heisey entered into an agreement with designer Eva Zeisel in 1953, and the Holophane Company that owned Verlys moulds in 1955, to develop new products. Neither agreement produced the desired greater sales.

In December of 1957, the Heisey factory closed for Christmas and never reopened. In April of 1958, Imperial Glass purchased all of the Heisey moulds, customer lists, and famous diamond H trademark.

Bull #1 (designed by Royal Hickman), Crystal, 3.25" tall 8" long, Circa 1949-1952, **$2,500.00**

84 A.H. Heisey & Co.

Cherub - candlestick #111, Flamingo, 11.25" tall 5" wide, Circa 1926-1929, **$400.00** each
Also made in Crystal & Moongleam.

Chicken - hen #2 (designed by Royal Hickman), Crystal, 4.25" tall 3.75" long, Circa 1948-1949, **$650.00**

Chicken - rooster #1 (designed by Royal Hickman), Crystal, 5.5" tall 4.5" long, Circa 1948-1949, **$850.00**

Chick #3 (designed by Royal Hickman), Crystal, 1.2" tall 1.4" long, Circa 1948-1949, **$95.00**

Chicken - rooster "Bantam" stem #5063 (designed by Ray C. Cobel) liquor cocktail, Crystal, 4.15" tall, Circa 1951, **$395.00**

Chicken - Chanticleer "Fighting" rooster #2, Crystal, 7.4" tall 5.5" long, Circa 1940-1946, **$175.00**

A.H. Heisey & Co. 85

Chicken - fancy rooster stem #5038 (designed by Ray C. Cobel) sherbet, Crystal, 5.5" tall, Circa 1942-1957, **$75.00**

Chicken - rooster cocktail shaker #4036 (designed by Ray C. Cobel), Crystal, 11.25" tall 3" wide, Circa 1941-1957, three separate pieces of glass make up this shaker (shaker, strainer, & stopper), **$350.00**

Chicken - Chanticleer rooster vase #1557, Crystal, 6.5" tall 6.5" long, Circa 1939-1948, **$175.00**

Doe Head #1 (designed by Royal Hickman), 6" tall 3.5" wide,.
Left: Crystal, Circa 1947, **$950.00**
Right: Sultana (dark amber), Circa 1947, **$2,950.00**

Dog - Airedale #1 (designed by Royal Hickman), Crystal, 5.8" tall 6.5" long, Circa 1948-1949, **$1,200.00**

Dog - Scottie #1541, Crystal, 3.5" tall 4.75" long, Circa 1941-1946, **$165.00**

86 A.H. Heisey & Co.

Dolphin - candlestick #110, 10.25" tall 4.25" wide, Circa 1925-1935.
Left: Moongleam, **$450.00** each
Right: Flamingo, **$350.00** each

Left: Dolphin stemmed candlestick #109, Crystal, 6.4" tall 4.25" wide, Circa 1925-1935, **$75.00** each
Center: Dolphin stemmed comport, Moongleam & Crystal (two-tone), 8" tall 7.5" wide, Circa 1925, **$245.00**
Right: Dolphin stemmed candlestick #109, Moongleam, 6.4" tall 4.25" wide, Circa 1925-1935, **$150.00** each
Also made in Flamingo, Cobalt, and Sahara.

Dolphin - candlestick #110, 10.25" tall 4.25" wide, Circa 1925-1935.
Left: Amber, **$1,000.00** each
Center: Crystal, **$200.00** each
Right: Cobalt, **$1,500.00** each
Also made in Sahara $1,000.00 each and Zircon $3,000.00 each.

Donkey #1 (designed by Royal Hickman), Crystal, 6.6" tall 5.25" long, has original paper Heisey label, Circa 1944-1953, **$475.00**

Left: Dolphin stemmed comport #109, Flamingo, 7.25" tall 7.75" wide, Circa 1925, **$245.00**
Right: Dolphin stemmed candlestick #109, Flamingo, 5.75" tall 4.75" wide, Circa 1925-1935, **$150.00** each
Also made in Crystal, Cobalt, Moongleam, and Sahara.

Donkey #1 on bust off base (designed by Royal Hickman), Crystal, 8.1" tall 5.75" long, Circa 1944-1953, **$750.00**

save up to **90%** on your favorite books

BARGAIN BOOKSTORES.com

there's a DEAL FOR Every DAY!

BARGAINBOOKSTORES.COM

A.H. Heisey & Co. 87

Duck - ashtray #357, 2.6" tall 4.5" long, Circa 1928-1933.
Top: Crystal, **$100.00**
Bottom left: Flamingo, **$225.00**
Bottom right: Moongleam, **$250.00**
Also made in Marigold $500.00+

Left: Duck - Mallard #10 - wings down, Crystal, 5" tall 4.5" long, Circa 1947-1955, **$350.00**
Center: Duck - Mallard #11 - wings half up, Crystal, 5" tall 5.25" long, Circa 1947-1955, **$295.00**
Right: Duck - Mallard #12 - wings up, Crystal, 6.8" tall 4.5" long, Circa 1947-1955, **$185.00**
All three Mallards were designed by Royal Hickman.

Duck stopper #77 on cologne bottle #4035, 4.5" tall 1.75" wide, holds .75 fluid ounces, Circa 1926.
Left: Moongleam, **$295.00**
Right: Flamingo, **$295.00**

Duck - Wood Duck #20 (designed by Royal Hickman), Crystal, 4.5" tall 6" long, Circa 1947-1949, **$600.00**

Duck - flower frog #15, Designed by Ray C. Cobel. Crystal, 5" tall 5.5" wide, Circa 1927-1933, **$175.00**
Also made Flamingo, Hawthorne, and Moongleam.

Left: Duck - Wood Duckling #21 - floating, Crystal, 2.25" tall 3.25" long, Circa 1947-1949, **$200.00**
Right: Duck - Wood Duckling #22 - standing, Crystal, 2.5" tall 2.25" long, Circa 1947-1949, **$200.00**
Both Wood ducklings were designed by Royal Hickman.

A.H. Heisey & Co.

Elephant small #3 (designed by Royal Hickman), Crystal, 4.6" tall 4.75" long, Circa 1944-1953, **$295.00**

Left: Elephant large #1, Amber, 4.8" tall 6.5" long, Circa 1944-1953, **$3,000.00**
Right: Elephant medium #2, Amber, 4" tall 6.5" long, Circa 1944-1953, **$2,400.00**
Both elephants were designed by Royal Hickman.

Elephant medium #2 (designed by Royal Hickman), Crystal, 4" tall 6.5" long, Circa 1944-1953, **$375.00**

Elephant handled mug #1591A (designed by Horace King), 5" tall 5" wide, holds 12 fluid ounces.
Left: Crystal, Circa 1947, **$300.00**
Right: Amber, Circa 1947, **$650.00**

Elephant large #1 (designed by Royal Hickman), Crystal, 4.8" tall 6.5" long, Circa 1944-1953, **$495.00**

Fish - bookends #1554 (designed by Royal Hickman), Crystal, 6.75" tall 5" long, Circa 1942-1952, **$350.00** pair

A.H. Heisey & Co. 89

Fish - bookends #1554 (designed by Royal Hickman), Crystal with "Charleton" hand painted decoration, 6.75" tall 5" long, Circa 1942-1952, **$395.00** pair

Fish - bowl (vase) #1550 (designed by Royal Hickman), Crystal, 9" tall 9" long, Circa 1941-1946, **$850.00**

Fish- candlestick #1550 (designed by Royal Hickman), Crystal, 5.25" tall 4" wide, Circa 1941-1948, **$225.00** each

Fish - bowl (vase) #1550 (designed by Royal Hickman), Crystal with Charleton ruby flashed decoration, 9" tall 9" long, Circa 1941-1946, **$1,000.00**

Fish - Tropical #101 (designed by Royal Hickman), 12.5" tall 5.75" long, Circa 1948-1949.
Left: Crystal Satin, **$1.800.00**
Center: Amber, **$3,800.00**
Right: Crystal, **$2,400.00**

Fish - match holder #1550 (designed by Royal Hickman), Crystal, 3" tall 2.75" long, Circa 1944-1946, **$185.00**

90 A.H. Heisey & Co.

Fox (sleeping) ashtray #1601, Crystal, 6.25" long 4.25" wide, Circa 1947, **$300.00**

Girl "Dinky Doo" #7079, Crystal, 4.4" tall 3" wide, Circa 1944-1948, **$195.00**

Girl "Victorian Belle" #2001, Crystal, 4.25" tall 2.75" wide, Circa 1944-1948, **$125.00**

Gazelle #104 (designed by Royal Hickman), Crystal, 10.75" tall 3.25" long, Circa 1947-1949, **$2,400.00**

Giraffe Head Back #2, Crystal, 10.25" tall 3" long, Circa 1942-1952, **$250.00**

Giraffe Head Turned #1, Crystal, 11.25" tall 3.25" long, Circa 1942-1952, **$300.00**

A.H. Heisey & Co. 91

Left: Goose #3 wings up, Crystal, 6.4" tall 7.5" long, Circa 1942-1953, **$175.00**
Right top: Goose #2 wings halfway up, Crystal, 4.6" tall 8.5" long, Circa 1942-1953, **$175.00**
Right bottom: Goose #1 wings down, Crystal, 2.5" tall 10.25" long, Circa 1942-1953, **$475.00**

Left: Horse - Clydesdale #2 (designed by Thomas Clarence Heisey), Honey Amber (light amber), 7.4" tall 6.75" long, Circa 1942-1948. Note, this one has flaws on the mane, neck, feet & tail (most of these are not perfect and only a few have been found), **$2,400.00**
Right: Clydesdale, Crystal, 7.5" tall 7" long, Circa 1942-1948, **$550.00**

Goose stem #5058 - sherbet, Amber, 5.75" tall, Circa 1947, **$475.00**

Left: Horse - colt balking, Crystal #1529, 3.5" tall 3.5" long, Circa 1941-1945, **$275.00**
Center: Horse - colt standing #1522, Crystal, 5" tall 3" long, Circa 1941-1952, **$125.00**
Right: Horse - colt kicking #1527, Crystal, 4" tall 3.5" long, Circa 1941-1945, **$245.00**
All three of the colts were designed by Thomas Clarence Heisey.

Left: Goose stem #5058 - liquor cocktail, Crystal, 5.75" tall, Circa 1947, **$185.00**
Center: Goose decanter #5050, Crystal, 11.75" tall, holds 27 fluid ounces, Circa 1947, **$595.00**
Right: Goose stem #5058 - sherry, Crystal, 6.5" tall, holds 2 fluid ounces, Circa 1947, **$225.00**

Left: Horse - colt kicking #1527, Cobalt, 4" tall 3.25" long, Circa 1941-1945, **$1,400.00**
Right: Horse - colt standing #1522, Honey Amber (light amber), 5" tall 2.75" long, Circa 1940-1952, **$650.00**
Both colts were designed by Thomas Clarence Heisey.

92 A.H. Heisey & Co.

Left: Horse - filly #2 head back, Crystal, 8.75" tall 5" long. Circa 1948-1949, **$2,500.00**
Right: Horse - filly #1 head forward, Crystal, 8.75" tall 5" long. Circa 1948-1949, **$2,500.00**
Both were designed by Royal Hickman.

Horse - plug #1540 (designed by Thomas Clarence Heisey), 4.25" tall 3.6" long. Also called Oscar and Sparky.
Left: Crystal, Circa 1941-1946, **$125.00**
Right: Cobalt, Circa early 1940s, **$350.00**

Horse - flying mare #1 (designed by Royal Hickman), Crystal, 8.75" tall 11.5" long, Circa 1951-1952, **$3,800.00**

Horse - plug #1540 (designed by Thomas Clarence Heisey), Crystal with "Charleton" hand painted decoration, 4.25" tall 3.6" long, Circa 1941-1946, **$150.00**

Horse - flying mare #1 (designed by Royal Hickman), 8.75" tall 11.5" long.
Left: Honey Amber (light amber), Circa 1951-1952, **$5,500.00**
Right: Sultana (dark amber), Circa 1951-1952, **$6,000.00**

Horse bookend "Rearing" (designed by Royal Hickman), Lavendar Ice, 7.5" tall 7" long, reissued by the Heisey Club of America, 1993, **$85.00** each
The original was issued in Crystal, Circa 1948-1949, **$2,500.00+** each

A.H. Heisey & Co. 93

Horse - show horse #5 (designed by Royal Hickman), Crystal, 7.1" tall 6.5" long, Circa 1948-1949, **$1,500.00**

Horse - four headed ashtray #7069, Crystal, 1.75" tall 7.5" wide, Circa 1948, **$175.00**

Horse stem #5065 - liquor cocktail, Crystal, 5.5" tall, Circa 1948, **$500.00**

Horse head bookend #1 (designed by Thomas Clarence Heisey), Crystal, 6.75" tall 6.25" long, Circa 1937-1955, **$175.00** each

Horse head ashtray #1489 (designed by Thomas Clarence Heisey), Crystal Satin, 3" tall 4.6" wide, Circa 1941-1957, **$85.00**

Horse head bookend #1 (designed by Thomas Clarence Heisey), Crystal Satin, 6.75" tall 6.25" long, Circa 1937-1955, **$195.00** each

94 A.H. Heisey & Co.

Horse Head cigarette box #1489 1/2 (designed by Thomas Clarence Heisey), Crystal, 6.25" tall 4" wide, Circa 1941-1957, **$125.00**

Kingfisher - flower frog #14, 5.4" tall 4.5" long, Circa 1927-1933.
Left: Hawthorne, **$350.00**
Right: Flamingo, **$250.00**
Also made in Crystal $150.00 and Moongleam $275.00

Horse Head miniature #1 (designed by Thomas Clarence Heisey), Crystal, 1.75" tall 1.75" wide, Circa 1944-1945, **$75.00**

Lion - covered box #1519, Crystal, 4.5" tall 6.5" long, Circa 1949, **$495.00**

Horse head stem #5066 - sherbet, Crystal, 4.25" tall, Circa 1948, **$125.00**

Pattern detail of Lion Head bowl, Sahara.

A.H. Heisey & Co. 95

Lion Head - bowl, 3.75" tall 10.25" long. This bowl can also be found flared out, Circa 1929-1940.
Top: Crystal, **$350.00**
Bottom: Sahara, **$600.00**

Mike J. Owens bust, Flamingo, 5" tall 5" wide, marked on front: "1859 M.J. Owens 1923" (Made for Edward Libbey of Libbey-Owens Glass Company. Mike J. Owens designed the machinery for automated glass production and this piece was to honor his achievements.) Circa 1923, **$750.00**

Penguin - bottle #5039 (designed by Royal Hickman), Crystal, 8.4" tall 4.5" wide, Circa 1942-1949, **$350.00** complete (stopper only, $125.00)

Madonna Bust #2, Crystal Satin, 11" tall 3.25" wide, Circa 1945-1952, **$950.00**

Madonna #1, Crystal Satin, 8.75" tall 3" wide, Circa 1942-1956, **$125.00**

Pheasant - Asiatic #100 (designed by Royal Hickman), 10" tall 7.25" long, Circa 1945-1955.
Left: Amber, **$850.00**
Right: Crystal, **$475.00**

A.H. Heisey & Co.

"Charleton" hand painted decoration, 4.75" tall 12" long, Circa 1942-1953, **$250.00**

Left: Rabbit - bunny #3 - head up, Crystal, 2.5" tall 2.5" long, Circa 1948-1949, **$295.00**
Right: Rabbit - bunny #2 - head down, Crystal, 2.4" tall 3" long, Circa 1948-1952, **$250.00**
Both bunnies were designed by Royal Hickman.

Left: Piglet #3 - head down, Crystal, 1" tall 1.25" long, Circa 1948-1949, **$125.00**
Center: Piglet #2 - head up, Crystal, 1" tall 1" long, Circa 1948-1949, **$125.00**
Right: Pig - sow #1, Crystal, 3.25" tall 4.5" long, Circa 1948-1949, **$1,150.00**
Both piglets were designed by Royal Hickman.

Rabbit #1 (designed by Royal Hickman), Crystal, 4.5" tall 5.5" long, Circa 1948-1952, **$1,100.00**

Pigeon - Pouter #1 (designed by Royal Hickman), Crystal, 6.25" tall 7.25" long, Circa 1947-1949, **$1,100.00**

Rabbit - paper weight #1538, Crystal, 2.6" tall 3.6" long, Circa 1941-1946, **$195.00**

A.H. Heisey & Co. 97

Seahorse #5074 stem, 6.75" to 7" tall. Three shades of Amber are shown. This just shows that this color can vary from light to dark shades, Circa 1952.
Left: Crystal with Sultana (dark amber) stem, **$1,000.00+**
Left center: Crystal, **$195.00**
Right center: Crystal with Honey Amber (light amber) stem, **$900.00+**
Right: Crystal with Amber (medium amber) stem, **$800.00**

Swan #4 (designed by Royal Hickman), Crystal, 7" tall 8" long, Circa 1947-1953, **$1,200.00**

Sparrow #1553, Crystal, 1.75" tall 4.25" long, Circa 1942-1945, **$145.00**

Swan - baby (Cygnet) #5 (designed by Royal Hickman), Crystal, 2.25" tall 2.5" long, Circa 1947-1949, **$195.00**

These figural stoppers came in decanters, but shown here without the bottle. Collectors now seem to favor collecting just the stoppers.
Left to right:
1. Large Horse head #129, Crystal, 4.8" tall 3.5" long, Circa 1948, **$195.00**
2. Small Horse head #132, Crystal, 4" tall 2.5" long, Circa 1948, **$145.00**
3. Penguin head #116, Crystal, 2.8" tall 2.5" long, Circa 1950, **$125.00**
4. Ram head #7002, Crystal, 3.5" tall 2.25" long, Circa 1947, **$225.00**
5. Rooster head #5038, Crystal, 4.5" tall 2.25" long, Circa 1941, **$165.00**
6. Girl in Curls #7064, Crystal, 4.7" tall 1.75" long, Circa 1941, **$395.00**

Left: Swan "Crystolite" jelly or candy #1503, Crystal, 4" tall 6.5" long, Circa 1943-1957, **$45.00**
Right: Swan "Crystolite" individual nut dish #1503, Crystal, 1.8" tall 2.5" long, Circa 1943-1957, **$24.00**

A.H. Heisey & Co.

Swan handled "Crystolite" water pitcher #1503, Crystal, 9" tall 64 oz., Circa 1944, **$750.00**

This photo will show you the different colors of amber side by side. Note, the difference between each one.
Left: Filly - Sultana (dark amber)
Center: Elephant Mug - Amber (medium amber)
Right: Plug Horse - Honey Amber (light amber)

Swan two handled candlestick #133, Moongleam, 6.5" tall, Circa 1929-1936, **$195.00** each

Horse Head #1551, Crystal 5" tall 7" long, Circa 1940s and on, **$85.00** Note: This is not Heisey Glass but is from a mould that was made at the Heisey mould shop. The mould was found at Imperial after they closed mixed with the Heisey material. The Horse Head has caused a lot of debate for many years. The glass is very inferior and has a greenish cast similar to window glass. In reality that is what it is. Heisey made the mould as contract work. It is assumed a handful of glass horse heads were made to test the mould and then it was sent over to the United States Glass & Tile Company. They made the horse heads to be used as a promotional. All the ones seen on the market have been made by this company and not Heisey, so we are only pricing these.

Tiger - paperweight #103 (designed by Royal Hickman), 2.8" tall 8" long, Circa 1949.
Left: Crystal satin, **$1,100.00**
Right: Crystal, **$1,450.00**

Starting with this picture, the following photos are Heisey animals that have been reissued by the Heisey Club of America (HCA) Chick Head Down, Rosalene (made for HCA by Fenton), .75" tall 1.4" long, Circa 1992. (View of left side and right side of Chick.), **$20.00**

A.H. Heisey & Co. 99

Donkey #1 (made for HCA by Fenton), 6" tall 5.75" long.
Top: French Opalescent, Circa 1987, **$75.00**
Left: Sea Mist, Circa 1992, **$85.00**
Right: Sea Mist Satin, Circa 1992, **$75.00**

Left: Elephant small #3 (made for HCA in 1996 by Dalzell Viking), Ruby, 4.25" tall 5.25" long, Circa 1996. Marked "D HCA 96", **$75.00**
Center: Elephant medium #2 (made for HCA in 1988 by Fenton Art Glass), French Opalescent, 4.1" tall 6.6" long, Circa 1996. Marked "HCA 88", **$75.00**
Right: Elephant large #1 (made for HCA in 1993 by Dalzell Viking in a limited edition of 450 pieces), Cranberry Ice, 5" tall 6.5" long, Circa 1996. Marked "HCA 93", **$75.00**

Made for HCA in 1991 by Dalzell Viking.
Left: Duck - Mallard #12 - wings up, Ruby, 6.8" tall 4.5" long, **$50.00**
Center: Duck - Mallard #11 - wings half up, Ruby, 5" tall 5.25" long, **$50.00**
Left: Duck - Mallard #10 - wings down, Ruby, 5" tall 4.5" long, **$50.00**

Elephant small #3, 4.6" tall 4.75" long.
Top left: French Opalescent (made for HCA by Fenton), Circa 1987, **$65.00**
Top right: Lavender Ice Satin (made for HCA by Dalzell Viking), Circa 1993, **$45.00**
Bottom left: Blue - sample color (made for HCA by Dalzell Viking), Circa 1993, **$150.00**
Bottom right: Pink (made for HCA by Dalzell Viking), Circa 1993, **$58.00**

Made for HCA in 1991 by Dalzell Viking.
Left: Duck - Wood duckling #21 - floating, Ruby, 2.25" tall 3.25" long, **$48.00**
Right: Duck - Wood duckling #22 - standing, Ruby, 2.5" tall 2.25" long, **$48.00**

Elephant Head (Storybook) mug #1591, 3" tall 4" diameter.
Left: made for HCA by Fenton Art Glass, Rosalene, Circa 1990, **$35.00**
Right: made for HCA by Dalzell Viking, Ruby, Circa 1996, **$35.00**

100 A.H. Heisey & Co.

Fish - candle holder #1550, Transparent Blue (made for HCA by Dalzell Viking), 5.25" tall 4" long, Circa 1995, **$45.00**

Heisey "Lavender Ice Limited Edition" from 1994 made for HCA by Dalzell Viking. They were limited to 450 pieces. They are marked with an ink mark on the bottom with the piece number and also marked in the glass with an D and the letters HCA. Note, more than the 450 were produced and these seconds were satinized.
Tropical Fish #101, Lavender Ice, 12" tall 6" long, Circa 1994, **$350.00**

Fox - ashtray, Lavender Ice from 1993 Heisey Museum addition dedication on June 16, 1993. Made for HCA by Dalzell Viking in their color "Lavender Ice", 6.25" long 4.25" wide, Circa 1993, **$35.00**

Made for HCA in 1991 by Dalzell Viking.
Left: Horse - colt balking #1529, Ruby, 3.6" tall 3.5" long, Circa 1941-1945, **$50.00**
Center: Horse - colt kicking #1527, Ruby, 4" tall 3" long, Circa 1941-1945, **$50.00**
Right: Horse - colt standing #1522, Ruby, 5" tall 2.75" long, Circa 1940-1952, **$50.00**

Girl "Dinky Doo" #7079, 4.4" tall 3" wide, made for HCA by Dalzell Viking.
Left: Vaseline, Circa 1998, **$35.00**
Right: Green, Circa 1994, **$40.00**

HCA mould used by Mosser and made for Longaberger. Each one marked with: 99 and a maple leaf on one side, and HCA M on other side.
Left: Horse - colt standing #1522, Transparent Blue, 5" tall 2.5" long, Circa 1999, **$45.00**
Right: Horse - colt balking #1529, Transparent Blue #1529, 3.6" tall 3.5" long, Circa 1999, **$45.00**

A.H. Heisey & Co. 101

Horse - flying mare #1, Emerald Green (sample for HCA by Dalzell Viking - only 5 made), 8.75" tall 11.5" long, Circa 1993, **$3,500.00**

Horse bookend "Rearing", Ruby, (Made for HCA by Dalzell Viking), 7.5" tall 7" long, Circa 1992, **$95.00** each

Heisey "Lavender Ice Limited Edition" from 1994 made for HCA by Dalzell Viking in their color, "Lavender Ice". They were limited to 450 pieces. They are marked with an ink mark on the bottom with the piece number and also marked in the glass with an D and the letters HCA. Note, more than the 450 were produced and these seconds were satinized.
Horse - flying mare #1, Lavender Ice, 8.75" tall 11.25" long, Circa 1994, **$450.00**

These miniature horse head paperweights were designed after the horse head bookend. HCA had the mould made for their use.
Miniature Horse head paperweight, 3.3" tall 3.1" long, Circa 1984.
Top row Left to right:
1. Crystal, **$25.00**
2. Cobalt, **$30.00**
3. Ruby, **$35.00**
Bottom row Left to right:
1. Transparent Blue, **$28.00**
2. Crystal Satin, **$20.00**
3. Cobalt Satin, **$25.00**
4. Ruby Satin, **$30.00**

Horse - plug #1540, Made by Fenton Art Glass, 4.25" tall 3.6" long.
Top: Burmese Gloss, Circa 1992, **$45.00**
Center left: Burmese Satin, Circa 1992, **$50.00**

Horse - double headed paperweight on bust off base (mould made up for HCA, never originally made by Heisey), 2.8" tall 2.25" wide.
Left: Lavender Ice, Circa 1998, **$65.00**
Right: Ruby, Circa 1992, **$75.00**

102 A.H. Heisey & Co.

Madonna, 8.75" tall 3" wide, Made for HCA by Dalzell Viking, except for the Rosalene which was made by Fenton.
Left to right:
1. Dark Blue, Circa 1992, **$100.00**
2. Lavender Ice, Circa 1998, **$55.00**
3. Transparent Blue, Circa 1996, **$45.00**
4. Rosalene (sample made by Fenton), Circa 1990, **$300.00**
5. Blue Satin, Circa 1996, **$40.00**

Pigeon - Pouter #1, Emerald Green (sample for HCA by Dalzell Viking - only 7 made), 6.25" tall 7.25" long, Circa 1993, **$350.00**

Left: Piglet Sitting, Rosalene (made for HCA by Fenton), 1" tall 1.4" long, Circa 1992, **$25.00**
Right: Piglet Sitting, Crystal Satin (made by James Burkam to be similar to Heisey. Note, shown here for comparison only), .75" tall 1.4" long, Circa 1980s, **$20.00**

Made for HCA by Dalzell Viking.
Top: Rabbit - bunny - head up, Pink Satin, 2.5" tall 2.5" long, Circa 1991, **$22.50**
Bottom left: Rabbit - bunny - head up, Pink, 2.5" tall 2.5" long, Circa 1991, **$25.00**
Bottom right: Rabbit - bunny - head down, Ruby, 2.4" tall 3" long, Circa 1990, **$35.00**

Pheasant - Asiatic #100, Brown, (sample made for HCA by Dalzell Viking), 10.4" tall 7.25" long, Circa 1995, **$150.00**

Swan - baby "Cygnet" #5 (made for HCA by Dalzell Viking), 2.25" tall 2.5" long.
Top: Pink Satin, Circa 1991, **$30.00**
Left: Pink, Circa 1991, **$35.00**
Right: Ruby, Circa 1991, **$45.00**

A.H. Heisey & Co. 103

Heisey "Gold Series" from 1992 made for HCA by the Fenton Art Glass Company in their color, "Rosalene". There were a total of 12 animals in this series and were limited to 450 complete sets. They are marked with an ink mark on the bottom with the number in the series and also marked in the glass with an F in an oval and the letters HCA. Six of the animals in the series are shown in this photo. Note, more than the 450 of some of the animals were produced and there were seconds which were satinized.
Top row: Tiger paperweight #103, 2.75" tall 8" long, **$125.00**; Sow #1, 3" tall 4.5" long, **$100.00**
Center row: Cygnet #5, 2.1" tall 2.5" long, **$45.00**
Bottom row: Filly #1 head forward, 8.75" tall 5" long, **$175.00**; Airedale #1, 6" tall 5.25" long, **$125.00**; Rabbit #1538, 2.6" tall 3.6" long, **$100.00**

Heisey "Lavender Ice Series" from 1993 made for HCA. There were a total of 9 animals in this series and were limited to 450 complete sets. They are marked with an ink mark on the bottom with the number in the series and also marked in the glass with an D and the letters HCA. Five of the animals in the series are shown in this photo. Note, more than the 450 of some of the animals were produced and these were seconds which were satinized.
Top row: Mallard #10 - wings down, 4.75" tall 4.5" long, **$45.00**; Kingfisher flower frog #14, 4.25" tall 4.5" long, **$65.00**
Bottom row: Mallard - #11 wings 1/2 up, 4.8" tall 5.25" long, **$45.00**; Mallard #12 - wings up, 6.8" tall 3.75" long, **$45.00**; Pigeon, 6" tall 8" long, **$125.00**

Heisey "Gold Series" from 1992 made for HCA by the Fenton Art Glass Company in their color, "Rosalene". There were a total of 12 animals in this series and were limited to 450 complete sets. They are marked with an ink mark on the bottom with the number in the series and also marked in the glass with an F in an oval and the letters HCA. Six of the animals in the series are shown in this photo. Note, more than the 450 of some of the animals were produced and there were seconds which were satinized.
Top row: Hen #2, 4.25" tall 3.25" long, **$95.00**; Duckling #22, 2.75" tall 2.5" long, **$45.00**
Bottom row: Giraffe #2 head back, 10.25" tall 3" long, **$145.00**; Colt Standing #1522, 5" tall 2.75" long, **$65.00**; Fish bookend #1554, 7" tall 5" long, **$110.00** each; Gazelle #104, 10.75" tall 3.5" long, **$145.00**

Heisey 2000 Election Collection from H.C.A.
Top left: Heisey dealer sign (Cabochon), Milk Glass, 3.3" tall 3" wide, **$45.00**
Bottom left: Elephant, Cobalt, 4.4" tall 6.5" long, **$75.00**
Bottom right: Donkey #1, Ruby, 6" tall 6" long, **$65.00**

Heisey "Lavender Ice Series" from 1993 made for HCA by Dalzell Viking. There were a total of 9 animals in this series and were limited to 450 complete sets. They are marked with an ink mark on the bottom with the number in the series and also marked in the glass with an D and the letters HCA. Four of the animals in the series are shown in this photo. Note, more than the 450 of some of the animals were produced and these were seconds which were satinized.
Top row: Filly #1 head forward, 8.75" tall 5" long, **$95.00**; Rearing Horse bookend 7.75" tall 6.5" long, **$85.00** each
Bottom row: Bull #1, 3.6" tall 8" long **$125.00**; Scottie #1541, 3.25" tall 4.5" long, **$65.00**

Hemingray Glass Company 1876-late 1890s

The Hemingray Glass Company was located in Covington, Kentucky, and specialized in novelty items. The earliest information found on the company was a patent by Julius Proger in 1876 for the bird pickle dish Hemingray made. An 1890 advertisement showed them to be still in business. In 1888 the firm moved to Muncie, Indiana, where they were listed as makers of bottles, jars, and insulators. During this time, four other glass factories were located in Muncie making fruit jars. Hemingray was located just east of the Ball jar-making facility. Hemingray's amber and black globe jars are highly prized among collectors today.

Bird - pickle dish #842, 2.25" tall 10.75" long, Circa 1883.
Left: Semi-opaque Pink, **$95.00**
Right: Amber, **$60.00**

Hocking Glass Company 1905-Present

Hocking Glass Company began in 1905 in Lancaster, Ohio. In the early years they made jelly jars, lamp chimneys, and globes. In the 1920s they expanded to tableware and novelty items.

The glass-covered pachyderm was made in 1928 when 36 were sold to the Avon Company as gifts for their top sales representatives. The glass elephants came filled with Vernafleur bath salts. It is now assumed that after this contract was filled, the glass elephants were sold under the Hocking label.

The Hocking company purchased Lancaster Glass in 1924, Monongah Glass in 1930, merged with Anchor Cap & Closure Corporation in 1937 to became known as Anchor-Hocking, and bought the Standard Glass Company in 1940.

Anchor-Hocking's popular Fire King line of glass ovenware came out in the 1940s, along with some novelty and curio items. Phoenix Glass was purchased in 1970. Today, Anchor-Hocking is the largest producer of glass tableware in America.

Elephant - Pachyderm covered dish, 4.25" tall 6" long, Circa 1920s.
Top: Crystal Satin, **$85.00**
Bottom left: Crystal, **$95.00**
Bottom right: Green, **$175.00**

Fish covered jam, Crystal, 3.5" tall 4.75" long, Circa 1940s-1950s, marked with a H over an anchor, **$12.50**

Houze Glass Company 1902-Present

Leon J. Houze, originally from Belgium, founded the Federated Glass Company in 1902 in Point Marron, Pennsylvania, just north of Morgantown, West Virginia, to make window glass. Later, the company was renamed the L.J. Houze Convex Glass Company and made desk items, lamps, and smoking sets. A variety of glass, animal-shaped ink blotters were made that had been designed by Garrett Thew in 1931. It is rumored today that their Scottie dog ink blotter was made as a likeness of President Franklin Roosevelt's dog, Fala. The glass donkey and elephant figurines were issued for the political campaigns of his time.

When Harry Truman was President, the White House was renovated and Houze made all the new glass windows. The company has been versatile, also making glass gearshift knobs, sunglass lenses, perfume bottles, and glass pictures.

Today, Houze Glass advertises specialty glassware made with a special technique that involves a direct, screen-printing application.

Dog "Scottie" ink blotter, Jade, 2.4" tall 3.6" long, Circa 1930s, **$60.00** Also came in an opaque Black & Yellow.

Elephant - ink blotter, Black, 2.25" tall 3.5" long, Circa 1930s, marked on the underside of blotter © THEW31 - 1931, **$45.00** Also came in an opaque Jade & Yellow.

Hunter Collectible Art Glass 1979-1985

Vi Hunter, a designer in Akron, Ohio, introduced her Jenny glass figurine in March of 1979. Her plan was to issue Jenny in a new color once a month. The series continued until 1983, when a miniature version of the Jenny design was introduced. In October of 1981, Josh, a companion figurine, was offered in a limited series, like Jenny. These faceless figures are reminiscent of Amish dolls. A similar series in carousel horse designs was introduced in 1985. The glass for all of these figures was made at Mosser Glass.

In 1983 Hunter Collectible Art Glass was moved to Copley, Ohio, and became a division of the Hanseatic Corporation. No further information about Vi Hunter after 1985 has been found.

Left: Jenny, Turquoise, 4.25" tall 1.75" wide, Circa 1980, **$35.00**
Right: Jenny, Cobalt, 2.1" tall 1" wide, Circa 1983. Note, her original box is shown to the right, **$28.00**

Left: Jenny, Violet d'Or, 4.25" tall 1.75" wide, Circa 1982, **$35.00**
Right: Josh, Wintergreen, 4.25" tall 1.75" wide, Circa 1981, **$28.00**

Imperial Glass Company 1901-1982

When the Muhleman's Crystal Glass Company was purchased in 1901, owner Edward Muhleman went in search of a new opportunity. He contacted other investors in Bellaire, Ohio, and reached an agreement to build a glass factory there. Production began in 1904, and soon Imperial Glass Company became a major glass manufacturer.

In the 1930s, Imperial's major tableware lines, Candlewick and Cape Cod, produced huge sales. In the 1940s, they acquired the Central Glass moulds. Imperial took a bold step in the 1940s by hiring designer Virginia B. Evans to develop a special line for them. Her Cathay line premiered in 1949 as an oriental theme. It did not sell well, probably due to the current American political conflicts with Japan and Korea. People were not interested in decorating their homes with oriental items during the 1950s.

Imperial marked some of their glass with the "I.G." mark, in the 1950s. After they acquired the Heisey Company in 1958, Imperial also acquired the Cambridge Company. The Heisey glass animals, made in new colors, significantly boosted Imperial's sales. At the same time, Imperial experimented with old formulas of slag, carnival, and peach blow glass. All of these efforts helped to stimulate the company.

Interested in expanding into the glassware business, Lenox ceramic tablewares company purchased Imperial in 1973. The mark on the glass was then changed to "L.I.G". With the aging Imperial plant in need of renovation, the Lenox company sought to sell the Imperial Glass Company rather than invest further in it. Arthur Lorch purchased the Imperial company in 1981, and the mark was changed again, this time to "A.L.I.G." Lorch was unable to solve technical problems of the glass company and sold it to Robert Stahl in 1982. Even though Stahl had come up with an ambitious plan to save Imperial, the local banks rejected the plan and a bankruptcy court sold the company to Lancaster Colony in 1984. A liquidation sale proceeded and members of the Heisey Collectors of America and the National Cambridge Collectors Club purchased many of the moulds.

Bull (former Heisey mould), Black, 3.25" tall 8" long, Circa 1984, **$450.00**

Bull (former Heisey mould), 3.25" tall 8" long.
Top: Sunshine Yellow, Circa 1984, **$400.00**
Bottom left: Nut Brown, Circa 1983, **$450.00**
Bottom right: Ultra Blue, Circa 1984, **$550.00**

"Cathay", detail of signature by Virginia B. Evans found on all pieces in the original offering of Crystal Satin.

Imperial Glass 107

"Cathay", Bamboo Urn #5014 covered candy, Crystal Satin, 9.75" tall 5.5" wide, signed by Virginia B. Evans, Circa 1949, **$450.00**

"Cathay", Candle Man Servant #5033/34 (candlestick), Crystal Satin, 9" tall 4" wide, signed by Virginia B. Evans, Circa 1949, **$200.00 each**

"Cathay", Concubine bookend #5000, Crystal Satin, 8" tall 5.25" wide, signed by Virginia B. Evans, Circa 1949, **$250.00 each**

"Cathay", Dragon candlestick #5009, Crystal Satin, 6.5" tall 6.5" long, signed by Virginia B. Evans, Circa 1949, **$250.00 pair**

"Cathay", Lu-Tung bookend #5030, Crystal Satin, 7.4" tall 5.25" wide, signed by Virginia B. Evans, Circa 1949, **$250.00** each

108 Imperial Glass

"Cathay", Lu-Tung bookend #5030, Black, 7.5" tall 5" wide, Circa 1950s, **$125.00** each

"Cathay", Egrette #5017, Crystal Satin, 9.1" tall 7" wide, signed by Virginia B. Evans, Circa 1949, **$295.00**

"Cathay", Empress bookend #5029, Crystal Satin, 7.5" tall 5.25" wide, signed by Virginia B. Evans, Circa 1949, **$250.00** each

"Cathay", Pagoda #5001 covered candy, Crystal Satin, 8.25" tall 6" wide, signed by Virginia B. Evans, Circa 1949, **$450.00**

"Cathay", Phoenix Bowl #5026, Crystal Satin, 5" tall 7.75" long, signed by Virginia B. Evans, Circa 1949-1957, **$350.00**

"Cathay", Phoenix Bowl #5026, Crystal, 5" tall 7.75" long, (from the Cathay mould, but not signed), Circa 1949-1957, **$250.00**

Imperial Glass 109

"Cathay", Scolding Bird #5024, Crystal Satin, 5.1" tall 6.25" long, signed by Virginia B. Evans, Circa 1949, **$195.00**

Chicken - hen (former Heisey mould), 4.25" tall 3.75" long.
Top: Sunshine Yellow, Circa 1983, **$150.00**
Left: Pink Satin, Circa 1978, **$275.00**
Right: Charcoal Satin, Circa 1980, **$250.00**

"Cathay", Scolding Bird #5024, Jade, 5.1" tall 6.25" long, (from the Cathay mould), Circa 1980-1983, **$95.00**

Chicken - rooster (former Heisey mould), 5.5" tall 4.5" long.
Left: Milk Glass, Circa 1978, **$50.00**
Right: Amber, Circa 1984, **$495.00**

"Cathay", Shang #5002 covered candy jar, Crystal Satin, 7.75" tall 5" wide, signed by Virginia B. Evans, Circa 1949, **$295.00**

Chicken - rooster egg cup #43639 (No. 459), Ruby Slag, 4.1" tall 4.75" long, Circa 1971-1976, **$60.00**

110 Imperial Glass

Chicken - rooster egg cup #43639, Horizon Blue Carnival, 4.25" tall 4.75" long, Circa 1979, marked with the letters IG, **$25.00**

Chicken - rooster fighting (former Heisey mould), Pink, 7.75" tall 6" long, Circa 1984, **$350.00**

Dog - Airedale (former Heisey mould), Ultra Blue, 5.75" tall 7" long, Circa 1982, marked with the letters ALIG, **$100.00**

Dog - "Scottie" #5, Amber, 3" tall 3.75" long, Circa 1983, **$35.00**

Dog - Airedale (former Heisey mould) #43947, 6" tall 6.5" long, Circa 1969-1973.
Left: Carmel Slag (dark), **$250.00**
Right: Carmel Slag (light), **$195.00**

Bulldog - "Parlor Pup" #43943, Carmel Slag, 3" tall 3.5" long, marked with IG, Circa 1969-1976, **$45.00**

Imperial Glass 111

Dog - "Scottie" (former Heisey mould), Ultra Blue, 3.5" tall 4.75" long, Circa 1982, marked with the letters ALIG, **$145.00**

Donkey (former Heisey mould) #43941, 6" tall 5.75" long.
Top: Green Carnival, Circa 1980, **$95.00**
Left: Ultra Blue, Circa 1982, **$175.00**
Right: Carmel Slag, Circa 1969-1977, **$125.00**

Dog - "Scottie" (former Heisey mould), 3.5" tall 4.75" long.
Top: Sunshine Yellow, Circa 1983, **$295.00**
Bottom Left: Amber, Circa 1984, **$345.00**
Bottom Center: Black, Circa 1984, **$195.00**
Bottom Right: Carmel Slag, Circa 1969-1970, **$225.00**

Duck - Mallard wings up #9/1 (former Heisey mould) #43939, Carmel Slag, 6.75" tall 4.75" long, Circa 1969-1977, **$45.00**

Dolphin candlesticks #71762 made for the Metropolitan Museum of Art (marked MMA), Blue Milk Glass top with Opal bottom, 10.5" tall. These also came as electric lamps, Circa 1977-1980, **$250.00** pair (**$150.00** for one electrified)

Left: Duck - Mallard wings up (former Heisey mould) #43939, Milk Glass, 6.8" tall 4.5" long, Circa 1982, **$135.00**
Center: Duck - Mallard wings half up (former Heisey mould) #43940, Horizon Blue, 5" tall 5.25" long, Circa 1980, **$45.00**
Right: Duck - Mallard wings down (former Heisey mould) #43941, Carmel Slag, 5" tall 4.5" long, Circa 1969-1970, **$375.00**

Imperial Glass

Left: Duck - Mallard wings half up (former Heisey mould) #43940, Amber, 5" tall 5.25" long, Circa 1984, **$45.00**
Center: Duck - Mallard wings up (former Heisey mould) #43939, Amber, 6.8" tall 4.5" long, Circa 1984, **$45.00**
Left: Duck - Mallard wings down (former Heisey mould) #43941, Amber, 5" tall 4.5" long, Circa 1984, **$45.00**

Duck - Wood duck (former #8 Heisey mould) #43939, Sunshine Yellow, 4.5" tall 6" long, Circa 1983, **$45.00**

Left: Duck - Wood duckling #21 - floating (former Heisey mould), Sunshine Yellow, 2.25" tall 3.25" long, Circa 1981, **$35.00**
Center: Duck - Wood duckling #22 - standing (former Heisey mould), Ultra Blue, 2.5" tall 2.25" long, Circa 19883, **$45.00**
Right: Duck - Wood duckling #21 - floating (former Heisey mould), Sunshine Yellow Satin, 2.25" tall 3.25" long, Circa 1981, **$30.00**

Left: Duck - Mallard wings half up (former Heisey mould) #43940, Horizon Blue, 5" tall 4.5" long, Circa 1980, **$45.00**
Center: Duck - Mallard wings down (former Heisey mould) #43941, Horizon Blue, 4.8" tall 4.5" long, Circa 1980, **$45.00**
Right: Duck - Mallard wings up (former Heisey mould) #43939, Horizon Blue, 6.75" tall 4.5" long, Circa 1980, **$45.00**

Eagle "Candlewick" ashtray #1776, 6.25" tall 3.9" wide, Circa 1942-1950.
Left: Crystal Satin, **$60.00**
Right: Crystal Satin with ruby flashed and gold trim, Circa 1966-1967, **$95.00**

Duck - Wood duck (former #8 Heisey mould) #43939, Carmel Slag, 4.5" tall 6" long, Circa 1969-1977, **$75.00**

Imperial Glass 113

Eagle "Candlewick Federal Column" bookend #L/777/3, Crystal Satin on Black Suede base, 9.1" tall 5" long, Circa 1943-1950, **$450.00** each

Top: Elephant small #3, Charcoal Satin (sample item only 15 made from Heisey mould), 4.6" tall 4.75" long, Circa 1983, **$350.00+**
Bottom left: Elephant large #1 (former Heisey mould), Horizon Blue, 4.8" tall 6.5" long, Circa 1984, **$275.00**
Bottom right: Elephant medium #2 (former Heisey mould) #43942, Green Carnival, 4" tall 6.5" long, Circa 1980, **$75.00**

Left: Elephant small (former Heisey mould), Carmel Slag (dark), 4.75" tall 4.5" long, Circa 1982-1983. Marked with embossed letters ALIG, **$85.00**
Right: Elephant medium (former Heisey mould) #43942, Carmel Slag (light), 4.1" tall 6.3" long, Circa 1969-1977. Marked with embossed letters ALIG. Note: original Imperial paper label, **$95.00**

Elephant handle - Storybook mug #1591 (former Heisey mould), 3" tall 4" diameter.
Left: Crystal, Circa 1980, **$25.00**
Right: Ruby Slag, Circa 1975-1977, **$45.00**

Elephant medium (former Heisey mould) #43942, Ultra Blue, 4" tall 6.5" long, Circa 1982, **$125.00**

Fish bookend (former Heisey mould), 6.6" tall 5" long.
Top: Horizon Blue, Circa 1984, **$225.00** each
Left: Ruby, Circa 1984, **$375.00** each
Right: Verde Green, Circa 1984, **$175.00** each

114　Imperial Glass

Fish - candlestick (former Heisey mould), Sunshine Yellow, 5.25" tall 4" wide, Circa 1982, **$75.00**

Fish - match holder (former Heisey mould), Sunshine Yellow, 3.2" tall 2.75" long, Circa 1982, **$45.00**

Gazelle (former Heisey mould), Ultra Blue, 10.75" tall 3.5" long, Circa 1982, marked with the letters ALIG, **$135.00**

Left: Giraffe - head to side (former Heisey mould), Amber, 11.1" tall 3" long, Circa 1980, **$495.00**
Right: Giraffe - head back, Amber (former Heisey mould), 11" tall 3.2" long, Circa 1980, **$495.00**

Girl - Dresden #43846, Carmel Slag, 7.8" tall 4" wide, Circa 1981, **$65.00**

Girl - Dresden #43846, Ultra Blue, 7.8" tall 4" wide, Circa 1981, **$50.00**

Left: Girl - Minuet (Heisey "Dinky Doo" mould), Rose Pink, 4.4" tall 3" wide, Circa 1981, **$95.00**
Right: Certificate of Authenticity states: "June 26, 1981 was the last day Imperial produced items with the LIG hallmark. On this day we produced the limited edition Heisey Minuet Girl in a quantity of only 426 pieces. Thank you for your continued interest in Imperial Glass."

Girl - Victorian Belle (former Heisey mould) actual bell & a cute play on words, 4.25" tall 2.8" wide.
Left: Amber, Circa 1984, **$45.00**
Center: Horizon Blue Satin, Circa 1980, **$40.00**
Right: Light Green, Circa 1980, **$60.00**

Girl - Suzanne bell #42844, 5.75" tall 3.75" wide.
Left: Lilac, Circa 1966-1969 **$35.00**
Right: Horizon Blue Carnival, Circa 1979, **$45.00**

Goose wings halfway up (former Heisey mould), Ultra Blue, 4.6" tall 8.5" long, Circa 1984, **$175.00**

Girl - Victorian Belle (former Heisey mould), Ruby, 4.25" tall 2.75" wide, marked AIG, Circa 1981, **$45.00**

Horse - Pony kicking (former Heisey colt mould), Carmel Slag, 4.1" tall 3.25" long, Circa 1969-1977, **$75.00**

116 Imperial Glass

Left: Horse - Pony balking (former Heisey colt mould), Ultra Blue, 3.6" tall 3.5" long, Circa 1980, **$60.00**
Center: Horse - Pony kicking (former Heisey colt mould), Ultra Blue, 4.1" tall 3.25" long, Circa 1980, **$60.00**
Right: Horse - Pony standing (former Heisey colt mould) #43946, Ultra Blue, 5" tall 2.75" long, Circa 1980, **$60.00**

Horse - filly head forward (former Heisey mould), Amber, 8.1" tall 5.5" long, Circa 1982, marked with the letters ALIG, **$225.00**

Left: Horse - Clydesdale (former Heisey mould), Salmon, 7.4" tall 6.75" long, Circa 1984, **$450.00**
Right: Horse - Clydesdale (former Heisey mould), Amber, 7.2" tall 7.5" long, Circa 1982, **$400.00**

Horse - filly head forward (former Heisey mould), Crystal Satin, 7.5" tall 5.25" long, Circa 1982, **$195.00**

Horse - Clydesdale (former Heisey mould), 7.2" tall 7.5" long, Circa 1984.
Left: Ultra Blue, **$250.00**
Right: Antique Blue (lots of air bubbles in the glass), **$500.00**

Horse - filly (former Heisey mould), 7.5" tall 5.25" long, Circa 1982.
Left: head back, Verde Green, **$250.00**
Right: head forward, Amber, **$450.00**

Imperial Glass 117

Horse - filly head forward on bust off base (former Heisey mould), Salmon, 10" tall 6.25" long, Circa 1984, **$650.00**

Horse head bookend (former Heisey mould), Pink (sample item only 8 made), 6.75" tall 6.25" long, Circa 1984, **$750.00** each

Horse - flying mare (former Heisey mould), Amber, 8.75" tall 11.5" long, Circa 1982, **$1,500.00**

Horse - plug named "Oscar" (former #12 Heisey mould) #43945, Carmel Slag, 4.25" tall 3.6" long, Circa 1969-1977, **$45.00**

Horse head ashtray (former Heisey mould), Amber, 1.75" tall 7.5" wide, Circa 1984, **$65.00**

Horse - plug (former Heisey mould), 4.25" tall 3.6" long.
Top: Sunshine Yellow, Circa 1979, **$45.00**
Center Left: Antique Blue, Circa 1985, **$55.00**
Center Right: Red, Circa 1984, **$65.00**
Bottom Left: Tangerine, Circa 1983, **$75.00**
Bottom Center: Black, Circa 1985, **$60.00**
Bottom Right: Teal, Circa 1994, **$45.00**

118 Imperial Glass

Horse - bookend "Rearing" (former Heisey mould), Black Satin, 7.5" tall 7" long, Circa 1982, **$450.00** each

Lion - covered box #1519 (former Heisey mould), Amber (made for Collectors Guild of New York), 4.5" tall 6.5" long, Circa 1981, **$175.00**

Horse - show horse (former Heisey mould), 7.1" tall 6.5" long, Circa 1983.
Left: Ultra Blue, **$650.00**
Right: Amber, **$1,250.00**

Madonna #1 (former Heisey mould), Crystal Satin, 8.75" tall 3" wide, Circa 1980s, **$50.00**

Kingfisher (Heisey mould changed from flower frog to just a figure, HCA Heisey Club of America), Black, 4.5" tall 4.5" long, Circa 1982, **$350.00**

Mouse "Little Pal Series" #51941S, Crystal Satin, 4.25" tall 4" long, Circa 1980, **$18.00**

Imperial Glass 119

Owl "Hoot Owl" #18, Carmel Slag, 3.75" tall 3.25" wide, Circa 1969-1977, **$45.00**

Owl - covered jar #800, Carmel Slag, 6.5" tall 3.5" wide, Circa 1970-1977, **$95.00**

Owl "Hoot Owl", Milk Glass, 3.75" tall 3.25" wide, Circa 1950s, **$25.00**

Pheasant - Ringneck (former Heisey mould), Black Carnival Glass, 5.25" tall 11.75" long, Circa 1985, **$575.00**

Left: Owl sugar #335, Ruby Slag, 3.4" tall 2.4" long, Circa 1974-1976, **$35.00**
Right: Owl creamer #335, Purple Slag, 3.5" tall 3.5" long, Circa 1971-1976, **$35.00**

Pig - sow #1 (former Heisey mould), Ultra Blue, 3.25" tall 4.5" long, Circa 1983, **$145.00**

120 Imperial Glass

Pig - detail of mark on sow (former Heisey mould) showing the ALIG mark.

Rabbit (former Heisey mould), 4.5" tall 5.5" long.
Top: Milk Glass, Circa 1978, **$60.00**
Bottom left: Red, Circa 1977, **$450.00**
Bottom right: Ultra Blue, Circa 1982, **$350.00**

Pig - sow #1 (former Heisey mould), 3.25" tall 4.5" long.
Top: Pink, Circa 1984, **$375.00**
Center left: Amber Satin, Circa 1983, **$275.00**
Center right: Sunshine Yellow, Circa 1983, **$395.00**
Bottom left: Black, Circa 1984, **$450.00**
Bottom center: Ruby, Circa 1984, **$395.00**
Bottom right: Ultra Blue, Circa 1983, **$145.00**

Rabbit (former Heisey mould), 4.5" tall 5.5" long.
Top: Sunshine Yellow, Circa 1983, **$250.00**
Bottom left: Verde Green, Circa 1982, **$225.00**
Bottom right: Carmel Slag, Circa 1982, **$300.00**

Left: Piglet - sitting (former Heisey mould), Amber, 1.1" tall 1" long, Circa 1984, **$75.00**
Left center: Piglet - sitting (former Heisey mould), Sunshine Yellow, 1.1" tall 1" long, Circa 1984, **$60.00**
Right center: Piglet - standing (former Heisey mould), Ultra Blue, 1" tall 1.25" long, Circa 19883, **$35.00**
Right: Piglet - standing (former Heisey mould), Ruby, 1" tall 1.25" long, Circa 1984, **$135.00**

Top: Rabbit - bunny - head down (former Heisey mould), Milk Glass, 2.4" tall 3" long, Circa 1977, **$35.00**
Bottom left: Rabbit - bunny - head down (former Heisey mould), Carmel Slag, 2.4" tall 3" long, Circa 1982-1983, **$75.00**
Bottom right: Rabbit - bunny - head up (former Heisey mould), Ultra Blue, 2.5" tall 2.5" long, Circa 1982, **$60.00**

Imperial Glass 121

Rabbit paper weight (former Heisey mould), 2.75" tall 3.6" long.
Left:, Horizon Blue, Circa 1984, **$175.00**
Right: Milk Glass, Circa 1977, **$85.00**

Sparrow (former Heisey mould), Crystal, 2.1" tall 4" long.
Top left: Meadow Green, Circa 1980, **$95.00**
Top right: Horizon Blue, Circa 1984, **$75.00**
Bottom left: Ultra Blue, Circa 1983, **$95.00**
Bottom right: Ruby, Circa 1983, **$125.00**

Shakers - lady & man #1950/267 (pair number), Cobalt Carnival, 5.75" tall 2.5" wide, Circa 1975.
Left: "Salz" shaker (Snow woman) #1950/266
Right: "Pfeffer" shaker (Snowman) #1950/265, **$65.00** pair

Swan #27/147, 4" tall 4.75" long Circa 1950s.
Top: Rose, Circa 1920s, **$16.00**
Center left: Crystal Satin, Circa 1920s, **$12.00**
Center right: Pink Milk Glass Satin, Circa 1950s, **$18.00**
Bottom left: Milk Glass Satin, Circa 1950s, **$14.00**
Bottom center: Custard Satin, Circa 1950s, **$18.00**
Bottom right: Crystal, Circa 1920s, **$12.00**

Sparrow #400, Horizon Blue, 2.1" tall 4" long, Circa 1984, **$75.00**

Swan - detail of labels on the bottom.

122 Imperial Glass

Swan #27/147, 4" tall 4.75" long Circa 1950s.
Top: Crystal, **$14.00**
Bottom left: Blue, **$18.00**
Bottom right: Amethyst Carnival, **$18.00**

Swan #400, Carmel Slag, 5" tall 9.5" long, Circa 1969-1976, **$125.00**

Swan #27/147, 4" tall 4.75" long, Circa 1950s.
Top: Crystal Satin, **$12.00**
Center left: Ruby, **$24.00**
Center right: Green, **$14.00**
Bottom: Black, **$20.00**

Swan #400, 5" tall 9.5" long.
Top: Amethyst Carnival, Circa 1981, **$65.00**
Bottom: Purple Slag, Circa 1969-1975, **$150.00**

Swan #27/147, 4" tall 4.75" long, Circa 1950s.
Top: Milk Glass, **$14.00**
Bottom left: Forget Me Not Blue (blue milk glass), **$18.00**
Bottom right: Amber, **$12.00**

Swan #400, Pink Carnival, 5" tall 9.5" long, Circa 1978-1983, **$60.00**

Imperial Glass 123

Swan #400, Rubigold Carnival, 5" tall 9.5" long, Circa 1965-1971, $60.00

Swan - baby (former Heisey "Cygnet" mould), 2.25" tall 2.5" long.
Top: Horizon Blue, Circa 1980, **$35.00**
Left: Carmel Slag, Circa 1982-1983, **$60.00**
Right: Black, Circa 1984, **$75.00**

Swan (former Heisey mould), 7.5" tall 8.25" long.
Left:, Ruby, Circa 1983, **$1,650.00**
Left: Horizon Blue, Circa 1984, **$850.00**

Swan "Crystolite" handled pitcher #1503 1/2 (former Heisey mould), Stiegel Green, 9.5" tall 64 oz., made for Smithsonian Institute in 1980, **$125.00**

Swan - baby (former Heisey "Cygnet" mould), Pink, 2.25" tall 2.5" long, Circa 1981, **$45.00**

Swan "Crystolite" jelly or candy (former Heisey mould), Ultra Blue, 3.5" tall 8.5" long, Circa 1981, **$45.00**

124 Imperial Glass

Tiger - paperweight on bust off base (former Heisey mould), Nut Brown, 5" tall 8" long, Circa 1984, **$350.00**

Turkey #149 (covered dish), Rubigold Carnival, 4.75" tall 6" long, Circa 1965-1970, **$68.00**

Tiger - paperweight (former Heisey mould), 2.8" tall 8" long
Left: Light Blue, Circa 1996, **$175.00**
Right: Yellow Mist, Circa 1997, **$125.00**

Venus Rising, 6.5" tall 3.25" wide at base, marked "I.G. 81", made for Mirror Images (adapted from a Cambridge mould), Circa 1981.
Left to right: Pink, **$35.00**, Opaque Blue, **$35.00**, Jade, **$45.00**, Carmel Slag, **$85.00**

Tiger - paperweight (former Heisey mould), 2.8" tall 8" long.
Top: Amber, Circa 1983, **$195.00**
Center left: Jade, Circa 1980, **$175.00**
Center right: Ruby, Circa 1980, **$350.00**
Bottom: Black, Circa 1982, **$195.00**

Woodchuck #43949, Carmel Slag, 4.5" tall 2.5" wide, Circa 1969-1977, **$60.00**

Indiana Glass Company 1909-Present

A glass company was begun in 1896 in Dunkirk, Indiana, as Beatty-Brady Glass Company. Incorporation took place in 1909 when the name was changed to Indiana Glass Company. Items first offered included restaurant ware and items for soda shops.

During the 1920s, Indiana produced glass panthers that are hard to find today. In the 1930s, they were a major producer of "depression glass" patterns. While continuing to make tableware items, Indiana was also a major producer of automotive glass in the 1940s. Then, with a decline in glass sales to car manufactures in the 1950s, Indiana successfully returned to the production of giftware lines.

Lancaster Colony purchased Indiana Glass in 1961. In the 1970s, old patterns, like Kings Crown and a line of Carnival Glass, were brought back into production. Tiara Exclusives was an extension of Indiana, offering special items at home parties. When Lancaster Colony also purchased Imperial Glass in 1984, and Fostoria Glass in 1981, several of their old moulds were utilized to make different items for the Tiara catalog.

Today, Lancaster Colony survives by adapting to changes in the market and offering glassware for everyday use. Lancaster Colony glass is found today in Walmart, Target, and Kmart national discount stores.

Horse Head - bookends, Crystal, 6" tall, Circa 1940s-1950s, **$75.00** pair

Panther, Blue, 3" tall 7" long, Circa 1930s, **$375.00**

Panther, Amber, 3" tall 7" long, Circa 1930s, **$275.00**

Pigeon - bookend, Crystal Satin, 5.8" tall 3.5" wide, Circa 1940s, **$48.00** pair

Jeannette Glass Company 1920s-Present

Jeannette Glass Company began as a bottle factory in Jeannette, Pennsylvania. In the 1920s, the company changed its focus to making tableware. By investing in automatic machinery, it rose to the top among glass producers and by 1927 all hand-production was ended.

By the 1950s, Jeannette Glass still produced tableware and expanded into different giftware and novelty lines. Jeannette purchased the McKee Glass Company in 1961 from Thatcher Glass, and the following year Jeannette completed the move into the old McKee facility. Jeannette Glass continues today producing glassware for the home.

Eagle - candlestick #3423, Shell Pink (pink milk glass), 3.1" tall 3" wide, Circa 1958-1959, **$35.00** each

Left: Butterfly small #3490 (individual nut dish), Crystal with gold trim, 3.5" wide 4.5" long, Circa 1940s-1950s, **$5.00**
Right: Butterfly large #3432 (master nut dish), Crystal with gold trim, 7" wide 7.75" long, Circa 1940s-1950s, **$10.00**

Pheasant - three footed bowl, Crystal, 3" tall 7.9" wide, Circa 1950s-1960s, **$25.00**

Kanawha Glass Company 1955-1985

When Dunbar Glass closed in 1953, former manager D. Merritt and a few of the Dunbar employees saw it as an opportunity to start over. Together they worked out a plan to establish a new glass company in nearby Kanawha, West Virginia, and in 1955 their dream was realized. Soon, colorful glassware was being made. While crackle glass was the bulk of their business, glass animals, baskets, and vases were also produced.

In 1985, Kanawha Glass Company was still selling glass, the business was sold to the Raymond Dereume Glass Company.

Cat #834, Blue, 5" tall 2.25" long, Circa 1960s-70s, **$24.00**

Bird on nest #828, Dark Blue, 2.75" tall 4.75" long, Circa 1960s-70s, **$18.00**

Dog "Scottie" #907, Blue, 2.75" tall 3" long, Circa 1960s-70s, **$24.00**

Bird on nest #828, 2.75" tall 4.75" long, Circa 1960s-70s.
Left: Red, **$20.00**
Right: Amber, **$16.00**

Donkey #876, Blue, 3.5" tall 5" long, Circa 1960s-70s **$28.00**

128 Kanawha Glass

Horse Head #910, Amber, 3.1" tall 3" long, Circa 1968, **$12.00**

Praying Hands, Blue, 5" tall 3.5" wide, Circa 1960s-70s, **$14.00**

Owl, Dark Green, 4" tall 1.75" long, Circa 1960s-70s, **$16.00**

Detail of label found on the Lady with dog #933.

Lady with dog #933, Blue, 8.6" tall 5.25" long, Circa 1960s-70s, **$75.00**

Swan #5 solid glass, Dark Green, 3.25" tall 4.25" long, Circa 1960s-70s, **$15.00**

Swan #5 solid glass, 3.25" tall 4.25" long, Circa 1960s-70s.
Top: Ruby, **$18.00**
Bottom left: Amber, **$9.00**
Bottom right: Dark Green, **$15.00**

Kemple Glass Company 1945-1970

John and Geraldine Kemple began planning to open a glass company soon after they married in 1941. Two buildings in East Palestine, Ohio, were leased in 1945 after moulds were purchased from the closed Mannington Art Glass Company.

In 1946, additional moulds were purchased from H.M. Tuska, a glass distributor, and about 30 moulds were purchased from McKee Glass over time from 1950 to 1957. In 1958, 25 moulds were obtained from Haley and 30 more from Sinclair. Whenever possible, the moulds were marked with a "K" for Kemple. All their glass production left the factory with a Kemple sticker.

Milk glass was made at Kemple originally, but after the factory was destroyed in 1956, Kemple purchased the old Gill Glass Works in Kenova, West Virginia, and they added colored glass to their milk glass line.

When John Kemple died in 1970, Geraldine Kemple felt it was time to sell the business. Frank Wheaton, of Wheaton Glass Company in Millville, New Jersey, realized the value and importance of the Kemple moulds and made her an offer. For a short time, some glass items were made in the moulds. The Wheaton Historical Association, a division of Wheaton Glass Company, acquired the moulds in 1975 and has put them safely in storage.

Deer #251 (from old Haley mould), Amber, 6.75" tall 5.5" long, Circa 1960-1970s, **$75.00**

Colonial Lady #162, Crystal, 4.75" tall 3" wide, Circa 1971-1979, **$35.00**

Victorian Lady #164, Crystal, 4.75" tall 3" wide, Circa 1971-1979, **$45.00**

King Glass Company 1859-1891

Cascade Glass Works opened for business in 1859, in Pittsburgh, Pennsylvania. Started by partners Johnson and King, the company went through several name changes and was incorporated and renamed King Glass in 1888. Three years later, King Glass joined the United States Glass conglomerate and became known as Factory K.

Elephant Head - match safe, Amber, 4.5" tall 4.6" wide, Circa 1889, **$60.00**

Libbey Glass Company 1818-Present

Libbey Glass Company started as New England Glass, in 1818. The factory moved to Toledo, Ohio, and was renamed Libbey in 1892. In the early years, brilliant cut glass was produced. Libbey introduced their animal glass stemware line in 1933, which they called Silhouette. Douglas Nash designed this line. The animals were made in clear crystal, black, and moonstone, an opalescent crystal.

The Silhouette goblets featured Libbey's Saferidge™ rim, unlike Libbey's other goblets that had a ground and polished rim. Saferidge™ was Libbey's patented design, from 1924, that had an extra roll of glass on the rim that prevented chipping. Almost all drinking vessels today use a form of this design.

Owens-Illinois Glass purchased the Libbey Glass Company in 1935. Libbey operates under its own name today. Owens-Illinois is Americas oldest operating glass company and a major producer of glassware for the table.

Cat, Silhouette Line, Crystal Satin, 10 oz water goblet, 7" tall, Circa 1933, **$200.00**

Kangaroo, Silhouette Line, Crystal opalescent, 3.5 oz cocktail goblet, 5.8" tall, Circa 1933, **$175.00**

Monkey, Silhouette Line, Crystal opalescent, 3 oz sherry goblet, 7" tall, Circa 1933, **$150.00**
Not pictured but also part of the Silhouette line include the following:
Bear, 4 oz claret, 5.5" tall
Camel, 6" tall candlestick
Elephant, 10" wide footed bowl
Giraffe, 6" tall comport
Greyhound, 1.5 oz cordial, 4" tall
Rabbit, 5 oz champagne, 4" tall and a 10" tall vase
Squirrel, 5 oz champagne, 4" tall and a 5.5 oz hollow stem champagne, 5.5" tall

Eagle, Crystal, 5.5 oz champagne goblet, 5.5" tall, Circa 1971, **$15.00**

Old Crow, Crystal, goblet, 6.25" tall, Circa 1970s, **$18.00**

McKee Glass Company 1853-1951

McKee Glass Company was founded in 1853, in Pittsburgh, Pennsylvania. When huge natural gas fields were discovered in Westmoreland County, Pennsylvania, in 1888, the glass factory was moved there to a new town called Jeannette, named after McKee's wife. The large factory produced a variety of glass items such as banks, bottles, candlesticks, jars, drawer pulls, and lamp parts. The com-

Crab Shell seafood baking dish, Crystal, 5" wide, Circa 1924-1934.
Left: Crab Shell, **$6.50**
Right: Original box that a set of six came packaged in.

Crab seafood server (shaped like a lobster), Crystal, 9.75" long 5.25" wide, Circa 1924-1934. Marked with "Glassbake" trademark, **$28.00**

pany gradually also produced tableware patterns, kitchenware, and ovenware.

In the 1929, McKee produced the Louvre glass line that was inspired by the exhibit of Rene Lalique's art glass in Paris. These items have a sculptured effect designed by Paul Sailer and a stain finish. They include the Dance Lumiere lamp and Jolly Golfer pieces. Thatcher Glass purchased the McKee Glass Company in 1951.

132 McKee Glass

Danse De Lumiere (electric lamp), Green Satin, 11" tall 9.8" wide, Circa 1926, **$750.00+**

Fish Baker, 17.75" long 8.5" wide. Marked on the bottom: USA Glassbake #4141, Circa 1924-1934.
Top: Crystal, **$19.50**
Bottom: Milk Glass, **$24.50**

Jolly Golfer, Circa 1926.
Left: covered tumbler, Pink Satin, 3.8" tall 3" wide, **$145.00**
Center: decanter (missing hat stopper), Pink Satin, 11" tall 4" wide, **$250.00**
Note, complete decanter with hat stopper is $600.00
Right: tumbler, Green Satin, 3.5" tall 3" wide, **$85.00**

Jolly Golfer, covered tumbler, Pink Satin, 3.8" tall 3" wide, Circa 1926. **$145.00**
The lid (hat) was made to be removed and used as a coaster or ashtray.

Jolly Golfer, Circa 1926.
Left: covered tumbler, Pink Satin, 3.8" tall 3" wide, **$145.00**
Right: tumbler, Green Satin, 3.5" tall 3" wide, **$85.00**

Morgantown Glass Works 1899-1971

Morgantown, West Virginia, was the site where the Morgantown Glass Works was established in 1899. Among their first glass production were tableware, stemware, bar bottles, and whiskey jugs. When the Prohibition era in America ended, many stylish drink sets were made in vibrant colors that attracted customers.

In the 1940s and 1950s, Morgantown Glass concentrated heavily on blown stemware in many patterns and colors. The Chanticleer cocktails were one such line in which stems were sold in a set of eight different pastel colors; their bowls and feet were colored while the rooster was clear crystal. The dark ruby and cobalt sets also were sold in a set of eight, including four of each color; but in them only the bowl was colored.

During the late 1950s and through the 1970s, decor for the home was their main products. Fostoria bought the Morgantown Glass company in 1965, but operated it under its own name. In 1971 the Morgantown division was closed, due to declining sales.

Chanticleer Stem, Green bowl, Crystal stem & Green foot, 3.8" tall 4 oz., Circa 1950s, **$45.00**

Chanticleer Stem, 3.8" tall 4 oz., Circa 1950s. All eight pastel colors done with colored bowl and foot (having crystal rooster stem).
Top Left: Amethyst, **$45.00**
Top Right: Blue, **$45.00**
Center Left: Olive, **$45.00**
Center: Pink, **$45.00**
Center Right: Smoke, **$45.00**
Bottom Left: Amber, **$45.00**
Bottom Center: Blue, **$45.00**
Bottom Right: Green, **$45.00**

Chanticleer Stem, Ruby bowl, Crystal stem & foot, 3.8" tall 4 oz., Circa 1950s, **$50.00**

Top Hat Stem, colored bowl & foot, Crystal stem, 5.1" tall 4.5 oz., Circa 1950s,
Left: Amethyst, **$65.00**
Center: Green, **$65.00**
Center: Topaz, **$65.00**
Right: Blue, **$65.00**

Jockey Stem, Crystal bowl & foot, Topaz stem, 5.5" tall 6 oz., Circa 1950s, **$60.00**

Mosser Glass Company 1971-Present

Tom Mosser started working at Cambridge Glass at the age of 16. After Cambridge Glass closed, Tom helped to start the Variety Glass Company in 1959, and now is its sole owner. Variety Glass made medical and scientific glassware.

Tom Mosser got back into the glass giftware business when he purchased land, in 1971, along Route 22 in Cambridge, Ohio. A new factory was built and Tom's whole family became involved. They make giftware and novelty items in many different colors and some of their items are marked with their trademark "M."

At the L.G. Wright auction in 1999, Tom bought several moulds, but only one was an animal shape. He astounded everyone by bidding $10,000 for the covered turkey mould, and now the glass turkey is in their catalog in cobalt color.

Angel #219, Crystal Opalescent, 3.4" tall 2.5" wide, Circa 2001-current, **$14.50**

Bird in Flight #175, Amethyst, 5.8" tall 5" long, Circa 2001-current, **$10.00**

Cat #101, 3" tall 1.75" wide, Circa 1990-current.
Top: Crystal, **$8.00**
Center row: Blue Carnival, **$9.00**; Vaseline, **$9.50**; Green Satin, **$8.00**
Bottom row: Cobalt, **$8.00**; Red Satin, **$10.50**; Green Slag, **$11.00**; Red, **$10.00**

Bird - Cardinal #177, 5.4" tall 4.5" long, Circa 1990s-current.
Left: Red, **$18.00**
Right: Green, **$15.00**

Mosser Glass 135

Dog - Collie, Pearlized Milk Glass, 3.25" tall 2" wide, Circa 1980s, **$12.50**

Elephant #166, 1.8" tall 2.5" long, Circa 1980s to early 1990s.
Left: Amber **$5.00**
Right: Chocolate **$6.50**

Frog #121, Hunter Green, 2.5" tall 4.5" long, Circa 1990s-current, **$11.00**

Donkey #150, Teal, 3" tall 3.25" long, Circa 1990s-current, **$11.00**

Horse - pony, Vaseline, 5.5" tall 2.75" long, marked with M, Circa 1980-1990s, **$18.00**

Elephant with trunk up, Green Slag, 3.3" tall 4" long, Circa 1980s, **$28.00**

136 Mosser Glass

Lion #184, Chocolate Carnival, 3.25" tall 3.4" long, Circa 1980s, **$12.00**

Pheasant #136, Willow Blue, 4" tall 5" long, Circa 1990s-current, **$13.50**

Owl #137, Cobalt Carnival, 4" tall 2.25" long, Circa 1980s, **$15.00**

Pigeon - Pouter (miniature bookend), Cobalt, 2.75" tall 2.5" long, Circa 1995, **$10.00** to **$12.00** range for all colors

Owl, Vaseline #124, 4" tall 2.25" long, Circa 1998, **$18.00**

Rabbit #191, Rose, 2.25" tall 3.25" long, Circa 1990s & current, **$8.00**

Mosser Glass 137

Rabbit holding basket #219, Jade, 5.3" tall 2.25" wide, Circa 1990s-current, **$14.50**

Ram head #157 (copy of the Heisey stopper), Cobalt, 3.8" tall 2.25" long, Circa 1990s, **$8.50**

Soldier #169, Ruby, 2.6" tall 1.25" wide, Circa 1990s & current, **$8.50**

Swans #118 (former Cambridge mould), 2" tall 3.5" long, Circa 1990s.
Top row: Crystal.
Center row: Green, Amber.
Bottom row: Pink Satin, Blue, Amber Satin, **$12.00-$15.00**

Contract work: Bimbah Elephant, Cobalt Carnival, 4" tall 2.25" long, Circa 1980. Made for Robert T. Henry, President of Henry's Bimbah Collectible Art Glass Inc. This limited issue started in July 1980. A new color was issued once a month and continued until 24 colors were made. The mould was retired in June 1982 and placed in the Fort Wayne, Indiana Historical Museum. $15.00-$24.00

Covered Turkey #402 (former L.G. Wright mould), Cobalt, 8.25" tall 8.5" long, Circa 2001 & current, **$45.00**

Contract work: Elephant, Red, 2.4" tall 3.1" long, Circa 1973. Marked on base with M inside a circle for Mosser followed by the initials and date of EWR 73. $24.00

New Martinsville Glass Company 1901-1944

Mark Douglas and George Matting, both formerly associated with Specialty and West Virginia Glass Company, came to New Martinsville, Ohio, in November of 1900, with hope to establish a new glass company. They opened New Martinsville Glass Company in 1901, producing lamps, novelties, and tableware. David Fisher became general manager in 1908 but left in 1916 to form Paden City Glass. He took with him some of the better-skilled employees.

During 1926, New Martinsville introduced the glass cat and dog decanters as the first of their many animal designs. They also made beer mugs, ashtrays, and pipe rests. In 1932, a local theater gave away glass items at its matinees. The elephant incense burner appeared about this time, along with the early version of the police dog.

Strong sales of Moondrops and Radiance glassware sustained the company through the 1930s. For several years, New Martinsville had been making glass figurines for several other companies and eventually decided to market their own, after watching their success. In 1940, the Janice line premiered, some featuring swan heads. The horse and tiger glass bookends were also made in 1940. Three bears and a police dog were introduced in 1941. The following year a chick, a hen, a rooster, a seal, and a squirrel were added.

When a flood damaged the glass plant in 1943, reorganizing and refinancing became impossible, so the factory was closed in 1944.

Bear - Baby #487 (head straight) with cart, Crystal, 3" tall 4.25" long, Circa 1941-1944, **$75.00** set

Bear - Mama, Crystal, 4" tall 6" long, Circa 1941-1944, **$130.00**

Bear - Baby #487 (head turned), Crystal, 3" tall 4.25" long, Circa 1941-1944, **$45.00**

Bear - Papa, Crystal, 4.5" tall 6.75" long, Circa 1941-1944, **$250.00**

New Martinsville Glass 139

Chick #667, Crystal, 1" tall 1.25" long, Circa 1941-1944, **$25.00**

Chicken - rooster with curled tail #668, Crystal, 7.25" tall 8" long, Circa 1942-1944, **$85.00**

Chick #667, Red (Note, shows some yellow that some people incorrectly refer to as Amberina), 1" tall 1.25" long, Circa 1941-1944, **$35.00**

Dog - Police (German Sheppard) on rectangle base #733 bookend, Crystal, 5" tall 4.9" long, Circa 1941-1944, **$75.00** each
Left: side view
Right: front view

Chicken - hen with head down #669, Crystal, 5.25" tall 5" long, Circa 1941-1944, **$65.00**

Dog - Wolfhound bookend #716, Crystal, 7.25" tall 9.25" long, Circa 1942, **$95.00** each

140 New Martinsville Glass

Dog - Wolfhound bookend #716, Crystal with "Charleton" hand painted floral decoration, 7.25" tall 9.25" long, Circa 1942, **$145.00** each

Close up of label found on the blue elephant incense burner #201. The label says the following: "Fleurs de Mai - SELS de BAIN - Verlys - Paris - New York".

Elephant #237, Crystal, 5.25" tall 5.25" long, Circa 1942-1944, **$95.00**

Horse - bookend, Crystal, 7.25" tall 6" long, Circa 1940-1944, **$95.00** each

Elephant incense burner #201, 5.75" tall 6.5" long.
Left: Green, Circa 1930- early 1940s, shown with lid off and sitting to the left of figure, **$350.00**
Right: Blue, Circa 1930- early 1940s. Note, has original label (one with this label would add, $50.00 to the value), **$350.00**

Hunter #487 (later called the Woodsman), Crystal, 7.4" tall 4" wide, Circa 1941-1944, **$115.00**

New Martinsville Glass 141

Pelican #761, Crystal, 8" tall 5.25" wide, Circa 1942-1944, **$95.00**

Rabbit - Mama, Crystal, 3" tall 5.25" long, Circa 1942-1944, **$300.00**

Pig - Mama #762, Crystal, 4" tall 6.25" long, this is a large piece of glass weighing in at 3.5 lbs, Circa 1941-1944, **$250.00**

Rabbit - Baby, Crystal, 2.75" tall 3.5" long, Circa 1942-1944, **$75.00**

Porpoise #766 (looks like waves on base), Crystal, 6" tall 6" long, Circa 1942-1944, **$150.00**

Left: Seal with ball #452 (Note, even though listed as a seal they are actually resemble a Sea Lion), Crystal, 7.25" tall 5.75" long, Circa 1942-1944, **$80.00**
Center: Seal with ball candlestick #452, Crystal, 4.4" tall 3.5" long, Circa 1942-1944, **$40.00** each
Right: Seal with ball #452, Crystal satin, 7.25" tall 5.75" long, Circa 1942-1944, **$80.00**

142 New Martinsville Glass

Ship bookend, Crystal, 5.6" tall 4.6" wide, Circa 1930s, **$45.00** each

Swan #974, Red with Crystal head & neck, 5.25" tall 6" long, Circa 1940s, **$35.00**

Squirrel #674, Crystal, 4.5" tall 5.5" long, Circa 1942-1944, **$85.00**

Swan dish #974, 4.75" tall 6.5" long, Circa 1940s.
Top: Amber with Crystal neck/head, **$28.00**
Bottom left: Yellow with Crystal neck/head, **$32.00**
Bottom right: Emerald Green with Crystal neck/head, **$35.00**

Squirrel on rectangle base #670, Crystal, 5.5" tall 6" long, Circa 1942-1944. **$65.00**

Swan ashtray #412, Crystal, 2.75" tall 4.25" long, Circa 1940s, **$18.50**

New Martinsville Glass 143

Swan "Janice" low crimped candy #4541-1CSJ, Crystal with Cobalt neck/head, 5.25" tall 7.25" long, Circa 1940-1944, **$75.00**

Swan "Janice" two headed celery dish #4521-2SJ, Crystal with Cobalt necks/heads, 3.25" tall 12.25" long, Circa 1940-1944, **$85.00**

Swan "Janice" low candy #4541-1SJ, Crystal, 6.75" tall 7.25" long, Circa 1940-1944, **$40.00**

Swan "Janice" oval bowl #4521-1SJ, Crystal, 7.25" tall 11.5" long, Circa 1940-1944, **$48.00**

Swan "Janice" bowl #4551-1SJ, Crystal, 9.75" tall 11" long, Circa 1930-1970, **$85.00**

Tiger, Crystal, 6.75" tall 8" long, Circa 1942-1944, **$175.00**

Northwood Glass Company 1887-1925

Harry Northwood was the son of John Northwood, a designer of Cameo glass for the English company Stevens and Williams. Harry immigrated to the United States in 1881 and spent his early years in American working for Hobbs, Brockunier and LaBelle Glass companies. In 1887, along with several wealthy investors, Harry founded the Northwood Glass Company.

Colored pattern and opalescent glass was made first. Their carnival glass production started in 1909, a full year behind Fenton, and sales remained high until 1915. During this time Northwood's swan appeared.

After Harry died in 1919, financial problems caused the firm to struggle. A new color line, called Rainbow Ware, was brought out in 1924 with brightly colored pieces in a variety of shapes. The #595 turtle block was part of this line. Even though the stores loved the new line, overall sales for the company still declined. In addition, costs from renovations still had not been recovered, and the Internal Revenue Service was investigating the company. With no investors in sight to help through this difficult time, Northwood closed in 1925. The moulds for both the swan and turtle figurines were later sold to Fenton.

Swan, Green Carnival, 3.8" tall 4.75" long, **$35.00**

Turtle Flower Frog, Blue, 1.25" tall 4" long, Circa early 1920s, **$60.00**
Note, after Northwood closed Fenton Art Glass company purchased this mould and made it in several colors. Fenton made one change to the mould, adding two holes to the six existing holes found on the Northwood turtle.

Paden City Glass Company 1916-1951

After leaving the New Martinsville Glass Company in 1916, David Fisher worked to get a new glass factory built in Paden City, West Virginia, where operation of the Paden City Glass Company began in November of 1916. Upon David Fisher's death in 1933, his son, Sam Fisher, took over control of the company.

Paden City made glass primarily for other glass companies and distributors, but other companies also made glass for Paden City. Thus, there has been a great deal of confusion in the past in identifying Paden City glass products. With private mould work, the contracts might have been switched between Paden City Glass and New Martinsville Glass.

Another point of confusion concerns Harry Barth, who left New Martinsville to form Barth-Art. At times he designed some moulds, sent them to Paden City to have the pieces made, and then had them returned to him for finishing. He sold them under his own company name. At other times, Harry Barth designed moulds just for the Paden City Company. Hopefully, someday catalogs will be found to provide much-needed answers to the questions that arise.

As sales at Paden City grew, so did their need to expand. Paden City bought the nearby American Glass Company in what should have been a wonderful expansion. Unfortunately, it turned into a financial nightmare forcing the company to close in 1951.

Bear - Polar, Crystal, 3.8" tall 6" long, Circa 1940s, **$85.00**

Bird - long tailed, left side view, Blue, 4.75" tall 6.75" long, Circa 1940s, **$85.00**

Duck, Crystal, 3.4" tall 11.1" long, divided bowl, Circa 1940s, **$95.00**

Chicken - Rooster finial stopper and cocktail shaker (pictured with Ardith etching on bottle), Crystal, 12.25" tall, Circa 1940s, **$195.00**

Bottom left: Chicken - Rooster on rectangle base, Blue, 9.5" tall 7" long, Circa 1940s, **$350.00**

Bottom center: Chicken - tall Rooster on rectangle base, Blue, 11.25" tall 6" long, Circa 1940s, **$450.00**

Chicken - Rooster on oval base, Crystal, 8.5" tall 7" long, Circa 1940s, **$165.00**

146　Paden City

Eagle Head - bookends, Crystal, 7.25" tall 4.75" long Circa 1940s, **$300.00** each

Goose on bust off base, Blue, 6.5" tall, Circa 1940s, **$145.00**
Not pictured - Goose with normal base, $95.00

Horse - Pony, Blue, 11.75" tall 5.5" long, Circa 1940s, **$195.00**

Horse - Pony, 11.75" tall, Circa 1940s.
Left: Crystal Satin, $85.00
Right: Crystal, $95.00

Horse- Rearing, Crystal, 9.5" tall 5" long, Circa 1940s, **$450.00+**

Pelican, Crystal, 10" tall 5.75" long, Circa 1940s, **$700.00+**

Pheasant with head turned, Blue, 7" tall 13" long, Circa 1940s, **$175.00**

Pheasant - Chinese, Dark Blue, 5.75" tall 13.25" long, Circa 1940s, **$225.00**

Pigeon - Pouter, Crystal, 5.6" tall 5" wide, Circa 1940s, **$125.00**

Pheasant - Chinese, Crystal, 5.75" tall 13.25" long, Circa 1940s, **$95.00**

Pheasant - Chinese, Blue, 5.75" tall 13.25" long, Circa 1940s, **$175.00**

Rabbit - Bunny with ears back cotton ball dispenser, 5.1" tall 5.25" long, Circa 1940s.
Top: Crystal Satin, **$85.00**
Bottom left: Pink Satin, **$98.00**
Bottom right: Blue Satin, **$98.00**

148 Paden City & Pairpoint

Squirrel on log #677, Crystal Satin, 5.5" tall 6" long, Circa 1940s, **$60.00**

Seahorse bookend, Crystal, 8.2" tall 4" wide, Circa 1940s, **$125.00** each

Swan - Dragon, Blue, 6.5" tall 9.75" long, Circa 1940s, **$600.00+**

Starfish - bookends, Crystal, 7.75" tall 7.5" wide, Circa 1940s, **$195.00** pair

Pairpoint Glass Company 1880-Present

The principal owners of the Mt. Washington Glass Company founded the Pairpoint company in 1880. It originally was established to provide a line of silver-plated tableware and to make accessory silver-plated parts (handles, etc.) for Mt. Washington glass pieces. Named after its chief designer, Thomas Pairpoint, the company grew rapidly. In 1894, it made more sense to operate the companies as one, rather than two, so they were merged and retained the Pairpoint name.

During the early years, Pairpoint Glass Company made only high quality, expensive glassware. As the American Depression approached, Pairpoint suffered huge losses and in 1939 it was sold to Robert Gunderson and renamed Gunderson Glass Works. Sales returned and the company was again profitable. In 1952, the company was renamed Gunderson-Pairpoint. The factory needed major repairs in 1956, but their expense was too great so the company was moved to East Wareham, Massachusetts, in 1957. A brand new facility was built in 1970, in Sagamore, Massachusetts, and was given a new name, Pairpoint Crystal Company.

A characteristic identifying technique of Pairpoint has been the use of a controlled air bubble in their glass. To make the bubble, molten glass is poured into a round ball mould that contains spikes. The spikes cause an air bubble to remain trapped in the glass. This special ball can then be attached to another shape to create a unique design.

Bird with controlled air bubbles, Crystal, 13.4" tall 4.75" long Circa 1930s, **$175.00**

Pilgrim Glass Company 1949-2001

Alfred Knobler worked for the Trenton Potteries after he graduated from college in 1938, and during World War II he worked for the U. S. military War Department. He started a company to supply glassware to retail stores after the war. In 1949, Knobler purchased the Tri-State Glass Manufacturing Company in Huntington, West Virginia, and renamed it Pilgrim Glass. Later, he bought land in Ceredo, West Virginia, where he built a new factory that opened in 1956.

The main product of Pilgrim Glass was hand-blown, brightly colored glass animals. In the late 1960s, cranberry glass was brought in to the line for the first time. Cameo glass was introduced in 1985 in an attempt to enter the art glass market.

Knobler spent a few years searching for a buyer for his company and was associated with the Smith Glass Company in 2001. When a sales agreement did not materialize, Knobler closed the factory so he could retire.

Bear, Black, 3.2" tall 2" wide, Circa 1970s, **$12.50**

Dog, Olive Green, 3.2" tall 3.5" long, has original paper label, Circa 1970s, **$8.00**

Fish "Lucerne" #906, Crystal with blue fins, 5.6" tall 11.5" long, Circa 1960s, **$65.00**

Fish, Blue, 5.25" tall 3.25" long, Circa 1970s, **$19.50**

Owl, Cobalt, 3.8" tall 1.6" wide, Circa 1960s, **$12.50**

Princess House Company 1963-Present

Charlie Collis started the home-party sales plan of Princess House in Massachusetts, in 1963. His idea was to give women an opportunity to have their own business by being a "princess" in their house. The founder wanted every woman to be able to afford fine glassware.

Originally, the Princess House company purchased glass from other companies, but as they grew the need to make their own glass became apparent. In 1972, Princess House purchased the Louie Glass Company, of West Virginia. This factory was the largest supplier of hand-blown glass in the United States, and the arrangement worked well for 30 years.

In 1978, Charlie Collis sold Princess House to Colgate-Palmolive where it operated under its own name. Colgate-Palmolive sold Princess House in 1994 to a group of investors that owns it still. In order to focus on its primary goal of providing women with business opportunity, the investors sold the glass-making division to a new company, called Glass Works WV, in 2000. Glassworks WV continues to make glass for Princess House and also develops products for the greater glass market.

Most of the Princess House glass pieces are not marked. The original "Pets" line pieces have only a Princess House paper label. Animals from the "Wonders of the Wild" and "Crystal Treasures" lines are each marked with "PH" embossed on the glass. This new "PH" mark will make it easy to identify these pieces on the secondary market.

Bear "Bernie" #813 (from Pets series), Crystal, 3.5" tall 2.25" wide, Circa 1988-1998, **$29.50**

Bird #458, Crystal, 4" wide 7.75" long, Circa 1980s, **$12.00**

Bear "Brewster" #928 (from Crystal Treasures series), Crystal, 3.1" wide 2.5" long, Circa 2000-2001 (marked PH), **$25.00**

Princess House 151

Cat #811 (kitten, from Pets series), Crystal, 3.5" tall 2.6" long, Circa 1987-1996, **$29.50**

Pig "Penelope" #883 (from Pets series), Crystal, 3" tall 3.75" long, Circa 1994-1997, **$28.00**

Cow "Chloe" #817 (from Pets series), Crystal, 2.5" tall 4" long, Circa 1997, **$28.00**

Sea Lion #873 (from Wonders of Wild series), Crystal, 5.25" tall 3.25" long, Circa 1995-1998 (marked PH), **$35.00**

Dog "Puppy" #812 (from Pets series), Crystal, 1.5" tall 4.25" long, Circa 1987-1996, **$29.50**

Quality Glass Inc. 1970s

Quality Glass, Inc. was located in Cambridge, Ohio, making hand-blown lamp parts, novelties, and specialized private mould work. Advertisements in 1979 *Glass Review* issues pictured their milk glass animals. It is not known how long they were made or whether the company is still in business.

Left: Elephant, Milk Glass, 2" tall 3.6" wide, Circa 1970s, **$8.50**
Right: Frog, Milk Glass, 2.25" tall 4" long, Circa 1970s, **$9.50**

Rainbow Glass Company 1939-1972

Like Pilgrim Glass, Rainbow Glass Company started in Huntington, West Virginia. Established in 1939, Rainbow initially bought glass from other companies, decorated it to their specifications, and sold it under their own label.

A 1944 catalog shows glass made by Westmoreland, Blenko, Hocking, McKee, and consolidated all being decorated by Rainbow. Many of the Rainbow animals look like Pilgrim-made animals, and we suspect Pilgrim made some items for Rainbow, since they were located in the same town.

In 1954, Rainbow became part of the Viking Glass Company. They were allowed to operate under their own name for a while, before being completely absorbed by Viking in 1972.

Whale, Amber, 1.75" tall 5" long, Note, original paper label, Circa 1960s, **$15.00**

Owl, Dark Blue, 4.25" tall 3.75" wide, Note, original paper label, Circa 1960s, **$18.00**

L.E. Smith Glass Company 1907-Present

Lewis E. Smith, a gourmet cook, invented a special mustard formula in 1907. Wanting to market the mustard, Smith bought a former glass factory in Mt. Pleasant, Pennsylvania, and hired experienced glass workers to run the plant. Smith concentrated on marketing the mustard and sales were good until 1911, when he left to do something else.

The commitment of the employees enabled the L.E. Smith company to grow and create several tableware designs. They acquired the Greensburg Glass Works in the 1930s.

Inspired by the Hummel ceramic "Goose Girl" figurine, the L.E. Smith Company decided to make their own version in glass. In 1937 Island Mould made both a 6" and an 8" mould for them. Through the years, the Goose Girls were very popular. The moulds were modified in 1970 to add a sculptured base. Some limited edition pieces were made for Levay in 1976 and 1982. None have been made since then.

Smith has had several owners through the years. Items in the current catalog are a rooster and a covered turkey.

Angel candlestick, 4.8" tall 3.8" wide.
Left: Emerald Green, Circa 1960s, **$18.00**
Right: Red, Circa 1960s, **$20.00**

Bird in flight #4401A, 9" tall 6" long.
Left: Almond Nouveau, Circa 1980, **$45.00**
Right: Dark Blue, **$35.00**

Bird, Crystal, 2" tall 2.5" long, Circa 1950s, **$12.00**

Left: Bird head down #1409A, Almond Nouveau, 3.6" tall 4" long, Circa 1980, **$30.00**
Right: Bird head up #1409, Almond Nouveau, 3.5" tall 3.25" long, Circa 1980, **$30.00**

154 L.E. Smith

Cat ashtray, Pink, 2.75" tall 5.5" wide, Circa 1930s, **$45.00**

Dog - "Scotty" #6653, Black, 4.75" tall 5.75" long, Circa 1930s, **$60.00**

Chicken - fighting rooster, Crystal Satin, 8.5" tall 10.5" long, **$45.00**

Dog "Scotty", Milk Glass with hand painted red collar, 2.8" tall 3.5" long, Circa 1930s, **$24.50**

Chicken - rooster, Amber, 8.75" tall 6.75" long, **$45.00**

Left: Bull Dog ashtray, Black, 2.75" tall 5.5" wide, Circa 1930s, **$45.00**
Right: Terrier ashtray #1, Black, 3.5" tall 5.5" wide, Circa 1930s, **$45.00**

L.E. Smith 155

Left: Bull Dog ashtray, Green, 2.75" tall 5.5" wide, Circa 1930s, **$48.00**
Right: Terrier ashtray #1, Pink, 3.5" tall 5.5" wide, Circa 1930s, **$50.00**

Elephant, Crystal, 1.75" tall 2.4" long, Circa 1950s, **$16.00**

Dog "Scottie" creamer, Crystal, 3" tall 5.5" long, Circa 1930s, **$18.00**
Note, also can be used as a pipe rest.

Elephant, Crystal with gold, 1.75" tall 2.4" long, Circa 1950s, **$20.00**

Left: Duck cigarette box, Crystal, 4.4" tall 5.25" long, Circa 1940s, **$35.00**
Right: Duck ashtray, Crystal, 2.75" tall 4.25" long, Circa 1940s, **$12.00**

Elephant, Blue Carnival, 2.75" tall 3" long, Circa 1950s, **$28.00**

156 L.E. Smith

Elephant ashtray, Green, 3" tall 6" wide, Circa 1930s, **$45.00**

Fish - King Aquarium, Transparent Green, 10" tall 15" long, Circa 1925, **$450.00**

Goose, Black, 2.4" tall 2" long, Circa 1930s, **$24.50**

Goose Girl #6620, Green, 5.75" tall 3.75" long, small with plain base, Circa 1937-1969, **$35.00**

Goose, Crystal Satin, 4.75" tall 3.6" long, **$25.00**

Goose Girl #6620A, Pink, 5.5" tall 3.25" long, small with sculptured base, made for Levay - Limited Edition #173 of 260, Circa 1970s, **$115.00**

L.E. Smith 157

Goose Girl #6630, Crystal, 7.75" tall 5.25" long, large with plain base, Circa 1937-1969, **$35.00**

Goose Girl #6630, Amber, 7.75" tall 5.25" long, large with sculptured base, Circa 1970-1987, **$48.00**

Horse laying down front view, Dark Blue, 4.8" tall 8.5", Circa 1968, **$185.00**

Left: Goose Girl #6620, Red, 5.75" tall 3.75" long, small with plain base, Circa 1937-1969, **$35.00**
Right: Goose Girl #6630, Red, 7.75" tall 5.5" long, large with sculptured base, Circa 1970-1987, **$65.00**
Note, both show some yellow that some people incorrectly refer to as Amberina.

Horse laying down side view, Dark Ruby, 4.8" tall 8.5" long, Circa 1968, **$250.00**

Top left: Goose Girl #6630, Crystal Satin with stain color finish, 7.75" tall 5.25" long, large with plain base, Circa 1937-1969, **$75.00**
Top right: Goose Girl #6630, Crystal, 7.75" tall 5.25" long, large with plain base, Circa 1937-1969, **$35.00**
Bottom left: Goose Girl #6620, Green, 5.75" tall 3.75" long, small with plain base, Circa 1937-1969, **$35.00**
Bottom center: Goose Girl #6620, Amber, 5.5" tall 3.25" long, small with sculptured base, Circa 1970-1987, **$40.00**
Bottom right: Goose Girl #6620, Red (Note, shows some yellow that some people incorrectly refer to as Amberina), 5.75" tall 3.75" long, small with plain base, Circa 1937-1969, **$35.00**

158 L.E. Smith

Horse bookends "Rearing" #6200, Amber, 8" tall 5" long.
Left: Front view.
Right: Side view, **$78.00** pair

Left: Squirrel, Crystal, 2.25" tall 2.25" long, Circa 1950s, **$16.00**
Center: Swan, Crystal, 1.5" tall 2.25" long, Circa 1950s, **$12.00**
Right: Horse, Crystal, 2.4" tall 1.5" long, Circa 1950s, **$14.00**

Horse bookends "Rearing" #6200, Dark Blue, 8" tall 6" long.
Left: Side view.
Right: Front view, **$125.00** pair

Swan #15/10, Black with white splatter paint decoration, 3.5" tall 4.25" long, Circa 1950s, **$35.00**

Squirrel, Crystal, 2.25" tall 2.25" long, **$16.00**

Swan #15/10, 3.5" tall 4.25" long.
Top: Crystal Satin, Circa 1930s, **$10.00**
Center left: Olive Green, Circa 1970s, **$12.50**
Center right: Amber, Circa 1970s, **$12.50**
Bottom: Almond Nouveau, Circa 1980, **$25.00**

L.E. Smith 159

Swan large #3/10, Cobalt, 5.5" tall 9.25" long, Circa 1930s, **$35.00**

Swan #3/4, Crystal Lustre with limited edition with certificate of 1,000 pieces made, 6" tall 9.25", Circa 1980, **$75.00**

Swan large #3/4, 5.75" tall 9.25" long.
Top: Crystal, Circa 1930s, **$24.00**
Bottom left: Transparent Green, Circa 1930s, **$35.00**
Bottom right: Black, Circa 1930s, **$38.00**

Swan soap dish #65, Transparent Blue, 4.25" tall 8.75" long, Circa 1960s, **$28.00**

Swan large #3/4, Pink Satin with hand painted and matching flower frog, 5.75" tall 9.25" long, Circa 1920s-1930s, **$30.00** (add, $20.00 for having matching flower frog)

Turkey covered dish, 7.25" tall 6.5" long, Circa 1930s-1970s.
Back: Crystal, **$35.00**
Front left: Olive Green, **$48.00**
Front right: Emerald, **$60.00**

Steuben Glass Works 1903-Present

Frederick Carder was born in England and started work at his father's company, Leys Pottery. At age 15, he tutored under John Northwood and a few years later went to work for Stevens & Williams glassworks. In 1903 he came to New York to visit the Corning Glass Works and later met with Thomas Hawkes of Hawkes Glass. Carder and Hawkes formed their own company, Steuben Glass Works, in Corning, New York.

The early years were spent making outstanding pieces of art glass. The Steuben company is still in business today, making primarily fine crystal animals, bowls, and vases.

Gazelle #7399, Crystal, 6.4" tall 8" long, Circa 1932, **$450.00**

Dolphin hand cooler, Crystal, 2.75" tall 2.3" wide, Circa 1980s, **$175.00**

Oriental Lady #7133, Crystal, 9.25" tall 4.25" wide, Circa 1930s, **$350.00**

Eagle hand cooler #5519G, Crystal, 2" tall 2.75" wide, Circa 1983 to 1996, Designed by Lloyd Atkins, **$150.00**

Summit Art Glass Company 1972-Present

Russell and Joann Vogelsong in Ravenna, Ohio founded Summit Art Glass Company, in 1972, specializing in making novelty glass. Russell Vogelsong purchased many of the moulds from closed glass companies such as Cambridge, Imperial, Westmoreland, and St. Clair. Island Mould also has made moulds for him.

Many of his pieces were advertised as "authentic reproductions" in the *Glass Review* issues of the 1970s and 1980s. During the early years, Summit made several limited edition pieces, such as Oscar the Lion, Melanie lady figure, and Clown elephant. Each mould was made in a given number of colors before the mould was destroyed.

Their current catalog features a variety of moulds being offered in several different colors, but not on a limited edition basis. They do offer special colors available for a short time. Only a few Summit pieces bear their trademark, a "V" inside a circle.

Eagle, Crystal Satin, 4.75" tall 2.75" wide, embossed on base with "USA 1976 Bicentennial", **$18.00**

Bull Dog #78, Amethyst with red leather collar, 6.75" tall 7" long, Circa 1994, **$250.00** Several other colors were made, but are not pictured. Note, the glass is so thick that they all look like black glass, because the color only shows on the feet and ears. Price for all colors, $250.00

Top: Elephant double head toothpick #544, 2.4" tall 3.5" wide, marked with V inside a circle.
Top left: Vaseline, Circa 1998, **$12.00**
Top right: Pink Carnival, Circa 1979, **$15.00**
Bottom left: Cobalt, Circa 1998, **$12.00**
Bottom center: Red Carnival, Circa 1979, **$18.00**
Bottom right: Teal, Circa 1995, **$10.00**

Buffalo on octagonal base #Buf-1, Chocolate Glass, 3.5" tall 3.75" long, Circa 1997, **$18.00**

162 Summit Art Glass

Lion "Oscar" (on oval base), Green Carnival, 2.5" tall 4.6" long, made in 24 different colors, Circa 1979-1980, **$15.00** - **$20.00** range for colors.

Oscar (Lion on oval base), 2.5" tall 4.6" long.
Left: Vaseline Carnival, Circa 1979, **$20.00**
Right: Pink Carnival. Circa 1979, **$18.00**

Girl - Melanie, Gray & Blue Slag, 6" tall 3.5" wide, Circa 1970, **$22.00**

Rabbit #LR-1 (covered dish), Princess Purple, 4.75" tall 9" long, Circa 1998, **$45.00**

Pig standing on base #528, Cobalt, 2.5" tall 4" long, Circa 2001, **$12.00**

Pig Standing on base #528, 2.75" tall 4.25" long, Circa 1997.
Left: Chocolate Slag, **$18.00**
Right: Chocolate Slag Carnival, **$15.00**

Top: Swan (former Cambridge mould), Pink, 2" tall 3.5" long, Circa 1990s, **$15.00**
Center left: Swan #1043 (former Cambridge mould), Black, 6.75" tall 8.5" long, Circa 1990s, **$18.00**
Center right: Swan #1042 (former Cambridge mould), Red, 4.5" tall 7" long, Circa 1990s, **$20.00**
Bottom: Swan #1043 (former Cambridge mould), Chocolate Glass, 6.25" tall 9.25" long, Circa 1990s, **$25.00**

Tiara Company 1970-1998

Tiara was formed in 1970, as a division of the Indiana Glass Company, to gain a share of the home party business. Originally, dinnerware was their main product, but later novelty and gift items were added through their catalog. Many old moulds owned by Lancaster Colony, the parent company of Indiana Glass, were utilized by Tiara in new colors. Some of Tiara's moulds also were originally from Federal, Fostoria, Duncan & Miller, and Imperial. While Indiana Glass made many of the items, the Fenton Art Glass Company also made some of the glass for the Tiara catalog.

As more and more women joined the work force, the home party plan began to lose its appeal. In 1998, the home party plan was eliminated.

Man "Jolly Mountaineer" #10047, Blue, 10.25" tall 4" wide, 37 oz. decanter with tumbler, Circa 1980-1983, **$35.00**

Pigeon bookend, Azure Blue, 5.8" tall 3.5" wide, Circa 1990s, **$24.00** each

Duck ashtray #10002 (also listed as #378), Aqua, 4" tall 9" long, Circa 1980s, **$15.00**

Swan, Lime Green Carnival, 6.5" tall 7" long, Circa 1970s, **$35.00**

Elephant with dome back cover (copy of old Co-Operative Flint mould), 4.1" tall 7.5" long, Circa 1980s.
Left: Light Blue Satin, **$18.00**
Right: Cobalt (Note, has original Tiara label), **$24.00**

Tiffin/U.S. Glass Company 1889-1980

In 1889 production began in Tiffin, Ohio, at the A.J. Beatty Sons Glass factory. Three years later, the firm joined the U.S. Glass conglomerate and was known as Factory R.

Factory R was the top producing glass factory in the 1920s and became known as the Tiffin factory. During these early years, Tiffin produced several animals along with their many dinnerware patterns. In the 1930s, while many of the other factories in the conglomerate closed, Tiffin survived and became the main office for U. S. Glass.

Tiffin acquired the Duncan & Miller Company and the Hawkes Company in the 1950s. The 1960s were difficult for the company; bankruptcy closed the factory in 1962 and employees purchased it in 1963. Three more company sales occurred in the late 1960s and 1970s before the company was closed for good in 1980.

Cat - Grotesque #9446, Black, 6.5" tall 2.75" wide, Circa 1924-1934, **$195.00**

Cat - Grotesque #9446, Black Satin, 6.5" tall 2.75" wide, Circa 1924-1934, **$175.00**

Cat - Grotesque #9445, Black Satin, 6.25" tall 2.75" long, Circa 1925, **$500.00+**

Cat - Large "Sassy Susie" #9448, Black, 11" tall 4" wide, Circa 1924-1934, **$245.00**

Tiffin Glass 165

Cat - Large "Sassy Susie" #9448, Black Satin hand painted facial features, 11" tall 4" wide, Circa 1924-1934, **$225.00**

Cat - Large "Sassy Susie" #9448, experimental two tone Milk Glass and Black, 11" tall 4" wide, Circa 1924-1934, **$1,000.00+**

Cat - Large "Sassy Susie" #9448, Milk Glass, 11" tall 4" wide, Circa 1924-1934, **$350.00**

Bull Dog, Crystal Satin, 2.6" tall 2.8" long, Circa 1930s-1950s **$35.00**

Bull Dog #78, Black Satin, 7" tall 6.5" long, weight 5.5 pounds, Circa 1926 **$650.00**

Tiffin Glass

Fawn #6322 in candle bowl #5905-20, Crystal, fawn is 10.5" tall, bowl is 14.5" long, Circa 1940s-1950s, **$195.00** complete
Also found in Topaz and Blue, $295.00 complete

Fish, Crystal, 8.75" tall 9.25" long, Circa 1930s, **$300.00**

Frog candlestick #69, Black Satin, 5.75" tall 3.1" wide, Circa 1924-1934, **$125.00**

Love Birds (electric lamp) #E-9, Crystal painted multi colors with black glass base (Note, they screw together), overall height 10.75" and 6.75" wide, Circa 1926-1935, **$395.00**

Owl (electric lamp) #E-1, Crystal painted in shades of brown with black glass base (Note, they screw together), overall height 8.75" and 3.5" wide, Circa 1926-1935, **$495.00**

Tiffin Glass 167

Parrot (electric lamp) #E-6, Crystal painted multi colors with black glass base (Note, they screw together), overall height 11" and 3.5" wide, Circa 1926-1935, **$295.00**

Pheasant #6042-2, head down female with long tail sitting on a ball, Crystal, 8.75" tall 13.1" long, Circa 1935 to 1950s, **$175.00**

Pheasant #6042-1, head up female with long tail sitting on a ball, Crystal (Note, the controlled air bubbles), 7.4" tall 14.75" long, Circa 1935 to 1950s, **$250.00**

Turkey with cover, Transparent Blue, 8.25" tall 9" long, Circa 1891-1898, **$600.00**

Viking Glass Company (Dalzell-Viking) 1944-1998

When the New Martinsville Glass Company closed in 1944, stockholder G.R. Cummings purchased the company, reorganized it with new stockholders, and renamed it Viking Glass Company. The new company attracted investors who had not shown interest in New Martinsville.

Viking greatly expanded their products with new vibrant colors and styles influenced by Swedish designs. Harry Barth sold his business to Viking in 1952 and sales remained good through the 1960s and 1970s. Viking purchased Rainbow Glass Company in 1954.

In the early 1980s, sales slumped and additional financing could not be found. Viking closed in 1986.

Kenneth Dalzell, formerly of Fostoria Glass, purchased Viking in 1988 and renamed it Dalzell-Viking. Dalzell reintroduced the animal line with a new glass formula that was developed by Carl Hoffman, also a former Fostoria employee. The new animals had extra brilliance. Christmas items and colored Candlewick was also offered. The Smithsonian Institution licensed Dalzell to make new issues of some of its museum glass. Small bookends that Viking produced as Crystal Satin Sculptures were also made with #7864 base to be used as votive candlelights. Sometimes the Crystal Satin Sculptures were advertised as Icy Crystal Sculptures. In 1998, the company was forced to close due to several problems.

Made by Viking for Mirror Images.
Left: Bear - mama on bust off base, Ruby, 6.25" tall 6.5" long, Circa 1985, **$150.00**

Bird with long tail #1311, 10.1" tall, Circa 1962-1982.
Left to right:
Green, **$30.00**
Amber, **$26.00**
Crystal, **$28.00**
Dark Blue, **$38.00**
Also came in Orange $32.00 and Red $45.00

Made by Viking for Mirror Images.
Left: Bear - mama, Ruby, 4.25" tall 6.5" long, Circa 1985, **$85.00**
Right: Bear - baby, Ruby, 3.1" tall 4.5" long, Circa 1985, **$75.00**

Bird with long tail covered candy dish #1312, Dark Blue, 11.5" overall height 6.5" diameter, Circa 1962-1980, **$68.00**
Also came in Amber $40.00, Crystal $45.00, Green $45.00, Orange $48.00 and Red $85.00

Viking Glass 169

Bird bookend #7887, Crystal with satin highlighting, 7.25" tall 3.5" long, Circa 1980-1985, **$18.00** each
Not pictured is bird bookend #7890, $18.00 each

Boy Kneeling bookend #7950, Crystal with satin highlighting, 5.75" tall 2.4" long, Circa 1980-1985, **$14.00** each
Not pictured is Girl Kneeling bookend #7950, 6" tall, $14.00 each
Also Country Boy bookend #7879, 8" tall, and Country Girl bookend #7880, 6" tall, $15.00 each

Cat #1322 - hand blown, 8" tall 3" wide, Circa 1950s-1970s
Left: Orange, **$35.00**
Center: Crystal, **$35.00**
Right: Amber, **$30.00**
Not pictured Dark Blue $42.00, Green $35.00, and Red $45.00,
also a dog #1323 in this style can be found.

Love Birds double picture frame #8057, Crystal with satin highlighting, 4.5" tall 5.25" wide, Circa 1980-1985, **$18.00**

Buffalo bookend #8068, Crystal with satin highlighting, 4.5" tall 7.5" long, Circa 1980-1985, **$28.00** each

Bird - long neck Egret #1315, 9.5" tall 3" long, Circa 1962-1974.
Left to right:
Dark Blue, **$45.00**
Amber, **$35.00**
Green, **$38.00**
Orange, **$40.00**
Also came in Crystal $40.00, Green $40.00, and Ruby Epic $48.00

Viking Glass

Left: Cat #7286 - hand blown, Dark Blue, 5.8" tall 2.4" wide, Circa 1974-1977, **$35.00**
Also came in Amber $28.00, Crystal $30.00, Green $30.00, Orange $30.00, and Red $38.00
Right: Cat #7272 - hand blown, Red, 6.8" tall 2.25" wide, Circa 1974-1977, **$40.00**
Also came in Amber $30.00, Dark Blue $38.00, Crystal $32.00, Green $32.00, and Orange $32.00

Cat "Chessie" bookend #7881, Amber, 4.25" tall 6.75" long, Circa late 1970s-1985, **$20.00** each
Not pictured is cat (sitting up) bookend #8155, 5.5" tall, $24.00 each

Chicken rooster #1321, Green, 9.6" tall 5" long, Circa 1962-1974, **$40.00**
Also came in Dark Blue $50.00, Orange $45.00, and Red $60.00

Cat bookend #D7957, Crystal with satin highlighting, 6.5" tall 4" wide, Circa 1980-1985, **$20.00** each

Chicken bookend, Dark Amber, 4" tall 5" wide, Circa late 1970s-1985, **$18.00** each

Child's Face bookends, Crystal Satin (note, eyes are gloss), 7.25" tall 5.4" wide, Circa 1950s-1960s, **$95.00** pair

Viking Glass 171

Dog with bows bookend #7754, Crystal with satin highlighting, 6.25" tall 5" long, Circa 1980-1985, **$18.00** each
Not pictured are: Bassett (sleeping) #8063, 3" tall; Beagle #7966, 5" tall; Scotty #7967, 5.5" tall, range of $18.00-$20.00 each

Left to right:
1. Duck (small) #1316, Green, 5.1" tall 3" long, Circa 1962-1974, **$30.00**
2. Duck (large) #1317, Green, 9.4" tall 5" long, Circa 1962-1974, **$50.00**
3. Duck (small) #1316, Red, 5.1" tall 3" long, Circa 1962-1974, **$38.00**
4. Duck (small) #1316, Orange, 5.1" tall 3" long, Circa 1962-1974, **$30.00**
5. Duck (small) #1316, Amber, 5.1" tall 3" long, Circa 1962-1974, **$28.00**
6. Duck (large) #1317, Amber, 9.4" tall 5" long, Circa 1962-1974, **$45.00**
Not pictured: small duck in Dark Blue $35.00, and Crystal $28.00, also large duck in Dark Blue $60.00, Crystal $48.00, Orange $50.00, and Red $68.00

Dog - Basset bookend #7965, Crystal with satin highlighting, 5.1" tall 6" long, Circa 1980-1985, **$20.00** each

Duck fighting #6712, Dark Blue, 2.5" tall 6" long, Circa 1960s, **$45.00** Also came in Amber $35.00, Crystal $40.00, and Green $38.00

Duck standing, Crystal, 4.5" tall 3.5" long, Circa late 1940s-1960s, **$40.00**
Also came in Amber $35.00, Dark Blue $45.00, and Green $38.00

Dog - Police (German Sheppard), Ruby, 5" tall 5" long, Made for Mirror Images, Circa 1985, **$60.00**

172 Viking Glass

Elephant Crystal with satin highlighting, 3.75" tall 3.5" long, Circa late 1970s, **$35.00**

Left: Frog - miniature, Dark Green, 1.8" tall 2.4" wide, Circa 1962-1974, **$10.00**
Right: Frog - miniature, Dark Blue, 2" tall 2.5" wide, Circa 1962-1974, **$12.00**
Also came in Amber $8.00, Crystal $10.00, Orange $10.00, and Red $14.00

Angel Fish bookend #1301, Crystal, 6.8" tall 7.1" long, Circa 1957-1963, **$65.00** each

Lion bookend #8151, Crystal with satin highlighting, 6.5" long, 3.5" wide, Circa 1981, **$35.00** each
Not pictured is #8186 acrylic rectangle base 5" X 8", that was offered to go with this piece.

Angel Fish bookend #1301, Amber, 6.8" tall 7.1" long, Circa 1957-1963, **$60.00** each

Madonna bookend #7885, Crystal with satin highlighting, 6.6" tall 4.4" wide, Circa 1980s, **$15.00** each
Not pictured are: Madonna (full figure) #7877, 6.75" tall, $18.00; Madonna (bust only) #7756, 5" tall, $14.00.

Viking Glass 173

Mouse - sitting #8062, Crystal with satin highlighting, 4" tall 4" wide, Circa 1980-1985, **$18.00**
Not pictured mouse #8061, 4" tall, $18.00.

Mushroom #6942, Dark Blue, 3" tall 3.75" wide, Circa 1960-1970s, **$26.00**
Not pictured in Amber $20.00, Crystal $22.00, Green $24.00, Orange $24.00, and Red $28.00
Note, mushrooms came in three sizes, with the other two being larger than the one pictured. Also all three sizes were made with controlled air bubbles.

Owl bookend #7895, Crystal with satin highlighting, 5.5" tall 4.5" wide, Circa 1980-1982, **$18.00** each

Owl bookend #8156, Crystal satin, 6.6" tall 4.5" long, Circa 1980-1982, **$18.00** each
Not pictured are: owl #7764, 3.5" tall; owl #7968, 4" tall; owl by stump, 4.5" tall; owl #7751, 5.75" tall, range of $18.00-$20.00 each

Owl ashtray #6944, Amber, 8.5" long 4.75" wide, Circa 1970s-1981, **$9.00**

Owl "Glimmer Light" #6900 (two piece fairy light), 7.25" tall 3.25" wide, Circa 1975-1982.
Left: Amber, **$28.00**
Right: Green, **$32.00**
Also came in Dark Blue $35.00, Orange $32.00, and Red $38.00

174 Viking Glass

Porpoise #766 called Dolphins by collectors (made by Dalzell Viking), 5.75" tall 6.75" long, Circa 1990s.
Left: Crystal Satin, **$60.00**
Right: Crystal, **$65.00**
Also made by Viking, Circa late 1940s-1950s, $85.00

Swan #6946, 6.5" tall 5" long, Circa 1982.
Left: Amber, **$15.00**
Right: Yellow Satin, **$18.00**

Rabbit #6808 with ears up, Blue Satin, 6.6" long 3.5" long, Circa 1970s-1981, **$60.00**
Not pictured small baby rabbit #7908 with ears down, $28.00

Squirrel bookend #8066, Dark Amber, 5" tall 3.5" wide, Circa late 1970s-1985, **$18.00** each

Squirrel - hand blown, Amber, 6.75" tall, Circa 1970s, **$15.00** Also came in Crystal (20.00)

Seal, Ruby, 4.6" tall 3.5" long, Circa 1985, made for Mirror Images, marked with a V & IM, **$45.00**

Viking Glass & Weishar Enterprises 175

Swan #1324, Green, 5.5" tall 6.5" long, Circa mid 1980, **$20.00**

Tree, Green, 4.5" tall 4.5" wide, Circa 1990s, **$20.00**

Weishar Enterprises 1939-Present

Members of the Weishar family, at Wheeling, West Virginia, established Island Mould Company in 1939. For most of its existence, Island Mould has designed glass moulds for many glass companies, such as Fenton, Smith, and L.G. Wright.

Island Mould is recognized for making many of the Moon & Star moulds.

As an addition to their mould work, Weishar family members designed their own miniature Moon & Star moulds. The glass was sold under the new company name, Weishar Enterprises, in 1988, enabling them to be identified with their miniature pieces. These items are marked with a "W" inside the outline of the state of West Virginia. In 1993, a new full-size limited edition line of Moon & Star was offered. These are marked with the Weishar signature.

Weishar Enterprises makes a ring tree with an owl sitting on a branch, that is included here. This is the only animal item they have made so far.

Owl ring holder, Blue, 5" tall 3.75" wide, Circa 1996 to present. The base has the "Moon & Star" pattern on it. Note, on the underneath side it is marked "Weishar", **$24.00**
Designed by Joseph J. Weishar in 1981, but not put into production until 1996.

Westmoreland Glass Company 1888-1980

The Specialty Glass Company was incorporated in 1888 in Jeannette, Pennsylvania, and was sold to two brothers, Charles and George West, a year later. Ira Brainard financially backed them. The company was renamed Westmoreland Specialty Company and was moved to Grapeville, Pennsylvania.

Westmorland's initial product line was candy containers before they made tableware. They acquired former Atterbury and Challinor Taylor & Company covered animal moulds and sold their glass items to food packers who filled and sold them.

In the 1920s, Ira Brainard purchased half of the company and by the late 1930s his family owned it completely. Superior milk glass was their primary product line in the 1950s. In the 1960s, bright colors were brought into production along with an o-site gift shop.

J.H. Brainard, the president and grandson of Ira, sold Westmorland Glass to David Grossman in 1981. Grossman's first few years were successful, but labor problems forced the company to close in 1984.

The Rosso family, longtime wholesalers for Westmoreland, bought the Westmorland moulds and set up a museum in Port Vue, Pennsylvania, along with a gift shop. Summit, Plum, and Fenton companies make glass for the Rosso gift shop and retail trade.

Bird - Wren #5 on tree stump base (Note, two pieces), 3.5" overall height 3" wide square base, Circa 1969-1980s.
Top: Pink Mist Bird, Milk Glass base, **$48.00**
Bottom left: Black Bird, Black base, **$60.00**
Bottom center: Green Bird, Milk Glass base, **$48.00**
Bottom right: Almond Bird, Brown base, **$55.00**
Not pictured, several other colors with price range of $48.00-$65.00 (Note, the bird has a small round column that fits into the hole in the top of the tree stump base).

Bird open back #10 small dish, 1.8" tall 5" wide, Circa 1969-1980.
Left: Pink Mist, **$18.00**
Right: Blue Mist, **$18.00**
Not pictured, several other colors with price range of $12.00-$20.00

Bird - Wren #5/1 (originally called Kingbird), Blue Mist, 1.6" tall 3.5" long, Circa 1950s.
Left: Dark Blue Mist, **$24.00**
Right: Chartreuse Mist, **$24.00**
Not pictured, several other colors with price range of $20.00-$28.00

Bird - Cardinal #11, 2.75" tall 5" long.
Top: Crystal, Circa 1950-1960, **$28.00**
Bottom: Ruby, Circa 1970s-1980s, **$34.00**
Not pictured, several other colors with price range of $28.00-$40.00

Westmoreland Glass

Left: Butterfly - small, Crystal, 1.25" long 1.4" wide, Circa 1970s, **$24.00**
Not pictured, several other colors with price range of $24.00-$35.00
Right: Butterfly - large, Blue Mist, 1.75" long 2.3" wide, Circa 1971-1978, **$40.00**
Not pictured, several other colors with price range of $35.00-$45.00

Camel #1 covered dish, Yellow Mist, 5.5" tall 6" long, Circa 1974-1975 (limited edition for Levay Company), **$95.00**

Large Butterfly #3, Purple Marble, 1.4" tall 4.75" wide 3.1" long, Circa 1972-1983, has original label **$48.00**

Chick egg cup #602, Milk Glass decorated with red paint, 3.5" tall 4" long, Circa 1940s, **$20.00**

Left: Butterfly - large #3, Green Marble, 1.4" tall 4.75" wide 3.1" long, Circa 1972-1983, **$48.00**
Right: Butterfly on tree stump base (Note, two pieces), Black on Black, 4.75" wide 3.1" long, Circa 1970s-1980s, **$65.00**
Not pictured, several other colors and combinations with price range of $45.00-$65.00 (Note, the butterfly has a small round column that fits into the hole in the top of the tree stump base).

Chicken standing rooster covered dish, Milk Glass accented with red paint, 8.75" tall 7" long, Circa 1950-1984, **$65.00**

Westmoreland Glass

Bull Dog, Black Mist close up of the collar to show that it has three bumps next to the buckle, which is on the left side of the dog.

Bull Dog, 2.6" tall 2.5" long.
Left: Crystal Mist, Circa 1930s, **$35.00**
Right: Black Mist, Circa 1930s, **$48.00**

Duck #1 open back salt dip, 2" tall 5" long, Circa 1970s.
Top: Vaseline, **$18.00**
Center left: Black, **$18.00**
Center right: Pink Mist, **$14.00**
Bottom: Green Mist, **$14.00**
Not pictured, several other colors with price range of $14.00-$18.00

Dolphin candlestick, Crystal, 9.2" tall 4.5" wide, Circa 1930s, **$35.00**

Owl #1 standing on stump with glass eyes, 5.5" tall 3" long, Circa 1970s-1980s.
Top left: Almond, **$35.00**
Top right: Crystal Mist, **$30.00**
Bottom left: Milk Glass, **$38.00**
Bottom center: Antique Blue Milk Glass, $48.00
Bottom right: Carmel Mother of Pearl, **$35.00**
Not pictured, several other colors with price range of $30.00-$48.00

Owl on Books #10 with rhinestone eyes, 3.6" tall 1.75" wide.
Top: Cobalt Marble, Circa 1970s, **$38.00**
Center left: Dark Blue Mist, Circa 1969-1980s, **$34.00**
Center right: Antique Blue, Circa 1970s, $34.00
Bottom left: Light Blue Mist, Circa 1969-1980s, **$34.00**
Bottom center: Black, Circa 1950s, **$35.00**
Bottom right: Amber, Circa 1970s, **$35.00**
Not pictured, several other colors with price range of $30.00-$48.00

Westmoreland Glass 179

Owl on Books #10 with rhinestone eyes, 3.6" tall 1.75" wide.
Top left: Milk Glass, Circa 1950s, **$30.00**
Top right: Almond, Circa 1970s, **$34.00**
Bottom left: Pink Mist, Circa 1969-1980, **$34.00**
Bottom center: Green Mist, Circa 1969-1977, **$28.00**
Bottom right: Purple Marble (only 500 were made), Circa 1972-1983, **$48.00**

Pig, Dark Blue Mist, 1.1" tall 3.25" long, Circa 1971-1978, has original label, **$28.00**

Owl toothpick #62, 3" tall 2.4" wide.
Left: Purple Marble, Circa 1972-1983, **$38.00**
Right: Blue Mist, Circa 1969-1980s, **$25.00**
Not pictured, several other colors with price range of $18.00-$38.00

Pigeon - Pouter #9, 2.75" tall 3.25" long, Circa 1950-1970s.
Left: Dark Blue Mist, Circa 1971-1978, **$38.00**
Right: Crystal, Circa 1950-1960, **$30.00**
Not pictured, several other colors with price range of $35.00-$45.00

Left: Penguin on iceberg, Dark Blue Mist on Brandywine base (Note, when Brandywine has a satin finish, the name changes to Dark Blue Mist), 3.75" tall 3" wide, Circa 1971-1978, **$40.00**
Not pictured, several other colors with price range of $28.00-$48.00
Right: Penguin on iceberg, Crystal hand painted & artist signed 1999, made for the Westmoreland Museum by another company from original mould, 3.75" tall 3" wide, Circa 1999, **$48.00**

Santa in Sleigh, Milk Glass hand painted with Holly signed by Louise Plues, 4.6" tall 5.25" long, Circa 1940s, **$45.00**

Westmoreland Glass

Starfish candlestick, Pearlized Milk Glass, 1.4" tall 5.25" wide, Circa 1970s, **$20.00**

Commemorative miniature pieces made for Westmoreland Glass Society.
Left: Rooster, Crystal Mist hand painted with gold and dated 1993, **$28.00**
Center: Unicorn Horse, Crystal Mist hand painted with gold and dated 1995, **$35.00**
Right: Goose, Crystal Mist hand painted with gold and dated 1994, **$28.00**

Turtle, Green Mist, 1.5" tall 4.5" long, Circa 1969-1977, **$24.00**
Not pictured, several other colors with price range of $18.00-$28.00

Turtle covered cigarette box, Golden Sunset, 2" tall 7.25" long, Circa 1974-1975, **$35.00**
Not pictured, several other colors with price range of $28.00-$45.00

Wheaton Glass Company 1888-Present

Wheaton Glass Company was established in Millville, New Jersey, in 1888, to produce bottles and commemorative decanters. In 1965, Wheaton set up a new division called Wheatonware, a home-party line. From 1970 to 1975, many pieces made from the Kemple moulds were added to the home-party selection.

The U. S. Internal Revenue Service filed suit in 1975 to make Wheaton pay their sales representatives' Social Security payments. A year later the court decided against the IRS, declaring the company only had to issue 1099 tax forms. Before the suit was settled, though, the decision to close this division was made, since it wasn't making much money.

The Wheaton Historical Association, also a division of Wheaton Glass Company, acquired the Kemple moulds and put them in storage to preserve them.

Frog #106, Dark Amber, 2.75" tall 4.25" wide, Circa 1976-1977, **$20.00**

Dog, Amber, 3.25" tall 3.75" wide, Circa 1970s, **$18.00**

Girl - Southern Belle #160 (this mould was purchased from Kemple Glass Co. in 1970 after the death of John Kemple), Blue Carnival, 5" tall 3.75" wide, Circa 1970-1975, **$38.00**

Left: Girl bookend, Blue Carnival, 4.8" tall 2.8" long, Circa 1970-1975, **$34.00** each
Right: Boy bookend, Blue Carnival, 5" tall 2.75" long, Circa 1970-1975, **$34.00** each

Elephant bottle, Amber, 5" tall 6.5" long, Circa 1968, **$18.00**
Marked on right side: "Nixon 68 for President, Republican". Marked on left side: Agnew for Vice President" campaign. Marked on bottom: Wheaton NJ First Edition.

Santa Claus bottle, Red Satin, 10.5" tall 3.5" wide at base, made as a limited edition Circa 1970s, **$35.00**

Wilkerson Glass Company 1984-Present

Fred Wilkerson, Sr., began his glassmaking career at Fostoria Glass in 1958. As a part-time business, Fred began making paperweights in 1971. After Fostoria closed in 1984, he started Wilkerson Glass Company in Moundsville, West Virginia. He taught his son, Fred, Jr., the glassmaking techniques and they work together making paperweights and a few other items. Fred Jr. also teaches glassmaking at the Oglebay Institute.

Rabbit - egg cup, 3.25" tall 2.75" wide, embossed on bottom with the letters FW, 1990s.
Top left: Pink, **$8.00**
Top right: Lilac, **$8.00**
Bottom left: Green, **$8.00**
Bottom right: Cobalt, **$10.00**

Dog, Lilac, 2.5" tall 1.25" wide, 1990s **$12.00**

L.G. Wright Glass Company 1937-1999

Si Wright became a sales representative of New Martinsville Glass Company in 1936. The following year, he began to buy moulds from defunct glass companies such as National Mold & Machine Works, Erskine Glass, and Northwood. He contracted with the Fenton, Indiana, Paden City, New Martinsville, Viking, and Westmoreland companies to make glass for him from his moulds. In the later years, Fenton made most of the glass for Wright.

Wright died in 1969 and for many years his widow kept the company going. Following her death in 1990, ownership went to her cousin, Dorothy Stephan, who was unable to overcome the company's many problems. L.G. Wright closed in 1999 and was liquidated by public auction.

Fish with Basket toothpick #77/59, Amber 2.25" tall 4.5" long, Circa 1960-1970s, **$25.00**

Bird with Berry open back salt dip #77/50, 1.8" tall 4" long, Circa 1960-1970s.
Left: Vaseline, **$18.00**
Right: Green, **$14.00**

L.G. Wright & Comparison of Similar Moulds 183

Swan with open back #77/52, 2.5" tall 3.75" long, Circa 1960-1970s.
Left: Amethyst, **$18.00**
Right: Emerald Green, **$18.00**

Turtle #70/12 (covered dish), Amber, 3.5" tall 9.75" long, Circa 1960-1989, **$85.00**

Owl - "Hoot Owl" dish #77/75, Amber, 2" tall 8.5" long, Circa 1960-1970s, **$30.00**

Comparison of Similar Moulds

Rearing horses, swans, and turtle flower blocks are probably the most mislabeled glass animals that we have seen. It is hoped that by having comparison photos we can aid the collector in distinguishing between these similar glass animals.

Three rearing horses were made by Fostoria, New Martinsville, and L.E. Smith. The Smith horse has a knotted mane that is different from the other two, which have a combed mane. The Fostoria horse has a much thicker base and is hollow inside. The New Martinsville base is thinner and is only partially hollow.

Four companies made small swans: Fenton, Imperial, Northwood, and Smith. On the Smith swan, you will notice a longer bill with an indent. The Imperial swan has feathers going up the neck. The Fenton and Northwood swans have small dots. On the underside of the tail, the Fenton swan has wider panels of feathers. On the top half of the tail, the Fenton feathers have irregular notches in them. The notches on the Northwood swan are nearly all the same size and there are more of them than on the Fenton swan.

Turtle flower blocks by Northwood have six holes, while Fenton turtle flower blocks have eight holes.

Horses - Rearing (Note, differences in the manes)
Left: L.E. Smith, Ruby
Center: Fostoria, Silver Mist (crystal satin)
Right: New Martinsville, Crystal

Horses - Rearing (Note, differences in the bottom bases)
Left: L.E. Smith, Ruby
Center: Fostoria, Silver Mist (crystal satin)
Right: New Martinsville, Crystal

184 Comparison of Similar Moulds

Swans - with open back (Note, differences in body shapes)
Left: L.E. Smith, Milk Glass
Right: Imperial, Crystal satin (lightly iridized)

Swan - with open back, feather detail of Imperial, Crystal satin (lightly iridized)

Swan - with open back, head detail of L.E. Smith, Milk Glass

Swan - with open back, head detail of Imperial, Crystal satin (lightly iridized)

Swans - with open back, (Note, differences in the feathers at base of neck)
Left: Fenton, Blue Carnival
Right: Northwood, Green Carnival

Swans - with open back
Left: Fenton, Blue Carnival
Right: Northwood, Green Carnival

Comparison of Similar Moulds & Unknowns 185

Swan - with open back, feather detail of Fenton, Blue Carnival

Swan - with open back, feather detail of Northwood, Green Carnival

Turtle - flower blocks
Left: Fenton, Topaz (Note, difference of eight holes in back)
Right: Northwood, Blue (Note, difference of six holes in back)

Unknown Figurines

Figurines in this chapter are ones we wanted to include, but have found nothing about their makers. We believe them all to be American made. It is hoped that by listing them here, some information may come forth about them. These animals tend to appear frequently at glass shows and gift shops.

Bird in flight, Crystal, 5.4" tall 5.25" wide, **$34.00**

Camel with open back for holding cigarettes (may have been an advertising item for Camel cigarettes), Crystal, 3.25" tall 7.5" long, **$60.00**

186 Unknowns

Cat, Green, 7.75" tall 4" long, **$38.00**

Cat, Black Satin with gold painted bowl & rhinestone eyes, 3.1" tall 1.75" long, **$38.00**

Dog "Scottie" bookend, Crystal, 5" tall 6.75" long, **$48.00** each

Piranha fish bookends, Crystal, 4.5" tall 4.6" long, **$125.00** pair

Elephant, Crystal Satin, 3.25" tall 4.75" long, **$24.00**

Elephant, Green Satin, 2.8" tall 3.4" long, **$35.00**

Unknowns 187

Trout electric lamp, Crystal, 5.5" tall 8" long (measurements for glass part only), **$125.00**

Owl on round base, Black, 4.5" tall 3.25" wide (measurement across base), **$45.00**

Theodore Roosevelt bust, Crystal, 5.6" tall 2.5" wide, **$195.00**

Horse Head, Crystal Satin, 5" tall 6.1" long, Embossed on base- Majestic Glass Worcester, Massachusetts, **$195.00** (Note, was probably made for use as a car hood ornament.)

Rabbit bookends, Crystal, 5.8" tall 3.5" wide, **$150.00** pair

Collector Organizations

No matter what type of glass you collect, we encourage you to belong to a non-profit organization that works to preserve the history of the American glass making industry. These organizations enable you to gather more information on a particular glass company. All of the national organizations listed below provide information by publishing an educational newsletter, doing study guides, reprinting company catalogs, doing seminars, holding conventions, having a museum, or presenting other educational activities.

Boyd Art Glass Collectors Guild
P.O.Box 52,
Hatboro, PA 19040

Fostoria Glass Society
P.O. Box 826,
Moundsville, WV 26041
304-845-9188
$16/year for 8 newsletters
www.fostoriaglass.org

Heisey Collectors of America
169 West Church Street,
Newark, OH 43055
740-345-2932
$22/year for 12 newsletters
www.heiseymuseum.org

National American Glass Club
Box 8489,
Silver Springs, MD 20907
607-974-8357
$25/yr for 4 newsletters
www.glassclub.org

National Cambridge Collectors
P.O.Box 416,
Cambridge, OH 43725-0416
740-432-4245
$17/year for 12 newsletters
www.cambridgeglass.org

National Depression Glass Association
P.O.Box 8264,
Wichita, KS 67208-0264
$17/year for 6 newsletters
www.NDGA.net

National Duncan Glass Society
P.O.Box 965,
Washington, PA 15301
724-225-9950
$15/year for 4 newsletters
http://duncan-glass.com

National Imperial Glass Collectors Society
P.O.Box 534,
Bellaire, OH 43906
410-995-1254
$15/year for 4 newsletters
www.imperialglass.org

Old Morgantown Collectors Guild
Box 849,
Morgantown, WV 26505
304-599-2750
$15/year for 4 newsletters
www.oldmorgantown.org

Pacific NW Fenton Association
P.O.Box 881,
Tillamook, OR 97141
503-842-4815
$23/year for 4 newsletters and an exclusive piece of Fenton glass
www.glasscastle.com/pnwfa.htm

Paden City Glass Collectors Guild
P.O.Box 139,
Paden City, WV 26159
304-337-9257
$15/year for 4 newsletters
pcglasssociety@mailcity.com

Tiffin Glass Collectors
P.O.Box 554,
Tiffin, OH 44883
419-447-5505
$15/year for 4 newsletters
www.tiffinglass.org

West Virginia Museum of American Glass
P.O.Box 574,
Weston, WV 26452
304-269-5006
$25/year for 4 newsletters
http://members.aol.com/wvmuseumofglass

Bibliography

Archer, Margaret & Douglas. *Collectors Encyclopedia of Glass Candlesticks.* Paducah, Kentucky: Collector Books, 1983

Beaudoin, Amy. *Personal Correspondence.* Taunton, Massachusetts: Princess House, 2002

Belknap, E.M. *Milk Glass.* New York City, New York: Crown Publishers, 1949.

Bickenheuser, Fred. *Tiffin Glass Masters Volume I.* Grove City, Ohio: Glass Masters Publication,1979.

____ *Tiffin Glass Masters Volume II.* Grove City, Ohio: Glass Masters Publication, 1981.

____ *Tiffin Glass Masters Volume III.* Grove City, Ohio: Glass Masters Publication,1985.

Blenko Glass Company. *Company Catalogs.* Milton, West Virginia: Blenko Glass Company, 1990s -2002.

Bones, Frances. *Duncan Glass.* Des Moines, Iowa: Wallace Homestead Book Company, 1973.

____. *Fostoria Glassware 1887-1982.* Paducah, Kentucky: Collector Books, 1999.

Bradley, S. & C. & R. Ryan. *Heisey Stemware.* Newark, Ohio: Spencer Walker Press, 1979.

Brantley, William F. *A Collector's Guide to Ball Jars.* Muncie, Indiana: Western Publishing Company, 1975

Breeze, Linda & George. *Mysteries of The Moon & Star.* Mt. Vernon, Illinois: Image Graphics, 1995.

Bredehoft, Neila & Tom. *Heisey Glass 1896-1957.* Paducah, Kentucky: Collector Books, 2001.

Boyd, Bernard, John & Sue. *Boyd's Crystal Art Glass*. Cambridge, Ohio: Boyd Family, 1990

____. *Boyd's Newsletters.* Cambridge, Ohio: Boyd Family, 1985-2002

Burkholder, John & D. Thomas O'Connor. *Kemple Glass 1945-1970.* Marietta, Ohio: The Glass Press, 1997.

Cambridge Glass Co. *Company Catalogs.* Cambridge, Ohio: Cambridge Glass Company, 1920s.

Coe, Myra. *Fenton's Puppies PNWFA convention seminar,* Springfield, Oregon: Myra Coe, 2000

Corning Glass Museum. *Archival material and microfiche*. Corning, New York: Corning Glass Museum, 2000.

Courter, J.W. *Aladdin Electric Lamps.* Des Moines, Iowa: Plain Talk Publishing, 1987.

____ *Aladdin, The Magic Name in Lamps.* Paducah, Kentucky: Image Graphics, 1997

Coyle, Robert; Lynne Bloch & Art Hartman. *The Heisey Animals, Etc Book II.* Lahaska, Pennsylvania: LynneArt's Glass House Inc., 1978.

Craig, Betty. *New Glass Collectibles*. Fort Wayne, Indiana: Betty Craig, 1980 & 1981.

Cudd, Viola. *Heisey Glassware.* Brenham, Texas: Herrmann Print Shop, 1969.

Degenhart Glass Museum. *Company Catalog.* Cambridge, Ohio: Degenhart Glass Museum, 2002.

Dereume Glass. *Company Catalogs.* Punxsutawney, Pennsylvania: Dereume Glass, 1990s.

Dezso, Douglas & J. Leon & Rose Poirier. *Collectors Guide to Candy Containers.* Paducah, Kentucky: Collector Books, 1998.

Duncan & Miller Glass Company. *Company Catalog #93.* Washington, Pennsylvania: The Duncan & Miller Glass Company, 1955.

____. *Company Catalog #89.* Washington, Pennsylvania: The Duncan & Miller Glass Company, 1950.

____. *Highest Quality Glass.* Washington, Pennsylvania: The Duncan & Miller Glass Company.

Duncan & Miller Glass Society. *Duncan Glass.* Washington, Pennsylvania: The Duncan & Miller Glass Society, 1997.

____. *Company Brochures.* Washington, Pennsylvania: The Duncan & Miller Glass Society, 1955.

Felt, Tom & Bob O'Grady. *Heisey Candlesticks, Candelabra, & Lamps.* Newark, Ohio: Heisey Collectors of America, 1984.

Fenton Art Glass Co. *Company Catalogs.* Williamstown, West Virginia: Fenton Art Glass Co., 1958-2002.

Fenton, Frank M. *Personal correspondence.* Williamstown, West Virginia: Fenton Art Glass Company, 2002.

Ferson, Mary & Regis. *Yesterday's Milk Glass Today.* Greensburg, Pennsylvania: Chas M. Henry Printing, 1981.

Florence, Gene. *Collectors Encyclopedia of Akro Agate.* Paducah, Kentucky: Collector Books, 1992.

____ *Degenhart Glass & Paperweights.* Cambridge, Ohio: Degenhart & Paperweight and Glass Museum, Inc., 1982.

Fostoria Glass Company. *Company Catalogs.* Moundsville, West Virginia: Fostoria Glass Co., 1930-1980s.

Fostoria Glass Society. *Facets of Fostoria newsletters.* Moundsville, West Virginia: Fostoria Glass Society, 1980s-1990s.

Furr's Gifts Co. *Company Catalogs.* Deep Gap, North Carolina: Furr's Gifts Company, 1970.

Gallagher, Jerry. *Handbook of Old Morgantown Glass.*

Minneapolis, Minnesota: Merit Printing, 1995.
Garmon, Lee & Dick Spencer. *Glass Animals of the Depression Era.* Paducah, Kentucky: Collector Books, 1993.
Gibson Glass. *Company Catalogs.* Milton, West Virginia: Gibson Glass, 1990s-2002.
Gillinder Glass. *Company Catalogs.* Port Jervis, New York: Gillinder Glass, 2001-2002.
Grizel, Ruth. *American Glass Quarterly's.* Iowa City, Iowa: American Glass Quarterly's, 1990s.
_____ *American Slag Glass.* Paducah, Kentucky: Collector Books, 1998.
Hahn, Frank & Paul Kikeli. *Collectors Guide to Heisey & Heisey by Imperial Glass Animals.* Lima, Ohio: Golden Era Publications, 1991.
Hardy. Roger & Claudia, *Complete Line of the Akro Agate Co.* Clarksburg, West Virginia: Clarksburg Publishing Co., 1992.
Hastin, Bud. *Avon Products & California Perfume Co. Collectors Encyclopedia.* Fort Lauderdale, Florida: Bud Hastin, 1998.
Heacock, Bill. *Collecting Glass Volume 1.* Marietta, Ohio: Richardson Printing Corp., 1984.
_____. *Collecting Glass Volume II.* Marietta, Ohio: Richardson Printing Corp., 1985.
_____. *Collecting Glass Volume III.* Marietta, Ohio: Richardson Printing Corp., 1986.
_____. *Fenton Glass The First Twenty Five Years.* Marietta, Ohio: O-Val Advertising Corporation, 1978.
_____. *Fenton Glass The Second Twenty Five Years.* Marietta, Ohio: O-Val Advertising Corporation, 1980.
_____ *Fenton Glass The Third Twenty Five Years.* Marietta, Ohio: O-Val Advertising Corporation, 1989.
_____ *The Glass Collector #2 to #6.* Columbus, Ohio: Peacock Publications, 1982.
Heisey Collectors of America. *Heisey Catalog & Price List #32.* Newberg, Oregon: Headrick Buchdruckerei, 1994.
_____ *Heisey News newsletters.* Newark, Ohio: Heisey Collectors of America,1980-2001.
Holmes, Todd & Ann. *Boyd's Art Glass Production 1978-1992.* Kansas City, Missouri: Todd & Ann Holmes, 1992.
_____ *Boyd Glass Coloring Book.* Kansas City, Missouri: Todd & Ann Holmes, 1993.
Imperial Glass Corporation. *Company Brochure.* Bellaire, Ohio: Imperial Glass Corporation, 1947.
Imp_____. *Company Brochures.* Bellaire, Ohio: Imperial Glass Corporation, 1950s.
Kanawha Glass Company. *Company Catalogs 1960s-1970s.* Dunbar, West Virginia: Kanawha Glass Company, 1960-1970s.
Kemple Glass Works. *Company Catalog.* Kenova, West Virginia: Kemple Glass Works, 1950s.
Kerr, Ann. *Fostoria.* Paducah, Kentucky: Collector Books, 1994.
Kovar, Lorraine. *Westmoreland Glass 1950-1984.* Marietta, Ohio: Antique Publications, 1991.
_____. *Westmoreland Glass 1950-1984 Volume II.* Marietta, Ohio: Antique Publications, 1991.
Krause, Gail. *Duncan Glass.* Smithtown, New York: Exposition Press, 1976.
L. G. Wright Glass Company. *Company Catalogs.* New Martinsville, West Virginia: L. G. Wright Glass Company, 1960-1970s.
Long, Milbra & Emily Seate. *Fostoria Useful & Ornamental.* Paducah, Kentucky: Collector Books, 2000.
McGrain, Patrick H. *Fostoria the Popular Years.* Frederick, Maryland: McGrain Publications, 1982.
Measell, James. *Fenton Glass The 1980s Decade.* Marietta, Ohio: The Glass Press, 1996.
_____ *Fenton Glass The 1990s Decade.* Marietta, Ohio: The Glass Press, 2000.
_____. *Imperial Glass Encyclopedia Volume I.* Marietta, Ohio: The Glass Press, 1995.
_____. *Imperial Glass Encyclopedia Volume II.* Marietta, Ohio: The Glass Press, 1997.
_____ *Imperial Glass Encyclopedia Volume III.* Marietta, Ohio: The Glass Press, 1999.
_____. *L.G. Wright Glass Company.* Marietta, Ohio: The Glass Press, 1997.
_____. *New Martinsville Glass 1900-44.* Marietta, Ohio: Antique Publications, 1994.
Measell, James & Berry Wiggins. *Great American Glass Volume 1.* Marietta, Ohio: Antique Publications, 1998.
_____ *Great American Glass Volume 2.* Marietta, Ohio: Antique Publications, 2000.
McDermott, James. *Heisey Animals Book I.* Lima, Ohio: Golden Era Publications, 1973.
McRitchie, Tara Coe. *Fenton Glass Cats and Dogs.* Atglen, Pennsylvania: Schiffer Publishing, 2002
Miller, Everett & Addie, *The New Martinsville Glass Story.* Marietta, Ohio: Richardson Publishing Co.,1972.
Mosser Glass Company. *Company Catalogs.* Cambridge, Ohio: Mosser Glass Company, 1990-2002.
National Cambridge Collectors. *Colors in Cambridge,* Paducah, Kentucky: Collector Books, 1984.
_____. *Cambridge Glass Co. 1949-53.* Paducah, Kentucky: Collector Books,1978.
_____ *Cambridge Glass Co. 1930-34.* Paducah, Kentucky: Collector Books,1976.
_____ *Crystal Ball newsletters.* Cambridge, Ohio: National Cambridge Collectors,1980-2000.
National Duncan Glass Society. *Duncan Glass Journals.* Washington, Pennsylvania: National Duncan Glass Society,1990-2001.
National Imperial Glass Collectors Society. *Imperial Glass Catalog #66A.* Marietta, Ohio: Richardson Printing Corporation,1991.
_____. *Imperial Collectors Gazettes.* Bellaire, Ohio: National Imperial Glass Collectors,1990-2001.
Newbound, Betty & Bill, *Collector's Encyclopedia of Milk Glass.* Paducah, Kentucky: Collector Books, 1995.
Newbound, Betty. *Figurine Facts and Figures.* Union Lake,

Bibliography

Michigan: Bill Newbound, 1982.
Newark Heisey Collectors Club. *Heisey by Imperial.* Newark, Ohio: Heisey Collectors of America, 1982.
Old Morgantown Collectors Guild. *Morgantown newsletters.* Morgantown, West Virginia: Old Morgantown Collectors Guild.
Pacific NW Fenton Association. *Nor'Wester newsletters.* Tillamook, Oregon: Pacific NW Fenton Association, 1994-2002.
Paden City Glass Collectors Guild. *Paden City newsletters.* Paden City, West Virginia: Paden City Glass Collectors Guild.
Padgett, Leonard. Pairpoint Glass. Des Moines, Iowa: Wallace Homestead, 1979.
Pina, Leslie. *Blenko Glass 1962-1971 Catalogs.* Atglen, Pennsylvania: Schiffer Publications, 2000.
____ *Depression Era Glass by Duncan.* Atglen, Pennsylvania: Schiffer Publications, 1999.
____ *Popular "50s and '60s Glass.* Atglen, Pennsylvania: Schiffer Publications, 1995.
Pina, Leslie & Jerry Gallagher. *Tiffin Glass 1914-1940.* Atglen, Pennsylvania: Schiffer Publications, 1996.
Princess House Co. *Company Catalogs.* Taunton, Maryland: Princess House Co., 1990-2002.
Rainbow Art Co. *Company Catalog.* Huntington, West Virginia: Rainbow Art Co., 1944.
Revi, Albert Christian. *American Art Nouveau Glass,* Camden, New Jersey: Thomas Nelson & Sons, 1968.
____ *Spinning Wheel.* magazines, Hanover, Pennsylvania: Everybody's Press, 1970s.
Rice, Ferill J.. *Caught in the Butterfly Net.* Williamstown, West Virginia: Fenton Art Glass Collectors of America, 1991.
Richardson, David. *Glass Collectors Digest.* Marietta, Ohio: Richardson Printing Corp., 1980-1990s.
Saffell, Jon. *Personal correspondence.* Williamstown, West Virginia: Fenton Art Glass Company, 2002.
Shaeffer, Barbara, *Glass Review.* Marietta, Ohio: Barbara Shaeffer, 1980-1986.
Shuman, John. *American Art Glass.* Paducah, Kentucky: Collector Books, 1999.
Six, Dean. *West Virginia Glass Between the World Wars.* Atglen, Pennsylvania: Schiffer Publishing, 2002.
Smith, Bill & Phyllis. *Cambridge Glass 1927-1929.* Springfield, Ohio: Bill & Phyllis Smith, 1986.
Smith, L.E. *Company Catalogs.* Mt. Pleasant, Pennsylvania: L E Smith Glass Company, 1990-2002.
Snyder, Jeffrey. *Morgantown Glass From Depression Glass Through the 1960s.* Atglen, Pennsylvania: Schiffer Publications, 1998.
Stout, Sandra McPhee. *Complete Book of McKee Glass.* North Kansas City, Missouri: Trojan Press, 1972.
Summit Art Glass Co. *Company Brochures 1990-2002.* Ravenna, Ohio: Summit Art Glass Co., 1990-2002.
Taylor, Dorothy, *Encore by Dorothy Book I.* Kansas City, Missouri: Dorothy Taylor, 1985.
____, *Encore by Dorothy Book II.* Kansas City, Missouri: Dorothy Taylor, 1986.
____ *Encore by Dorothy Book III.* Kansas City, Missouri: Dorothy Taylor, 1990.
Teal, Ron Sr., *Tiara Exclusives.* Marietta, Ohio: The Glass Press, 2000.
Tiara Exclusives, *Company Catalogs 1970s-1990s.* Dunkirk, Indiana: Tiara Exclusives, 1970s-1990s.
Tiffin Glass Collectors. *Tiffin newsletters.* Tiffin, Ohio: Tiffin Glass Collectors, 1980-2001.
Van Pelt, Mary. *Fantastic Figurines.* Westminster, California: Mary Van Pelt, 1973.
____*Figurines in Crystal.* Westminster, California: Mary Van Pelt, 1975.
Viking Glass Co. *Company Catalogs.* New Martinsville, West Virginia: Viking Glass Co., 1960-1980s.
Vogel, Clarence. *Heisey's Early & Late Years.* Galion, Ohio: Fisher Printing, 1971.
____ *Heisey's Art & Colored Glass.* Galion, Ohio: Fisher Printing, 1970.
Weatherman, Hazel Marie. *Fostoria the First 50 Years.* Springfield, Missouri: The Weatherman's, 1972.
____ *Colored Glassware of the Depression Era.* Springfield, Missouri: Weatherman Glass Books, 1974.
Weishar Enterprises. *Company Catalog.* Wheeling, West Virginia: Weishar Enterprises, 2002.
Welker, Mary, Lyle & Lynn. Cambridge Glass Company Catalogs I. Cambridge, Ohio: Lynn Welker, 1970.
____. Cambridge Glass Company Catalogs II. Cambridge, Ohio: Lynn Welker, 1970.
Weltzel-Tomalka, Mary. *Candlewick, The Jewel of Imperial.* Notre Dame, Indiana: Mary Weltzel-Tomalka, 1995.
Westmoreland Glass Co. *Company Catalogs 1950s-1980s.* Grapeville, Pennsylvania: Westmoreland Glass Co., 1950s-1980s.
West Virginia Museum of American Glass. *Archival Material.* Weston, West Virginia: West Virginia Museum of American Glass, 2001.
Wheaton Glass Co. *Company Catalogs 1970s.* Millville, New Jersey: Wheaton Glass Co., 1970s.
Whitmyer, Kenn & Margaret. *Fenton Art Glass Patterns 1939-1980.* Paducah, Kentucky: Collector Books, 1999.
____ *Fenton Art Glass 1907-1939.* Paducah, Kentucky: Collector Books, 1999.
Williams, Juanita. *Fostoria Glass: Lunch Hour Whimsies*. California: Juanita Williams, 1996.
____ *Figurines by Fostoria Glass Study Guide*. California: Juanita Williams, 1990.
Wilson, Jack. *Phoenix and Consolidated Art Glass 1926-1980.* Marietta, Ohio: Antique Publications, 1989.
Wonsch, Lawrence L. *Hummel Copy Cats.* Lombard, Illinois: Wallace-Homestead Book Co., 1987.
Yeakley, Virginia & Loren. *Heisey Glass in Color.* Marietta, Ohio: Richardson Printing Corporation, 1978.
Zemel, Evelyn. *American Glass Animals A to Z.* North Miami, Florida: A to Z Productions, 1978.

Index of Animal Shapes

Angel- 38, 39, 60, 134, 153
Ballarina- 39, 40
Bashful Charlotte- 22
Bear- 14, 19, 40, 41, 42, 43, 70, 71, 138, 144, 149, 150, 168
Bird- 19, 20, 25, 31, 32, 33, 34, 43, 44, 75, 77, 81, 83, 94, 95, 96, 97, 103, 104, 108, 109, 118, 119, 121, 127, 131, 134, 145, 146, 147, 148, 150, 153, 166, 167, 168, 169, 176, 182, 185
Buddha- 20, 21, 79
Blue Jay- 20, 44
Buffalo- 161, 169
Bull- 83, 103, 106
Butterfly- 21, 44, 45, 126, 177
Camel- 60, 177, 185
Cardinal- 44, 134, 176
Cat- 14, 45, 46, 47, 48, 70, 127, 130, 134, 151, 154, 164, 165, 169, 170, 186
Cathay- 107, 108, 109
Cherub- 9, 84
Chicken- 48, 49, 71, 81, 84, 85, 97, 98, 103, 109, 110, 133, 139, 145, 154, 170, 177, 180
Clown- 49
Cow- 15, 83, 103, 106, 151
Crow- 131
Crab- 131
Cygnet- 97, 102, 103
Deer- 15, 55, 72, 82, 85, 129, 166
Dinosauer- 15
Dog- 15, 16, 21, 28, 30, 31, 37, 49, 50, 51, 70, 71, 79, 80, 82, 85, 103, 105, 110, 111, 127, 128, 135, 139, 140, 149, 151, 154, 155, 161, 165, 171, 178, 181, 182, 186
Dolphin- 22, 51, 86, 111, 141, 160, 174, 178
Donkey- 33, 51, 60, 86, 99, 103, 111, 127, 135
Dragon- 107
Draped Lady- 22, 23
Dove- 33
Duck- 11,12, 16, 33, 51, 52, 70, 72, 87, 97, 99, 103, 111, 112, 145, 155, 163, 171, 178
Eagle- 16,22, 52, 72, 112, 126, 131, 133, 146, 160, 161
Egret- 108, 169
Elephant- 12, 16, 28, 29, 30, 32, 37, 53, 54, 55, 72, 80, 88, 98, 99, 103, 104, 105, 113, 130, 135, 137, 140, 152, 155, 156, 161, 163, 172, 181, 186
Fish- 12, 34, 55, 56, 73, 78, 82, 88, 89, 100, 103, 104, 113, 114, 132, 149, 156, 166, 172, 182, 186, 187
Flower Frogs-
 Bashful Charlotte-22
 Draped Lady- 22, 23
 Duck- 86
 Elephant- 29
 Heron- 20
 Kingfisher- 94
 Seagull- 20
 September Morn- 66
 Turtle- 68, 144
Flower girl- 57
Fox- 16, 57, 90, 100
Frog- 16, 23, 24, 29, 56, 57, 73, 135, 152, 166, 172, 181
Fruit- 78
Gazelle- 90, 103, 114
Giraffe- 90, 103, 114
Golfer- 132
Goose- 34, 91, 115, 146, 156, 157, 180
Gorilla- 17
Grouse- 34
Heron- 20, 34
Horse- 11,17, 37, 64, 73, 79, 81, 82, 83, 91, 92, 93, 94, 97, 98, 100, 101, 103, 115, 116, 117, 118, 125, 128, 135, 140, 146, 157, 158, 183, 187
Horse shoe- 9

Kangaroo- 130
Kingfisher- 94, 103, 118
Kissing Kids- 58
Lion- 24, 59, 71, 79, 80, 81, 94, 95, 118, 136, 162, 172
Lobster- 131
Love Birds- 166, 169
Luv Bug- 59, 70
Lyre- 74
Madonna- 74, 95, 102, 118, 172
Man in Moon- 10
Mermaid- 74
Monkey- 131
Mouse- 17, 59, 60, 70, 118, 173
Mushroom- 173
Nativity- 60, 74
Nude- 25, 66, 132
Owens, Mike- 95
Owl- 10, 13, 31, 61, 62, 75, 119, 128, 136, 149, 152, 166, 173, 175, 178, 179, 183, 187
Pagoda- 108
Panther- 125
Parrot- 167
Peacock- 62, 77
Pelican- 75, 77, 141, 146
Penguin- 17, 62, 75, 95, 97, 179
People- 9, 22, 23, 24, 25, 31, 32, 33, 38, 39, 40, 49, 57, 58, 59, 60, 66, 71, 72, 75, 80, 82, 90, 95, 97, 100, 105, 107, 108, 114, 115, 121, 124, 128, 129, 132, 133, 137, 140, 156, 157, 160, 162, 163, 169, 170, 181, 187
Pheasant- 83, 95, 96, 102, 119, 126, 136, 147, 167
Pig- 18, 63, 96, 102, 103, 119, 120, 141, 151, 162, 179
Pigeon- 25, 96, 102, 103, 125, 136, 147, 163, 179
Porpoise- 141, 174
Praying hands- 128
Praying Kids- 59
Rabbit- 18, 26, 63, 64, 70, 75, 96, 102, 103, 120, 121, 136, 137, 141, 147, 162, 174, 182, 187
Raccoon- 64
Reindeer- 64
Roosevelt- 187
Sailfish- 33
Santa- 65, 76, 179, 181
Sea shell- 13, 80
Seagull- 20
Seahorse- 97, 148
Seal- 76, 141, 151, 174
September Morn- 66
Shakespeare- 80
Sheep- 60, 71, 97, 137
Ship- 142
Sleigh- 64, 76, 179
Snail- 66
Snowman- 66, 67
Southern Belle- 58
Sparrow- 97, 121
Squirrel- 67, 70, 76, 77, 78, 142, 148, 158, 174
Starfish- 13, 148, 180
Swan- 11, 18, 26, 27, 34, 35, 36, 67, 68, 76, 97, 98, 102, 103, 121, 122, 123, 128, 137, 142, 143, 144, 148, 158, 159, 162, 163, 174, 175, 183, 184
Tiger- 18, 98, 103, 124, 143
Tree- 68, 175
Turkey- 27, 124, 137, 159, 167
Turtle- 13, 68, 69, 77, 144, 180, 183, 185
Unicorn- 18, 70, 180
Venus Rising- 124
Viking ship- 36, 70
Whale- 70, 152
Woodchuck- 124